SUPERCOLLECTOR

SUPERCOLLECTOR

a critique of charles saatchi

rita hatton
john a walker

●●●ellipsis

first published 2000 by
●●●ellipsis
www.ellipsis.com

© 2000 rita hatton and john a walker

british library cataloguing in publication
a cip record for this book is available
from the british library

isbn 1 84166 024 8

printed in hong kong

●●●ellipsis is a registered trade mark of
ELLIPSIS LONDON LTD
2 rufus street, london n1 6pe

John A Walker and Rita
Hatton.

contents

acknowledgements

Many thanks are due to all those who have kindly granted interviews, supplied factual information and references, and comments on drafts of this book, especially the late Ivan Alter, James Armstrong (archive curator of the Tate Gallery Archive), Professor Jon Bird (Middlesex University), Jenny Blyth (curator of the Saatchi Collection/Gallery), Andrew Brighton (Tate Gallery education department), Judith Caul (of The Guardian Syndication), Christopher Collins, and Linda Copperwheat (archivist of the Saatchi Collection/ Gallery), Kevin Davey, Professor Christopher Frayling and Graham Crowley (Royal College of Art), Colin Gleadell (sales correspondent of *Art Monthly*), Anita Greene, Michael Hazzledine (a librarian at South Bank University), Beth Houghton (Librarian of the Tate Gallery), Linda Greenlick (librarian of the *Jewish Chronicle*), Titus Kroder, correspondent for the *Handelsblatt* (Germany's business and financial daily), Doris Lockhart, Sheila McCabe (City of Westminster Archives Centre), Sandy Nairne (Tate Gallery), Geraldine Norman (art sales reporter), Paul Overy (Middlesex University), Simon Tait (journalist) and Simon Veglio (Genius Sound & Vision).

John A Walker is grateful to Middlesex University's School of Art, Design and Performing Arts Research Committee for a grant towards the costs of illustrations, picture

research, permissions and so forth. Both authors are also indebted to the library staff, especially Veronica Nyong, of the university's art and design library, Cat Hill for their unfailing help in obtaining books and articles. We would also like to thank all those agencies and institutions that have supplied photographs and the artists for permission to reproduce their artworks: Jennifer Bartlett, Ashley Bickerton, Leon Golub, Hans Haacke, Jenny Holzer, Colin Lowe and Roddy Thomson, Charles Ray, Jamie Wagg, Mark Wallinger and Richard Wilson (individual credits are given in the captions). We are grateful to Michael-Ann Mullen, and Saatchi & Saatchi, M&C Saatchi and the Saatchi Gallery for the supply of photographs. While every effort has been made to trace and contact photographers and copyright holders of illustrations, the authors and publisher will be glad to hear from any that we have not been able to reach.

Finally, we would like to express our thanks to Tom Neville and Rosa Ainley of ellipsis for their editorial/design skills and general support for the book.

introduction

If culture means the
construction of empires, it also
means the critique of them.[1]

Worldwide, thousands of people collect examples of contemporary art, but only a few can be categorised as supercollectors. In 1986 Jane Addams Allen, art critic for the *Washington Times*, judged that Charles Saatchi belonged to this select group.[2] According to Allen, the defining characteristics of supercollectors are: their wealth derives from multi-million-dollar family businesses that are also international; they buy where art is cheap and sell where it is expensive – usually the US; they buy in bulk and work hard at their hobby; they use dealers as scouts but in general make their own selections; they establish art institutions and hire curators to run them; they exert a significant influence on the art market – they can even raise prices merely by viewing works of art.

The following year Richard W Walker, another American and a staff writer for *Art News*, wrote:

> Charles Saatchi. The name of a global advertising tycoon who is said to spend more than $2 million annually in the art market is heard everywhere. Many say he is the most powerful collector in contemporary art – in the words of one dealer, a twentieth-century Medici – one whose influence as a tastemaker exceeds that of any critic or curator, and who can make or break a trend. Where Saatchi leads, it is said a host of others follow. Fittingly, the adman

himself has become the ultimate advertisement for the latest artist or trend.[3]

To these remarks, which are still applicable, we can add that Saatchi sells art as well as buying it and that he owns a gallery in London – commodious but still only able to display a fragment of his extensive collection – and that his fortune is estimated at $200–300 million.

Saatchi's activities as a collector, patron, curator and dealer, his rapidly changing tastes in art, have prompted much comment in the art world, and while there are those who admire and praise him, others fear and denigrate him. This book is primarily a hostile critique written from a socialist standpoint; our analysis involves ideas derived from a number of social theorists including Karl Marx, Raymonde Moulin and Thorstein Veblen.

Like many rich and powerful individuals, Saatchi seldom grants interviews to journalists or art critics/historians (though we did ask). We do not consider this 'unauthorised' and 'unofficial'[4] status to be a drawback because an independent, critical study of Saatchi and his collecting and trading is surely to be preferred to writings by art critics who are paid by him to write catalogue introductions or who are in awe of his power. Many artists and dealers who speak to journalists about Saatchi are only prepared to do so providing their anonymity is preserved. In any case, the veracity or insight of interviewees can never be guaranteed.

Our information about Saatchi derives from interviews with certain artists and others who have known or worked for him, from observations of his actions and behaviour, from books about him and his brother Maurice, and from the stream of articles published in business pages and the art

press. We have drawn upon this mass of literature to provide an integrated, systematic, historical account.

Two substantial books about Charles and Maurice Saatchi, written by Philip Kleinman and Ivan Fallon, appeared in 1987 and 1988 respectively.[5] Both authors focused on the history of the brothers' advertising agencies and business activities. Rather than repeating this, we will simply list some of the key developments that occurred between 1970 and 1989:

1970	Saatchi & Saatchi agency founded. End of year profit £100,000 on billings of £1 million.
1971	profit before tax £1 million.
1973	agencies purchased in Belgium, France and Holland.
1975	reverse take-over of Garland-Compton in London. S & S moves from being thirteenth biggest agency in Britain to being the fifth biggest. It also gives S & S access to the Stock Exchange.
1978–79	first campaign for the Conservative Party.
1979	S & S become the largest agency in Britain. 774 employees. Profits before tax £2.4 million.
1981	bought Garrott Dorland Crawford of London for £7 million raised on the Stock Exchange.
1982	merged with Compton Communications Inc. of New York to become thirteenth biggest agency in the United States.
1983	S & S win British Airways account.
1984	bought American-based Hay Group (International Consultants in the Management of Human Resources – with 94 offices in 27 countries) for circa $100 million plus a $25 million earn-out. A significant diversification.
1985	the stock-market value of S & S reaches £450 million.
1986	bought the New York agency Ted Bates Worldwide Inc. for

	circa $500 million. S & S become the largest advertising conglomerate in the world. Employees number 14,000.
1987	the brothers prepare to raise £3 billion to buy the Midland Bank – but this plan fails.
1988	profit before tax reaches £138 million.
1989	companies acquired number 85 but profit before tax falls to £61 million.

The Hay Group was founded in Philadelphia by Edward Hay in 1943. In a 1984 Saatchi & Saatchi annual brochure a full-page colour photograph appeared showing Hay consultants with clients strolling in the Donald M. Kendall Sculpture Gardens, PepsiCo World Headquarters, Purchase, New York. Modern sculptures by such famous artists as Alexander Calder, Henry Moore, Claes Oldenburg and Tony Smith were thus seen as a suitably inspiring background for doing business.

Kleinman's book describes the Saatchi brothers' financial deals in mind-numbing detail; Fallon's is even fuller and contains much biographical and character information. One reviewer, the novelist Hanif Kureishi, complained that Fallon's account was 'subservient' because there was 'barely a critical or analytical word' about two people Kureishi judged to be 'shallow, greedy self-seekers … Thatcher's children; without dimension, mystery or inwardness, they are an appropriate monument to our age.'[6] The subject of art collecting was confined to a single chapter.

Both Kleinman's and Fallon's books were published at a time when the Saatchis' fortunes had peaked and their business empire was about to enter a period of crisis. Two further books about them (Alison Fendley, 1995 and Kevin Goldman, 1997), updated the brothers' story and explained

how they lost control of their empire during the early and mid 1990s.[7] Neither writer discussed art in any detail.

Given the frequency with which the name Charles Saatchi has appeared in the mass media and the expertise he has shown in using the media, his reticence seems paradoxical. His reclusiveness even extended to the employees and clients of the Saatchi & Saatchi advertising agency in Charlotte Street, London. Some employees worked for the agency for years without meeting him. It seems that he even became unwilling to meet clients: a well-known anecdote describes Saatchi pretending to be an office cleaner rather than greet clients touring the building.

For many years virtually the only photograph of Charles and Maurice Saatchi that appeared in the press was a 1976 stock portrait supplied by their agency – the brothers seemed to have discovered the secret of eternal youth since they never aged. Some writers claim that Charles Saatchi is 'naturally shy' but this, we believe, is a myth or a blind. The quite detailed account of his character and behaviour in Fallon's book reveals that he was aggressive and impatient; had a short attention span; was easily bored and therefore only undertook tasks that interested him; gradually he delegated financial matters to Maurice and presentations to clients to Tim Bell. He preferred to lurk in the background.

Saatchi favoured corporate rather than personal publicity; consequently, he did not foster a cult of personality as did some other lead-

Portrait of Maurice Saatchi (left) and Charles Saatchi (right) in Maurice's Charlotte Street office, c. 1976 (Keith McMillan).

ing advertising executives. During the early days, the 1970s, when he and Maurice wanted publicity for their agency, he made strenuous and systematic efforts to obtain it by feeding news and gossip about the advertising world to its trade magazine *Campaign*. In addition, both Maurice and Charles have been willing to talk to reporters 'off the record' and to leak stories to the press in order to discomfort their rivals when engaged in bitter boardroom battles over the control of the advertising empire.

In 1985, when Charles Saatchi opened his own gallery and made his expanding art collection available to the public – hardly the behaviour of a genuinely shy person – he must have anticipated the considerable publicity that this would bring. If Saatchi had wanted to avoid publicity, he could have donated a fortune anonymously to a public museum or arts organisation. But he did not do this. Extensive free publicity accompanies his buying expeditions, his gallery shows, and his sales too via articles in the broadsheets, in specialist art magazines and even via television programmes. Such publicity makes the name 'Saatchi' more and more famous and keeps it in the public arena; it also assists in making the artists he supports better known and their art works more valuable.

No doubt Saatchi values his privacy, but powerful individuals often have other reasons for keeping reporters and photographers at bay, for example, to create an aura of mystery around themselves, which has the effect of stimulating curiosity still further. Furthermore, negative press reports about a company can have dire financial consequences such as a drop in the value of shares, or, *in extremis*, they can cause a client to become so unhappy that they switch their account to another agency. Tony Brignull, a copywriter, has

commented that Saatchi's retreats to his office 'were not shyness alone but calculated to preserve the value of his currency: the less they see, the more they value.'[8] Other reasons can be suggested: to limit public scrutiny of a critical, analytical kind; and to preserve commercial secrecy. In one rare interview, Lord Maurice Saatchi explained that he and Charles had decided not to talk to outsiders because 'we began to see that giving interviews was only likely to help our competitors and we didn't want to explain to the world our view of what was making our company successful.'[9]

Those in charge of business and politics are keen to exploit the demand of the media to know everything when it suits their purposes but they desire only favourable coverage and wish to restrict access to keep down the number of competitors or avoid public condemnation – for instance, about the huge bonuses and salary rises top business people award themselves while expecting employees in the public sector to keep wage increases to the annual rate of inflation.

Nicholas Serota, director of the Tate Gallery, who knows Charles Saatchi in his capacity as an art collector, has said this about him:

> He regards himself as a private person rather than a public person, and therefore having essentially the responsibilities of a private person rather than a public person, therefore he doesn't feel any need to explain himself, he doesn't feel any need to be consistent, he doesn't feel any need to justify what he is doing even if he changes his mind. And he works in a profession where if you don't change your mind, and you don't move forward all the time, you are lost.[10]

Doubtless Saatchi believes he has a perfect right not to dis-

close when, and for what reasons and prices he buys and sells works of art – although trickles of information have appeared in the art press from time to time (and in December 1998 a small proportion of his collection was auctioned openly by Christie's) – but one unfortunate consequence is that speculation and rumour multiply. This makes it difficult for researchers to confirm – or even uncover – the facts. We suspect that Saatchi enjoys keeping his watchers guessing.

Our concern is not primarily with Saatchi's personal life and character – biographical information, therefore, has been kept to essentials – but with the role and function he performs within the art system of a capitalist society. This system, generally known as 'the art world', is a relatively autonomous subsection of developed nations which has its own superstructure and micro-economic base, producers and consumers, and which consists of a number of interconnected institutions and organisations – both public and private – and businesses. Within this system, individuals may position themselves as artist, critic, curator, dealer, patron, etc. In other words, if Saatchi had never lived or if he died tomorrow, the position of collector would have been occupied by someone else.

There are other collectors of contemporary art in Britain and there are precedents for Saatchi both as collector and as gallery founder. For example, during the 1950s Robert and Lisa Sainsbury, whose money came from retailing, purchased work by living British artists, such as Francis Bacon. In 1978 they donated their collection, along with an endowment, to the University of East Anglia where it is now housed in the Sainsbury Centre, a high-tech metal-and-glass structure designed by the architect Sir Norman Foster. (Incidentally, the Saatchi advertising agency handled the Sains-

bury account for a time during the 1970s.) Also in the 1950s and 1960s, E J (Ted) Power (and his son Alan), whose wealth derived from the manufacture of radio and television sets, was a major collector of recent art. Lord Alistair McAlpine, of the building contracting company, bought British new-generation sculptures during the 1960s and later gave them to the Tate Gallery. (Despite his enthusiasm for radical new art, McAlpine later became a treasurer of the Conservative Party.)

Of course, art collecting has a much longer history. Lisa Jardine, a professor at London University and the author of *Worldly Goods*, a history of the Renaissance which foregrounds the issue of arts patronage, remarks regarding Federigo Montefeltro, the Duke of Urbino:

> Federigo's immense wealth had been accumulated as direct payment for his military skills ... Spending lavishly on 'culture' was one way in which Federigo could give himself, and his princely court at Urbino, respectability. By surrounding himself with priceless artistic treasures, discerningly selected, he could establish himself as truly noble, and not simply as 'new money.'[11]

The Saatchi brothers too were examples of 'new money'. Jardine concludes her book by saying:

> The world we inhabit today, with its ruthless competitiveness, fierce consumerism, restless desire for ever wider horizons, for travel, discovery and innovation ... is a world which was made in the Renaissance.[12]

It was appropriate, therefore, that Jardine was commissioned to write a survey of British arts patronage in the

twentieth century for inclusion in a catalogue about part of the Saatchi Collection.[13] Jardine maintains that 'committees do not create good art' and that, therefore, individual collectors such as Sainsbury and Saatchi, who have a taste for art and the funds to buy it, are positive and necessary assets to present society. Strangely undemocratic views from someone who is reported to be a feminist and a member of the Labour Party.[14]

Since social mobility is common in today's society, social positions are often earned rather than inherited – though there are examples of family dynasties in business, the arts and the media. There are well-recognised educational routes to becoming an artist, curator or graphic designer but art collectors are not usually trained, though certain prerequisites are needed to become one: surplus capital; leisure-time; a discriminating faculty of judgement or 'eye'; and a home, gallery or store to house the collection.

It is also possible for an individual to perform a role well or badly and to embody or personify a political ideology (like Margaret Thatcher and Thatcherism). Charles Saatchi has invested far more attention, effort, money and time in his collection than the majority of British collectors of contemporary art. Indeed, his devotion to the collection prompted criticism during the 1990s by those who thought he should be paying more attention to his business responsibilities. The history of recent British art in particular would certainly have been different if Saatchi had not decided to become a collector because another collector would probably have focused upon a different set of artists. It is interesting to try to imagine what the history of British art and the international art scene would have been like without Saatchi.

One issue that prompted this study was the interrelation between the fine arts and mass media, the crossover from advertising to art, the shift from 'low' to 'high' culture, that occurred in Saatchi's case.[15] Both advertising and art contribute to the visual culture of a nation and advertising, even more than art, is an ideological and social force: it influences and shapes people's attitudes, feelings, thoughts and habits. (Precisely how this occurs is difficult to assess even within the advertising world but we can be certain that industry and business would not spend billions on advertising if it were believed to have no impact.) Consequently, those working for advertising agencies – whose names are not normally known to the general public, hence one meaning of the expression 'hidden persuaders' – exercise considerable power over consumers and voters, especially during election campaigns.

We made a special effort to identify the connections and continuities between Charles Saatchi the advertising man and Saatchi the art lover because we believe that an understanding of his experience/knowledge of advertising and marketing helps to explain his behaviour and taste as a collector.

We puzzled for some time over the question of why, since Saatchi became wealthy as a result of his skills in advertising, did he not found a museum of advertising rather than a museum of art? (Could it be that he despised or felt ashamed of his profession as an advertising copywriter? Or was it that art still carries more social prestige and has more investment potential than advertising? The latter is the more likely explanation.) After all, there are museums and galleries devoted to modern and contemporary art in London already, hence the addition of another one merely enriched

an already existing situation (we should say 'significantly enriched' …). Arguably, the founding of a museum of advertising would have been a more original and socially valuable gesture because advertising is such an important part of the mass media and daily life today that a large collection of examples available to historians, students and the public in London would be hugely useful.[16]

Indeed, the creativity, artistic skills and high-production values manifest in the best examples of advertising rivals or even surpasses that typical of contemporary art. As long ago as 1928, Gustav F Hartlaub, director of Mannheim's municipal gallery, wrote: 'Advertising art is today the one true public art. It alone – as graphics, as mass-reproduced printed type and images – reaches the nameless urban masses, whose enthusiasm no longer belongs to the church or to municipal authorities but rather to sports, fashion, football …'.[17] Hartlaub also recognised that fine art 'disseminates intrinsic value of its own volition' but that it could be used, subsequently, to 'enoble' commercial goals.

The attraction of fine art to those employed in advertising is widespread – witness its use in so many pictorial advertisements and television commercials, and the strenuous efforts made by Tony Kaye (b. 1953) – a well-paid and highly successful director of visually stunning television commercials (some of which were made for Saatchi & Saatchi) – to achieve recognition as a fine artist.[18]

Our history of the Saatchi phenomenon – an episode in what the American historian James S Allen has called 'the romance of commerce and culture'[19] – clarifies aspects of the workings of capitalism, the way certain predatory individuals pursue and achieve fame, wealth and power in the realm of business and are then able to control and profit from fine

art by creating a whole apparatus for adding value.[20]

Any account of the emergence of the Saatchi phenomenon needs to take note of certain historical and social changes which occurred during the 1970s and 1980s. For instance, globalisation, the growing importance of the information and service industries, advertising and consumerism, the impact of monetarist economic policies, and the transition from modernism to post-modernism. Robert Hewison, a cultural historian, has observed:

> It was no accident that at a time when his company was becoming the country's most influential distributor of commercial messages and, with its work for the Conservative Party, political images, Charles Saatchi became the most important British private collector of contemporary art. According to Fredric Jameson: 'Aesthetic production today has become integrated into commodity production generally: the frantic economic urgency of producing fresh waves of ever more novel-seeming goods (from clothing to airplanes), at ever greater rates of turnover, now assigns an increasingly essential structural function and position to aesthetic innovation and experimentation.' The result has been a massive expansion of the 'cultural' into the economic sphere, but where the 'economic' is the principal expression of the cultural: 'Every position on post-modernism in culture – whether apologia or stigmatisation – is also at one and the same time, and necessarily, an implicitly or explicitly political stance on the nature of multinational capitalism today.'[21]

Martin P Davidson, author of *The Consumerist Manifesto*, a text on advertising, has also remarked:

> The three biggest things that happened to advertising during the

1980s were its politicisation, its commercialisation and its assumption of the status of an art form. In other words it became more controversial, more lucrative and more pretentious than it had ever been before. And one agency has more to answer for this than any other ... Saatchi & Saatchi ... Their name became the flashpoint between politics, culture, media and the market-place, none of which will ever be the same again.[22]

The story of Charles Saatchi in both advertising and art, besides being a fascinating one in its own right, is instructive because of the light it throws on the history of British politics and society since the 1960s, in particular the shift of power from the Left to the Right, and from the public domain to the private sector which occurred during the 18 years of Tory rule (1979–97). Despite the election in 1997 of a 'Labour' (really a social democratic) government, many of the changes which the Tories and their supporters in business brought about are likely to persist well into the twenty-first century.

We suspect that Saatchi's supporters will claim that this book has been motivated by envy and spite rather than by a desire to see a more democratic, just and sustainable society. We also expect to be accused of 'Saatchi-noia' – Waldemar Januszczak's term – meaning a paranoia experienced by those who exaggerate Saatchi's abilities as a conspirator, those who 'love to see some deep Machiavellian purpose in everything he does'.[23] Whether or not we are guilty of these charges, we leave it to you, the reader, to judge.

the founding of
an advertising empire

> Advertising is the official art of
> modern capitalist society.
> Raymond Williams.[1]

> Advertising is the revenge of
> business on culture.
> Doug Lucie.[2]

Charles Nathan Saatchi, the second son of Nathan and Daisy Saatchi, was born into an Iraqi-Jewish family in Baghdad on 9 June 1943. (In Iraq the name Sa'atchi meant watchmaker or dealer. Maurice Saatchi later joked that the word 'Saatchi' was an acronym for 'Simple And Arresting Truths Create High Impact'.) His father was a prosperous merchant who imported cotton and wool products from Europe. Charles' elder brother David had been born in 1937 and was to become a successful commodity broker and then a sculptor resident in New York. Maurice Nathan Saatchi, a third brother, was born in Iraq in 1946 and became a close business partner of Charles – references to 'the brothers' mean Maurice and Charles. A fourth brother, Philip, who later worked in the music business, was born in London in 1953.

Iraq was a safe haven for its Jewish community during the Second World War but afterwards, when faced with the prospect of a Jewish state in Palestine, restrictions began to be imposed on Iraq's Jews. Sensing impending disaster,

Nathan decided to emigrate to Britain. Two British textile mills were purchased in 1946 and a year later a house for the family was acquired in the affluent London suburb of Hampstead. Visitors to a second, larger Hampstead home noted the lack of any signs of interest in the visual arts.

Charles Saatchi attended Christ's College, Finchley, an all-boys state school dating back to the nineteenth century. One of the friends he made at school was Bernard Jacobson who became a well-known London art dealer. Although eventually their tastes in art diverged (under the influence of Peter Fuller, Jacobson became a passionate supporter of landscape painting), Jacobson was close enough to assist Saatchi in his business affairs.

Teachers and fellow pupils remember Saatchi's energy and impatience but these characteristics did not translate into academic success and he left school at the age of 17 with few qualifications or skills. Ivan Fallon has suggested that this poor school record may have been due to undiagnosed dyslexia. The art director John Hegarty, who trained at Hornsey College of Art and the London College of Printing from 1960 to 1965, has also recalled that the young copywriter he worked with in the 1960s was poor at spelling. This learning difficulty may explain why Saatchi developed an orientation towards the visual. The lack of academic achievements prevented Saatchi from attending university and this may have fuelled the desire to make a splash in the realm of high culture by assembling a huge art collection.

jewish identity and social class
Without their Jewish identity the Saatchi family would probably not have migrated to Britain, but it seems that the brothers disliked journalists mentioning their origins. Klein-

man declares that Charles Saatchi was 'unnecessarily defensive ... about his Jewish identity and unwilling for it to be known'.[3] This appears not to have been because the brothers were ashamed of their background or because they experienced much anti-semitism in Britain – only one instance is cited in the four books about them[4] – but because they did not consider it relevant to their position as successful businessmen, because they thought of themselves as assimilated English rather than as Jewish. They had escaped from 'the ghetto' and had no wish to be reminded of it by journalists. There is an echo of this assimilationist attitude – nation is more important than race – in an anti-Labour-Party election advert Saatchi & Saatchi produced in 1983 which depicted a male of African or West Indian origin: 'Labour says he's black, Conservatives say he's British.'

Both Charles and Maurice ignored their parent's Sephardic faith by marrying outside the Jewish religion in register offices. Though this implies secularism, an indifference to Judaism, in 1998 the four brothers funded a new, 'brand-named Synagogue' – The Saatchi Synagogue – in north-west London in honour of their parents.[5] To attract a younger generation of worshippers, the small advertising agency Hype! was used to publicise the synagogue. One of their adverts parodied Damien Hirst's sculpture *Away from the Flock*, a dead sheep embalmed in a glass tank, a work in the Saatchi Collection. In the advert a chicken was substituted for the sheep.

It is clear that Charles Saatchi's class origin was that of the middle-class or bourgeoisie which came to prominence during the eighteenth and nineteenth centuries and now dominates many societies around the world (see *The Communist Manifesto* of 1848 for Karl Marx' catalogue of its achieve-

ments in revolutionising the mode of production, the means of transportation, etc.). During the 1970s and 1980s the brothers managed to galvanise and transform the advertising business and so continued the tradition of innovation associated with their class.

The fact that Saatchi's father was a businessman rather than a worker/employee, teacher or civil servant meant that it was easy and natural for Charles (and Maurice) to think of entering the world of business. He would be continuing a family tradition and in childhood he must surely have gained some inkling of business practices from his father. Being a success in business would enable him to redeem his lacklustre school record and, as the first generation of an immigrant family, it would help to secure his position in the host community. The desire for wealth and global influence that became evident during the 1970s and 1980s when the brothers set out to establish the largest advertising conglom-

erate in the world can be interpreted as indicative of profound insecurity. In his book *Britain on the Couch*, the psychologist Oliver James noted that entrepreneurial types often emerge from 'socially marginal' backgrounds.[6] Similarly, Karen Horney maintains that anxieties prompted by external circumstances can result in a 'quest for power, prestige and possession' designed to assuage those anxieties.[7] Outside the realm of business, Charles' passion for playing board and card games, sports, and racing go-karts reveals

Charles Saatchi dressed for go-karting, 1990s.

his competitive character and compulsion to win. (During the 1990s when more than 50 years old, he was reported to be spending £50,000 per annum on go-karting.) We suspect that he also enjoys 'playing games' with art and culture.

But whatever inner demons the brothers' ambition and drive were intended to placate, there were clearly business imperatives too. A small advertising agency finds it hard to attract major clients and is vulnerable to take-overs, hence the need to become larger and to become one of the leading agencies. Size – critical mass – is thus important, and this applies to Charles Saatchi's art collection too. Becoming a market leader – through organic growth or by mergers, buy-outs and take-overs – helps to secure a longer-term future. The brothers discovered that the easiest and quickest way for a company to increase its market share is to buy-up the competition.

As the globalisation of business increased during the 1980s, multinational companies demanded advertising agencies that could service their brands worldwide, hence the decision of the brothers to aim for a global empire rather than a successful national business. Another reason for acquiring businesses other than advertising agencies – such as market-research companies, management consultancies, etc. – was the 'cross-referral' or 'one-stop shopping' idea of serving all a client's needs within the same group of companies.

a career in advertising

After a period enjoying the wild parties of swinging London, Charles Saatchi spent a year in the United States where he was exposed to its dynamic television culture and advertisements, particularly those of Bill Bernach. On his return to

Britain, Saatchi studied advertising at the College for the Distributive Trades in central London for a time and then, in 1965, he joined the Knightsbridge agency Benton & Bowles as a junior copywriter. There he met his future wife Doris (of whom more later), and teamed up with the art director John Hegarty and met Ross Cramer, a more senior art director. In 1966 Cramer and Saatchi moved to Collett Dickenson Pearce & Partners (CDP) which was reputed to be a highly creative agency. Other employees included David Puttnam (now Lord Puttnam) and Alan Parker who, of course, were later to make their mark in the film industry. After two years Cramer and Saatchi established their own creative consultancy undertaking work for various advertising agencies. Hegarty also joined them, as did Jeremy Sinclair who had trained at Watford Art College.

Advertising is regarded as a 'people business', whose main assets are its staff. There are two main categories: the 'suits' – those who handle accounts and liaise with clients – and the 'creatives' – those who generate the ideas, words and images that persuade clients to place and keep their accounts, some of which are worth millions of pounds (the so-called 'billings' or 'client spend'), with one agency rather than another. If key staff decide to leave an agency to join or to form another one, they often take the clients' accounts with them because the clients know and value them. Agencies develop certain reputations: some – usually small ones – are considered more creative than others. (Unusually, the brothers aimed to square the circle by becoming big but remaining creative.) During the 1970s the Saatchi & Saatchi agency developed a creative reputation. Charles Saatchi was soon conscious of the importance of creativity in the realms of both art and advertising.

Adverts usually consist of a mixture of images and text and so the creatives comprised art directors (many of whom came from art and design colleges) and copywriters. Saatchi, the copywriter, was used to working in partnership with talented art directors such as Hegarty, Ron Collins and Bill Atherton (who had trained at the London College of Printing) who were generating a stream of visual material. The same collaborative behaviour marks his relation to certain fine artists: he once asked Damien Hirst if he has any ideas for an artwork; Hirst mentioned the idea of presenting a dead shark as a reminder of mortality but said that he could not afford the cost of implementing it. Intrigued by the proposal, Saatchi agreed to realise it and, just like in advertising, assistants were instructed to arrange for the killing of a shark, transporting it from Australia, etc.

New and striking ideas are essential to success in advertising and they became important in the art world in the form of conceptual art (also known as 'idea art'). The movement followed minimalism during the late 1960s and had a significant influence on art practice in subsequent decades.

Agencies, of course, have their own reasons for prizing cleverness, controversy, creativity, and originality in advertising. Every effective advert is positive publicity for the agency itself, especially within the industry, which holds annual conventions when the creatives are given awards for the most impressive adverts. In the opinion of some observers and clients the eye- and mind-catching brilliance of many British advertisements is not always useful in selling goods and services. Viewers may be enthralled by the flow of weird imagery in a television commercial, but they may be unable to recall the product the commercial was promoting.

Saatchi's ability to write effective copy soon gained him the respect of his colleagues and they also admired his outlandish ideas and knack of simplifying complex problems. Although he eventually made the transition from 'creative' to 'suit', his unorthodox appearance (an Afro hairstyle, for instance) and volatile temperament during his early years in advertising evoked the conventional image of the artist. His impatient streak has already been mentioned – it seems he almost never stayed to the end of business meetings and often walked out of cinemas before the end of films. But with impatience came the ability to make quick decisions and value judgements which served him well in advertising. He would review images and captions and declare them to be 'good' or 'rubbish' in a moment. Again, this ability is surely manifest in his art collecting: he visits an artist's studio or first gallery show and decides there and then whether or not to buy. Fallon qualifies this view by arguing that Saatchi's buying habits were not completely instinctive and intuitive because he often prepared himself by reading about artists before visiting their exhibitions or studios.

Cramer-Saatchi's most famous achievements were the adverts they produced for the Health Education Council: messages against cigarette smoking and for contraception. During the 1960s the link between smoking and lung cancer was slowly being established. In one image a man pours a stream of liquid tar from a glass on to a saucer. The caption reads: 'No wonder smokers cough'. Another stop-smoking advert showed a nicotine-stained hand being scrubbed with a nailbrush with the comment: 'You can't scrub your lungs clean'. These adverts aimed to shock and they succeeded. The need for contraception to prevent unwanted pregnancy and abortions

Cramer-Saatchi for Health Education Council, pregnant man poster, (1969–70).

Would you be more careful if it was you that got pregnant?

Anyone married or single can get advice on contraception from the Family Planning Association.
Margaret Pyke House, 27-35 Mortimer Street, London W1 N 8BQ. Tel. 01-636 9135.

prompted Sinclair and Atherton to devise a striking, role-reversal image: a pregnant man with the caption: 'Would you be more careful if it was you that got pregnant?' Saatchi greeted it with enthusiasm. The advert attracted much public comment in Britain and the United States and helped to enhance his reputation as a brilliant advertising man.

In 1970 Saatchi decided to establish his own advertising agency and he persuaded Maurice to join him in order to handle the business side. Their working relationship was often a stormy one: according to Fallon, verbal and physical fights took place in which Charles hurled chairs across the room.

the name

The brothers decided to call their new agency Saatchi & Saatchi even though, or perhaps because, it sounded bizarre. Many names of advertising agencies are cumbersome strings of the surnames of their partners. The brothers' agency name, in contrast, is short and memorable, a highly effective name for a company because the repetition of the same word/sound gives it a terse and poetical flavour. To British ears, initially at least, it sounded exotic.

Saatchi & Saatchi advertising during the 1980s and the early 1990s, geared to promoting New Zealand's dairy produce and also such key visual arts institutions as the Auckland City Art Gallery and The City Gallery, Wellington demonstrated the global reach of their appeal when a profile document produced to launch the latter gallery in 1993 received a creative excellence award a year later from Design & Art Direction. Not all New Zealand artists were favourably impressed. Lesley Kaiser and John Barnett, for instance, issued a critical typographic mailout (1993, 297 x

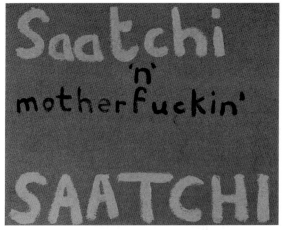

Colin Lowe and Roddy Thomson,
Saatchi 'n' motherfuckin' Saatchi,
1996. Acrylic on unprimed linen,
38 x 50 cm.

210 mm) which baldly stated 'Like it or not' and beneath 'Naazi & Naazi',[8] a particularly crass transformation of the agency's name.

In 1996 the fame of the twin names prompted a painting by two British artists, Colin Lowe and Roddy Thomson. It had no image, only the words 'Saatchi 'n' motherfuckin' Saatchi' borrowed from the rap music lexicon, and was at once insulting and respectful. The artists acknowledged their painting was confrontational but so, in their view, were many of the Saatchi agency's adverts. In contrast to the simple typography the brothers favoured for their nameplates – to emulate the *gravitas* of a bank or a firm of solicitors – the

lettering in the painting was handpainted in a crude manner.[9] The art critic Matthew Collings commented:

> The jokey rage of this painting, its spluttering incoherence, its ejaculation, was an effective expression of a strange artworld phenomenon. The way the word is so loaded, so guaranteed to provoke groaning and eyeball rolling, but at the same time nobody can ever quite sum up what the problem is. Or even, often, who they are dealing with.[10]

Collings' final point highlighted the confusion in many people's minds between the brothers' advertising agency and Charles Saatchi's collection/gallery. Ironically, by the time the painting was created, the brothers were no longer in charge of the London agency or the global advertising empire called Saatchi & Saatchi.

the new agency

In 1970, to publicise their new agency, the brothers spent £6000 – a substantial portion of their initial capital – on one, full-page advert in the *Sunday Times* advocating 'a new kind of advertising'. The final version of the text was actually written by Robert Heller but the advert vividly demonstrated the brothers' talent for self-promotion and their faith in the power of advertising. Charles Saatchi once remarked: 'Power is doing a great ad. That's power in this business. If you want power, do a great ad.'[11]

Strictly speaking the advertising agency Saatchi & Saatchi only existed from 1970 to 1975 when it merged with Garland-Compton and the full name of the new agency became 'Saatchi & Saatchi Garland-Compton Ltd'. Later on it became known as 'Saatchi & Saatchi Advertising'. It is also

important to distinguish between the London agency which bore their names and the brothers' holding company 'Saatchi & Saatchi Company Ltd or PLC' which was established for the purpose of controlling all the other companies which they acquired worldwide. The London agency remained the flagship company for many years; the brothers occupied offices on the sixth floor of the building in Charlotte Street, its principal premises, and stored their various cars in the basement garage.

The overlap in the names of the agency and the holding company did not trouble the brothers but it did cause others confusion from time to time and, eventually, it became a problem for American critics of the Saatchis. During the mid 1990s these critics managed to oust the brothers; the name of the holding company was then changed to 'Cordiant'. When, in 1995, Maurice was forced out he founded another advertising agency. Naturally he wanted to use the name Saatchi again and so he called the new agency 'M&C Saatchi' (which some wits then referred to as 'McSaatchi').

A significant move occurred in 1975 when the brothers merged their privately owned agency with Garland-Compton, a company quoted on the Stock Exchange whose shares were owned by members of the public and by institutional investors. The affairs of such companies are much more open to public scrutiny. Shares increase or decrease in value according to how the company performs and therefore shareholders expect the directors of the business to serve their interests rather than the directors' own interests. If the original owners possess a majority of the shares then they continue to control the company; however, if they then issue new shares or sell their own shares to raise cash to expand – as the Saatchis did – other shareholders become more pow-

erful. Normally, the founder of a company remains as chief executive and is elected chairman of the board and has to issue an annual report and hold an annual meeting to which all shareholders are invited. If they think that the chairman is running the company badly the shareholders can force him out. Rather than suffer such a fate, Maurice Saatchi resigned in 1994. Using the Stock Exchange to raise money for acquisitions, therefore, had short-term advantages but long-term disadvantages for the brothers.

the advertising age

Conservative politicians have often blamed 'the swinging sixties' for social behaviour they disapproved of in later decades, but arguably the cultural revolutions of the 1960s contributed to a renewal of capitalism in spheres such as advertising, the arts, design, fashion, publishing, rock music, and television. Many of the young, rebellious hedonists of the period later became multi-millionaires – Charles Saatchi's friend, Mick Jagger, is just one example – and highly successful businessmen and women. Saatchi himself is a case in point. Significantly, Mary Quant, the fashion designer who became famous in the 1960s, was one of the first to invest in Saatchi & Saatchi. The brothers and the advertising business in general benefited from the rise in affluence and consumerism in Britain that began in the mid 1950s. In the 1950s and 1960s the small-scale advertising scene in London was dominated by New York agencies and ideas, but by the 1980s – largely due to the efforts of the brothers – the situation was reversed.

John Galbraith analysed post-war prosperity in his book *The Affluent Society* (1962),[12] offering his opinion that this society had evaded the issue of distributing wealth more

fairly by increasing total production, income and employ-
ment, and by increasing 'wants' – artificial needs, desires for
new goods and services – via high-pressure advertising. The
power and techniques of American advertising to persuade
and manipulate consumers via their unconscious minds
based on the findings of motivation research had previously
been exposed by Vance Packard in his 1957 bestseller *The
Hidden Persuaders*.[13] In spite of increasingly sophisticated
critiques of advertising by such writers as John Berger,
Daniel Boorstin, Wolfgang Haug, Varda Leymore, Ray-
mond Williams, Judith Williamson and Don Slater, some of
which compared advertising to more ancient ideological sys-
tems such as magic and myth, its expansion and penetration
continued unimpeded.

Our environment is saturated in advertising. Although
some people enjoy adverts and admire their creativity, the
massive growth in advertising, marketing and business
sponsorship since the 1950s has also produced resistance.
Many consumers are suspicious of advertising and the
most sceptical regard it as an intrusive form of visual/aural
pollution. In 1962 Boorstin argued that thinking of adverts
as lies did not go far enough: 'We have underestimated the
effect of the rise of advertising. We think it has meant an
increase in untruthfulness. In fact it has meant a reshaping
of our very concept of truth.'[14] While advertisements may
not be, strictly speaking, lies, clearly they are partial, posi-
tive descriptions of goods and services. For impartial, inde-
pendent evaluations consumers turn to *Which?* reports.

One distasteful feature of advertisements is the way so
many of them sully other feelings, experiences and values
through co-option, such as a mother's love for her children,
friendship, individualism, freedom, etc., by associating them

with products. Associating the fresh air, outdoor life and landscape of the American West with cancer-causing cigarettes; using a song celebrating trade-union solidarity to promote the insurance company Norwich Union; equating the sensuous curves of a woman's body with the shape of an automobile; connecting the 'red revolution' to a brand of beer: the end result is the commercialisation and commodification of virtually every human experience.

Those who work in advertising also tend to be regarded with suspicion by those outside the profession. At one time it was considered unethical for agencies to solicit business from clients while they were signed with a rival agency, but no longer: clients/accounts are gained and lost by all agencies and the latter regularly poach staff. Rising agencies gobble up weaker ones via take-overs and disaffected staff leave to form new agencies, often taking clients with them. The names of advertising agencies change with bewildering rapidity and harsh boardroom battles are reported in the business press. Of course, this frenetic, war-like activity is quite standard for the free-enterprise system, and advertising in general is the most visible expression of that system. Advertising, we contend, is a powerful advocate for the benefits of capitalism and every day it implicitly reiterates the mantra: 'There is no alternative'. As Carol Duncan has remarked:

> Advertising gives us the universe – and ourselves – as transformed by the profit-seeking gaze of capitalism. Aside from the specific products it promotes, the persistent underlying message of advertising is the ideal of consumerism itself, the promise that individual happiness is best sought in the consumption of mass-produced goods and services.[15]

Huge numbers of the goods advertising promotes are badly designed or worthless kitsch. A massive waste of energy, labour and materials, they spew forth from factories without regard to the consequences for the Earth's ecosystem. In this way advertising encourages a suicidal materialism.

Advertising personnel are often required by the nature of the business – being advocates for a series of clients and their products/services – to promote products which contradict their personal beliefs and habits. For example, Charles Saatchi was a cigarette smoker when he worked on the anti-smoking campaign for the Health Education Council. The success of his work can be measured by the fact that he was himself frightened by the campaign so that he cut down. But later on he helped produce a campaign for Silk Cut cigarettes. Similarly, during the 1970s and 1980s the Saatchis worked for the Conservative Party, but in the 1990s they were willing to work for the Labour government.

In some other professions, such behaviour would be considered inconsistent, hypocritical and unethical. Exceptionally, there are a few advertising executives who refuse to work on certain accounts on ethical grounds. In contrast to Saatchi, David Puttnam lost his job at CDP because he refused to work on the Silk Cut account, while David Abbott, a founder of Abbott Mead Vickers, advocated the banning of all cigarette advertising in 1976. The loyalties of people in advertising then, are usually temporary, highly flexible and based on expediency and self-interest – conditions that later became more generalised as a result of Thatcherite employment policies. They last only as long as the account remains with the agency. We would contend that this attitude is mirrored by Saatchi's collecting habits because – unlike many other collectors

who have specialised in, say, impressionism or cubism –
he has no long-term attachment to any one artist, art
movement or style. His attention is brief, mobile and
repeatedly ratchets forwards, characteristics surely akin to
moving swiftly from account to account, campaign to
campaign, take-over to take-over, and being constantly
alert for new trends in consumer behaviour.

art and advertising

There is no denying the aesthetic and intellectual pleasures
provided by many adverts, nor the imagination, skill and wit
they frequently exemplify. One example of Saatchi's creativ-
ity and the interaction between advertising and art is the
series of adverts devised for Gallaher's Silk Cut cigarettes (a
name coined to imply that these cigarettes are 'as smooth as
silk' on the throat). Saatchi first won this account in 1983. It
was his sketch which translated the phrase 'a cut in silk' into
a visual image; shortly afterwards a billboard image showed
a huge expanse of silk with a slash or slit across it. The
colour mauve was also used. At first sight, the billboard
seemed to be displaying an example of modern, abstract art;
there were neither words nor a smoker nor a packet to indi-
cate that it was promoting a brand of cigarettes, so it pre-
sented viewers with a decoding challenge. This tactic is used
to catch the eye, delay the viewer's perception, prolong
visual pleasure and provide a sense of intellectual achieve-
ment when the puzzle is solved. Or, as the tactic lost its inno-
vatory impact, a perverse enjoyment in not solving the chal-
lenge. In this case, the prime clue as to the identity of the
product was the government health-warning strip across the
bottom of the image.

A perceptive semiotic analysis of the Silk Cut advert

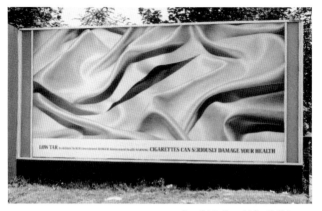

LOW TAR As defined by H.M. Government DANGER Government Health Warning CIGARETTES CAN SERIOUSLY DAMAGE YOUR HEALTH

Saatchi & Saatchi for Gallaher Tobacco Ltd, Silk Cut advert with slit on billboard in north London, 1985.

appears in David Lodge's novel *Nice Work* (1988). Dr Robyn Penrose, a university lecturer in English, is 'shadowing' Vic Wilcox, a local industrialist and businessman. In one scene Penrose attempts to explain to Wilcox the role of metaphor and metonomy in the pictorial rhetoric of advertising. The advert, according to Penrose:

> … was in the first instance a kind of riddle. That is to say, in order to decode it, you had to know that there was a brand of cigarettes called Silk Cut. The poster was the iconic representation of a missing name, like a rebus. But the icon was also a metaphor. The shimmering silk, with its voluptuous curves and sensuous texture, obviously symbolised the female body, and the elliptical slit,

41

> foregrounded by a lighter colour showing through, was still more
> obviously a vagina. The advert thus appealed to both sensual and
> sadistic impulses, the desire to mutilate as well as penetrate the
> female body.[16]

Once the advert's basic concept was established, endless
variations could be played upon it, and certain of the shapes
devised looked like the human sexual organs. They spawned
the expressions 'Slit Cunt' and 'Sic Cult'. Later on, cutting
implements – scissors, knives and chain saws – made an
appearance, communicating a frisson of danger and menace.
One advert had a cut-out shape resembling an erect penis.
The implied presence of scissors – a household tool mainly
associated with women – was designed to arouse the fear of
castration in male viewers.

The borrowing between art and advertising is two-way
traffic. In these adverts the obvious artistic precedents were
the slashed canvases made by the Argentinian-Italian artist
Lucio Fontana during the 1950s. Fontana had developed a
theory of 'spatialism' and he wanted to introduce real rather
than depicted spaces into his canvases and so he made
gashes and holes in them. The image/action 'cut' is also rem-
iniscent of Yoko Ono's disturbing *Cut Piece* (New York,
1965, London, 1966), a public event in which she invited
members of the audience to cut her clothes off with a pair of
tailor's shears.

Another example of the use of modern art in the Silk Cut
series dates from 1997 with an appropriation of Picasso's
1937 painting *Weeping Woman*. A female figure, arranged
as a relief, made from mechanical parts and tools with sharp
and jagged edges, holds in her hand a piece of silk.

At the time these were conceived, there were two

important contextual factors. The first was a growing opposition towards tobacco adverts and an awareness of the hazards of smoking. Cigarette commercials had been banned on British television and people smoking were forbidden in graphic images. It looked as if the promotion of tobacco might soon be forbidden altogether. Cigarette companies argued that their adverts were not designed to persuade non-smokers to start smoking, but to retain their market share by reminding smokers of their favourite brands. For the agency, the trick was to make the image as abstract as possible while stressing brand recognition. The more indirect the adverts, the more difficult it would be for governments to ban them.

Dave Hill, gives the name 'brand stretching' to making associations between the characteristics of two completely different things. Hill has remarked: 'The Silk Cut series proved so memorable that the tiniest hint of silky mauve imagery acted as effective promotion, its indirectness lending, if anything, a certain cachet.'[17]

The second factor was a brilliant rival advertising campaign by Collett Dickenson Pearce where Saatchi had worked in the late 1960s: art director Alan Waldie's highly creative and award-winning series of photographic adverts and cinema films made for Gallaher's Benson & Hedges brand employing the gold box motif. Another wordless campaign, it drew inspiration from two modern art movements, surrealism and pop art.

At the time Judith Williamson argued that while social class was not directly depicted in these kinds of advert it was implied because the advertisers were clearly addressing and flattering those who were familiar with modern art, and able to recognise the intertextual references to other images, that

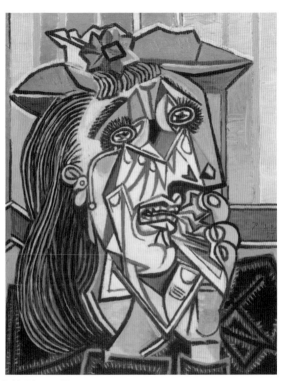

ABOVE Pablo Picasso, *Weeping
Woman*, 1937. Oil on canvas,
60 x 49 cm.
OPPOSITE M&C Saatchi for
Gallaher Tobacco Ltd, Silk Cut
magazine advert, *Guardian*
supplement, December 1997.

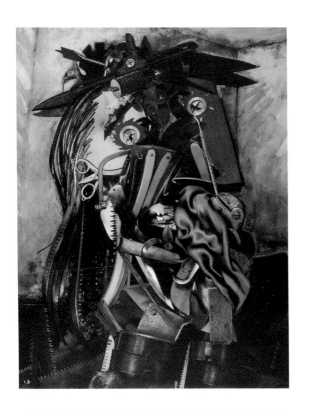

SMOKING CAUSES HEART DISEASE

Chief Medical Officers' Warning
5 mg Tar 0.5 mg Nicotine

is, the educated elite who had probably studied at university, who visited art galleries and who belonged to the professional segment of the middle-class.[18]

In March 1999 the advertising tactic of borrowing ideas from contemporary art backfired when it aroused the anger of Turner prizewinner Gillian Wearing (b. 1963, trained at Chelsea and Goldsmiths'). Her 1997 video *10–16* showed adult actors speaking but with the voices of children. The video was acquired by Saatchi and the lip-synching and overdubbing techniques were later employed in a television commercial made by M&C Saatchi for Skydigital. Wearing was upset that the agency had not asked her permission and had 'stolen her idea'. She informed one journalist that she would not sell any more artworks to Charles Saatchi.[19]

Damien Hirst is probably the most famous of the young British artists whose work Saatchi has collected. Hirst has grown up in a media-saturated environment and relishes the publicity he attracts as an art star. He has expressed his interest in, and admiration for, advertising several times. He has even devised an image for a billboard and a promo video for Blur, the band.[20] It is easy to see why Hirst and Saatchi were attracted to one another. Both men enjoy curating exhibitions and during the 1990s Hirst began to emulate his patron's business acumen by investing in restaurants and bars. In response to the question, 'You like advertising?' posed by Francesco Bonami, Hirst replied: 'I love it because it admits its own corruption.'[21]

'we are all conservatives':
the tory party's admen

> The success of the British state
> in avoiding both internal
> overthrow and external defeat
> has ensured that most of the
> national myths are Tory myths,
> and most of the rituals and
> institutions of the state are Tory
> rituals and institutions ... This
> makes the national culture a
> Tory culture. Andrew Gamble.[1]

working for the conservatives

In a structuralist analysis of advertising published in 1975, Varda Leymore maintained that advertising was 'a conservative force' because it was 'not concerned with revolutionising the existing order of things, but in preserving it'.[2] The close relation between the Saatchi agency and the Conservative Party, dedicated to the preservation of conservative values, is then not surprising, except as a rare instance of commitment. 'Preservation' was something of a misnomer, requiring as it did a ruthless 'modernisation' of Britain's economy, industries, public services and social fabric which benefited the few and left many casualties in its wake.

In March 1978 Gordon Reece, director of communications for the Conservative Party's Central Office, selected Saatchi & Saatchi as the agency he wanted to work for the party because it appeared to be Britain's most creative and

dynamic. At the time Reece, an ex-television producer of drama and light entertainment programmes with experience of American publicity from working for Occidental Oil in Los Angeles, made his decision, a weak Labour government led by Prime Minister Jim Callaghan was in office and the opposition leader was Margaret Thatcher. Hiring a fashionable agency was a sign that right-wing politicians were becoming more media-conscious and more aware of the need for slick political propaganda comparable to that produced for US elections. The brothers accepted because they realised the account itself would bring them national and international publicity which would in turn attract new clients. Maurice Saatchi thought that becoming 'Thatcher's admen' brought them fame in the US and that this helped their expansion programme there. The agency undertook work for the Tories for almost 20 years and contributed to five election campaigns in 1979, 1983, 1987, 1992 and 1997. All except the last were won by them and so, despite disagreements and problems, the relationship between party and agency proved to be a mutually beneficial one.

We need to consider the politics of the brothers and Tim Bell (now Lord Bell), the man running the London agency regarded by some as the third brother or the ampersand between the brothers' surnames. Bell was an avowed Conservative supporter and he was the main point of contact with the party's publicity department and, after 1979, with Prime Minister Thatcher whom he so charmed that they became good friends. Bell, therefore, had no qualms about helping the Tories although, ironically, he was at first doubtful that a political account would be worth

Richard Maris, caricature of Maurice and Charles Saatchi as the children of Mrs Thatcher, all with halos. Pen and ink illustration to a book review, *New Statesman & Society*, 2 September 1988.

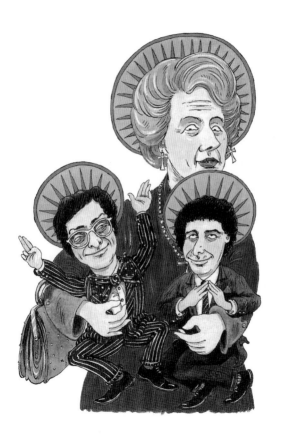

the extra work and bother it would generate.

Besides helping with several Tory election campaigns, Bell advised Ian McGregor, chairman of the National Coal Board, on publicity matters during 1984 when McGregor was fighting a bitter battle with the miners led by Arthur Scargill. Bell assisted, therefore, in the defeat of the miners and the decimation of the mining industry; his role was a sign of the changing 'post-industrial' times in which heavy industry and manufacturing were in decline and being over-taken by financial, media and service sectors.

Another man who signified the close connection between the Conservative Party and Saatchi & Saatchi was Michael Dobbs. From 1977 to 1979 he worked as a researcher for the party's Central Office and then, after the Tories 1979 election win, he was employed by Bell as his deputy. By 1983 he was advising the Tory party chairman Norman Tebbit. He left Saatchi & Saatchi in 1986 to work full time for the Conservatives but he rejoined the agency in 1988 where he remained until 1991. Subsequently, he wrote best-selling novels and popular television drama series about a subject he knew well: ruthless, scheming politicians.

During the 1960s and 1970s the brothers had been too busy to evince much interest in politics and their political convictions were not obvious to outsiders. When Maurice Saatchi worked for Haymarket Publications in the late 1960s he had become acquainted with the owner Michael Heseltine, a Tory career politician. When Maurice accepted the account from Central Office he reassured Reece by stat-ing 'We are all Conservatives'.[3]

Those close to the brothers are most likely to know their personal political outlooks. David Puttnam, the film-maker/producer, has been a friend of Charles Saatchi since

the late 1960s but he was also a member of the Labour Party. (Later he switched to the Social Democrats and is now a fan of New Labour.) Fendley reports that the two men once had a row about the agency's work for the Tories. She then quotes Puttnam as saying that Charles 'is probably too right-wing for the Tories. He is idiosyncratic, with an idiosyncratic view of politics'.[4]

When, in 1997, the journalist Catherine Milner interviewed him, her impression was:

> In many ways Saatchi seems to be a man of contradictions. On the one hand, he is modern, classless and proud to be associated with the avant-garde; on the other, a staunch Conservative. But this dichotomy, he says, is also an aspect of the artists whose work he collects.[5]

The artists too were entrepreneurial, business-minded and wanted to become rich and famous though this did not mean that all the young British artists whose work Charles Saatchi bought during the 1990s were right-wingers. Tracey Emin, for instance, voted Labour and was a fierce critic of Mrs Thatcher. Mark Wallinger and the Chapman brothers have also attacked the class and capitalist system.

In any event, since the Saatchis were clearly in favour of the free market and consumerism, and were benefiting greatly from them, they were the 'natural' allies of the Conservatives because the latter were at that time more inclined to reduce taxes and cut public services, favour business and market deregulation than the Labour Party. Although in practice both parties mainly serve the interests of the middle-class and are committed to a mixed economy, the Labour Party, of course, has a record of trying to ameliorate the

worse features of capitalism by regulating the market, by nationalising certain key industries, by funding welfare schemes, state education and council housing, and via public institutions such as the National Health Service, the museum system and the Arts Council.

Once the brothers had decided to assist the Tories – charging the going rate; they were not prepared to work for nothing – then the fortunes of their agency became linked to the success or failure of the Tories in running the country and in winning elections. The ideology of Thatcherism and the Saatchis dovetailed because Thatcherism fostered an economic environment in which the Saatchis could continue to flourish, and they in turn 'made the advertising business fit for Thatcherism'.[6] Hugo Young, Thatcher's biographer, notes the progress the brothers were able to make during the rule of the Conservatives:

> In 1978, when the Conservatives took them on, Saatchi & Saatchi's annual profit was £1.8 million. A decade later, with over 150 offices world-wide and over 60 of the world's largest 100 advertisers on their books, that figure had grown more than 50 times bigger.[7]

labour isn't working

Perhaps the most famous and effective image the agency devised for the Tories was an August 1978 billboard poster headlined 'Labour isn't Working'. Across a stark, white ground snakes a long queue of people which, the bold black headline confirms, is a dole queue. The caption beneath the image claimed: 'Britain's better off with the Conservatives.' According to Fallon, the copywriter Andrew Rutherford had been asked to focus on the economy and industry, and

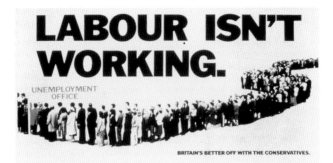

LABOUR ISN'T WORKING.

UNEMPLOYMENT OFFICE

BRITAIN'S BETTER OFF WITH THE CONSERVATIVES.

Saatchi & Saatchi poster for the Conservative Party, Labour isn't Working, 1978.

while doing so had noticed an increase in the unemployment figures. He then came up with the slogan 'Labour isn't Working' – inverting 'You Know Labour Government Works' previously used by the Labour Party – and the visual of a line of unemployed people, realised by Martyn Walsh, the art director.

Surprisingly, the reaction of Charles Saatchi and Jeremy Sinclair to the proposed poster was lukewarm and they discarded it. The next day Rutherford had to rescue it from the 'out' pile. When Reece and Thatcher were shown it, however, they both thought it was 'wonderful'.[8]

The poster set the pattern for what was to follow: a relentless attack on Labour, with little about the Conservatives' ideas and policies. This followed the conclusion of Maurice Saatchi's analysis of how political propaganda works – that governments lose elections rather than oppositions winning them. The best strategy was then to rubbish the competition.

The poster's double accusation that the Labour government was not managing the economy properly and was thereby creating unemployment, with the extra sting that the party of the workers was failing them, was particularly galling to Labour politicians. They attacked the poster and helped to bring it even more media coverage. This was another ploy the Saatchis used again and again: create an outrageous advert in order to generate lots of free publicity.

Denis Healey, then Labour's chancellor of the exchequer, made the absurd accusation that the agency was telling a lie because the people shown in the poster were not actually unemployed but were, rather, employees of the agency. (In fact, they were Young Conservatives from Hendon.) Most viewers realise that the majority of scenes shown in adverts are staged for the camera. What was really offensive about the poster became clear a few years later when, after the promise that Britain would be better off under the Tories, unemployment increased dramatically. In May 1979, when Labour were in power, unemployment stood at 1.2 million; in May 1983, under a Conservative government, it reached 3 million. It remained above 2 million for eight years.

Once the agency's creatives had found this effective formula they extended it to other areas of public concern: the issue of education prompted the clever misspelling, 'Educashun isn't Wurking'. Time and again Saatchi & Saatchi succeeded in capturing the public's attention because their work distilled the fears, priorities and values of Britain at specific moments.

Apart from adverts that ask for the return of mailed coupons, it is often difficult to measure the effectiveness of campaigns but when the Conservatives won the election in spring 1979 many observers were convinced that

the Saatchi adverts had made a significant contribution. Hugo Young, for instance, argues that the 'weight and effectiveness of their advertising [during the summer of 1978] … began to register in the opinion polls'. This persuaded Callaghan to defer the date of the election from October until the following spring, a disastrous error of judgement because the so-called 'winter of discontent' followed, a series of strikes for higher wages which demonstrated the ineffectiveness of the Labour government in controlling wage demands and confirmed the accuracy of the 'Labour isn't Working' slogan. (In 1979 the agency returned to the attack by issuing a variant of their 1978 poster that carried the headline 'Labour still isn't Working'.) Young concludes that the Saatchi campaign 'is one of the rare examples, in a field dominated by crude and baseless hype, of an advertising campaign having some demonstrable effect on the outcome of a political event'.[9]

campaigns of the 1980s

If, as Prime Minister Thatcher once famously remarked, 'there's no such thing as society', what remained were millions of individuals concerned only with their own well-being and survival. The 1980s were widely perceived as years of exceptional greed and selfishness on the part of the dominant class as national assets were sold off to benefit the few. Financial speculators like the Gordon Gekko character in movies such as *Wall Street* (1987, directed by Oliver Stone; one of the films which caught the flavour of the decade) openly expounded the credo 'greed is good'. Like Saatchi, Gekko – played with verve by Michael Douglas – was a collector of modern art. The amorality and greed exemplified by the character of Gekko were to be absorbed

by one of Saatchi's favourite artists, Damien Hirst; witness the following exchange:

> Carl Freedman: If you were asked to work on an advertising campaign for the Tories would you agree?
> Hirst: It depends on how much money.
> Freedman: So you don't adhere to any particular political beliefs?
> Hirst: That kind of integrity is bullshit. Nobody has that kind of integrity. Things change too much. There's no black and whites, only different greys.
> Freedman: You're not a socialist at heart?
> Hirst: I'm not anything at heart. I'm too greedy ...[10]

Since Hirst once donated one of his 'spin' paintings to help homeless people via *The Big Issue* magazine, he is perhaps not so selfish and hard-hearted as these remarks suggest.

Anti-communist sentiments were evident from one of Saatchi's 1983 election adverts which made a point-by-point comparison between the Communist and Labour Party

manifestoes capped by the remark 'Like your manifesto, Comrade', and also from the smug manner in which the agency capitalised on the collapse of East Germany. When the Berlin wall was breached in late 1989 and early 1990, they placed a banner on the east-facing side stating 'Saatchi & Saatchi, First Over The Wall', at a cost of a mere £5000. Photographs of the banner then appeared in the media. It was as if the Saatchis were saying that capital-

Damien Hirst holding child, 1997 (Michael Birt).

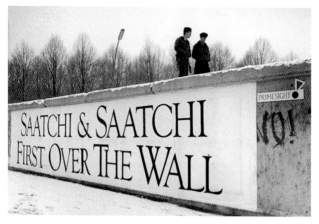

ism had triumphed over commu-
nism; they had helped it to achieve
victory, and now they would be the
first to take their aggressive business
practices to the East, a whole new
market to be exploited. Martin P Davidson described the
message of the banner as 'a bid to hijack the new decade'
and as 'the latest in a long line of classic Saatchi gestures,
bold chutzpah easy to despise but hard to quarrel with.'[11]
(Since those heady days , it has become evident that the tran-
sition to capitalism in the old Soviet bloc has been a very
mixed blessing.)

Saatchi & Saatchi First Over
The Wall poster, East Berlin, the
wall by the Brandenburg Gate
with border guards, 5 January
1990 (Melanie Friend).

Towards the end of the 1980s Labour had begun to make
a comeback under the leadership of Neil Kinnock and the

party became more sophisticated in its use of advertising. The 1987 election campaign was not one the Tories or the Saatchis thought they would win, but as the results were announced and it became clear Labour was going to lose yet again, the brothers and the agency staff were ecstatic. Fendley reports that on election night Maurice Saatchi hosted a party at his London house for the entire agency team. Their campaign adverts, with slogans like 'Britain is great again – don't let Labour wreck it', decorated the walls. 'Wild scenes of jubilation' occurred once it emerged the Tories were headed for victory. One of those present recalled Charles Saatchi 'sitting at the piano and every time the Tories won a seat he played a jingle that got more and more outrageous as the night went on.'[12]

Whatever the political views of Bell, Dobbs and the Saatchi brothers, they were willing propagandists for a party and a government that produced a more unequal and divided society. The Conservatives did untold damage to Britain and to large sections of its populace. The numbers of homeless people – 370,000 according to a Shelter annual report of 1988 – begging and sleeping on the streets of London and other British cities were simply one, visible sign of their harsh, uncaring rule.

Given this, socialists are bound to regard Charles Saatchi's apparently altruistic and benign contributions to art and culture with deep suspicion. Just as the Tory party account gave the brothers access to the highest level of government (though Charles never bothered to meet Thatcher face to face), so too Saatchi's spending on art, his loans and gifts have gained him access to national institutions such as the Royal Academy, the Tate Gallery and the Arts Council Collection, and to the RA's exhibitions secretary Norman

Rosenthal and the Tate's director Nicholas Serota. Maurice Saatchi is also a member of the College Council of the Royal College of Art, whose MA students line up to receive bursaries from Charles Saatchi. Then and now he has contact and influence with the powers that be.

The success of the brothers in transforming the advertising business and their association with the Tories prompted lots of caricatures and other critical responses. Among the most striking were the puppets made for the satirical television series *Spitting Image* by a team of designers headed by Peter Fluck and Roger Law. The puppets presented the brothers as manipulators of Thatcher's personal image even though this was

Puppets of Charles and Maurice Saatchi, 1980s, Spitting Image/Central Television.

not the role they actually played. Law has explained their motivation as follows:

> If you don't like what public figures are doing, and you've got absolutely no way of changing anything, it helps to slag them off. Saatchi & Saatchi are doing the opposite of us. People say we are too savage, but you never hear of anyone going to Saatchi to complain that they're grossly benevolent.[13]

hans haacke

One radical, politically aware artist who responded critically in 1983 and 1984 to the Saatchi/Thatcher association was the German-American Hans Haacke (b. 1936). His work employs a variety of media and he has a track record of researching and then documenting wealthy individuals, major business corporations and even art collectors and museums in order to expose perceived abuses and hidden relations of power. Many of his works are deliberately designed to resemble adverts (only they turn out to be anti-adverts). Haacke is particularly wary of business sponsorship of the arts and he believes that public institutions should be publicly funded in order to preserve their independence, so that a space remains for the display of art that is critical of society.

Mobil Oil, one of his targets, was sponsoring exhibitions at the Tate Gallery, an institution which offered Haacke a show. The paintings he showed were academic-style portraits of the British Prime Minister Thatcher and the American President Ronald Reagan.

Haacke's allegorical, full-length portrait of Thatcher was entitled *Taking Stock (Unfinished)*, (1983–84). The art critic Waldemar Januszczak described it:

Hans Haacke, *Taking Stock
(Unfinished)*, 1983–4. Oil on
canvas with wood, gold-leaf
frame, 241.3 x 206 x 17.8 cm.

The Prime Minister is shown in her drawing room, perched on the edge of a chair in that alert pose which royalty invariably adopts when they know an artist is watching. Back straight, head up, chin out, she would not look out of place on the prow of one of Drake's galleons.

The Right Honourable Member for Finchley East wears a very regal dress of powdered blue chiffon. The artist has given her a splendidly ornate frame to sit in, flanked her with fluted ionic pilasters, thus establishing the picture in the tradition of grand royal portraiture … So far the painting is wickedly funny, no more. But then you begin to inspect its details, all those signs and symbols with which it is cluttered … two cracked plates on the top of the bookshelf with portraits of the Saatchi brothers. [The plates were an art-world in-joke: they referred to the many Julian Schnabel paintings which were, in fact, reliefs because they had shattered crockery glued to their surfaces. The Schnabels were in the Saatchi Collection and some had been lent to the Tate Gallery for a 1982 exhibition.] The books on the shelves give the names of all the companies and institutions which employ Saatchi & Saatchi to advertise for them: the Conservative Party, of course, the South African Nationalist Party, the *Daily Mail* … as well as the Tate Gallery, the National Gallery, the V & A, the British Museum … When it comes to image-building our public galleries are currently keeping strange company.

Everywhere you look in this painting some detail or other is drawing your attention to the complexity of the relationships that link big business, art and politics. The depth of the Saatchis' involvement with the Tate as collectors, patrons, advertisers, advisors and lenders is recorded in fragments of Roman script on the base of the column behind the Prime Minister's back.[14]

Also featured in the painting was Harry Bates' marble sculp-

ture *Pandora* (first exhibited in 1891, which is in the Tate Gallery's collection) because Thatcher, in Haacke's view, was a woman who, like Pandora, was opening a box which would release pain and suffering on the world. The sculpture's position in the composition also connected it to the material about the Saatchis. The painting's style, frame and some of its contents were Victorian in character because Haacke thought Thatcher exemplified Victorian attitudes and economic policies.[15] Certainly, she spoke of the need to return to Victorian values.

Haacke's portrait was displayed at the Tate Gallery from January to March 1984 as part of a one-man show which also included installations critical of Thatcher's American counterpart, President Reagan. Earlier, in July 1983, the satirical magazine *Private Eye* had revealed Haacke's intentions and predicted that his show would cause 'acute embarrassment' to the Tate and its director Alan Bowness because of their courtship of Charles Saatchi and the business sponsors Mobil Oil.[16]

Haacke had created the Thatcher portrait specifically for the British context and it was designed to be provocative. If it had been censored, Haacke would have made sure this became headline news. Haacke says that Bowness did not attempt to censor his show but that he was asked to postpone it.[17] He refused this request and the exhibition went ahead as planned. However, Mobil Oil objected on copyright grounds to Haacke's use of their logo and trademark in illustrations that appeared in the catalogue and threatened legal action.[18] As a result, the catalogue was withdrawn for a time.[19]

In February 1984 the British magazine *Art Monthly* printed a photograph of *Taking Stock (Unfinished)* on its

front cover and provided a key to its iconography inside.[20] The following month the same magazine published an article by Jon Bird, a polytechnic lecturer, that defended Haacke's art and his 'bite the hand that feeds you' strategy.[21] One of the illustrations was a textual piece (white, hand-written words on a black ground) by the anonymous artists who called themselves 'Recession Pictures', a name clearly referring to the state of the British economy at the time. Their illustration declared: 'Advertisement: This space has not been taken over by Saatchi & Saatchi.'

In the same month, Thatcher attended a dinner given for her at the Tate Gallery which was hosted by Lord Palumbo, another rich man with an interest in the arts and one of the Tate's trustees. He made a speech in which he offered to loan Thatcher pictures from the collection.

Fallon claims that the Haacke painting caused 'a minor sensation', but, in his view, it 'totally misrepresented Charles Saatchi's whole approach to the art world' because 'he had no intention of engaging in the politics of the Tate'.[22] To which one can only reply that Saatchi was being naïve or disingenuous, and that the effects of one's actions can be different from one's intentions. Fallon added that Charles and Doris Saatchi 'were philosophical about Haacke's critique; they had been warned in advance and were also familiar with Haacke's regular attacks on sponsors and the business establishment'. *Taking Stock (Unfinished)*, then, was not a contemporary work of art they wanted for their collection. Even if they had offered to buy it, Haacke would probably have refused because earlier he been unwilling to sell a work critical of Peter Ludwig, the German collector Haacke called 'The Chocolate Master', to Ludwig. Some of Haacke's works have been bought by museums and private collectors

but in general his art does not lend itself to commodification. He maintains his independence by subsidising his own artistic practice from his earnings as a tutor in an American art school.

Public galleries such as the Tate are funded by the tax-payer; if the government is stingy with money then the gallery may well have to make redundancies, cut services, or seek additional funding from the private sector. This last is precisely what the Tate felt it had to do in the 1980s. The link between Thatcher, the gallery and the Saatchis was demonstrated again in 1988.[23] Serota, the new director, wanted Dennis Stevenson to become a trustee. Thatcher, who had the power to appoint ten of the eleven trustees, refused to appoint him because, although he was a success-ful Scottish businessman, his views were 'too liberal' for her liking. Sir Mark Weinberg, another trustee, contacted Tim Bell, the former chairman of Saatchi & Saatchi and friend of Thatcher, who was then prevailed upon to use his influence to persuade her to change her mind.

the ace caff with museum attached

On the back of the ornate chair depicted in Haacke's por-trait of Thatcher was an image of Queen Victoria and the actual chair was in the collection of the Victoria & Albert Museum. During the 1980s Maurice Saatchi was a trustee of the V & A (as was the former Conservative minister Lord Carrington) and the Saatchi agency was responsible for its publicity. For the first time the V & A appointed a market-ing manager – Charles Mills – who collaborated closely with the agency's staff who, he claimed, did more creative work than they were paid for.[24] The museum had severe financial problems which resulted in some redundancies and

a restructuring in which scholarly curators lost out. At this time a new restaurant was opened. This prompted an ironic advertising slogan that became notorious: 'An ace caff with quite a nice museum attached'. As Martin P Davidson recalls:

> the strapline ... underwrote a series of *objets d'art*, juxtaposed with disarmingly paradoxical low-brow things – souvenir mugs, cream cakes – things you could buy, which rarefied consumption and made edification seem earthbound, even pleasantly visceral.[25]

Davidson thinks the adverts set out to challenge 'the museum's forbidding middle-class image' and were based on observations of changes in the public's behaviour:

> The thought behind trying to brand the museum was that in fact, people had started to seek out quality places to meet and drink and that just as expensive wine bars and cafés were cashing in by a veneer of artiness – so too museums were becoming acceptable places to hang out in ... the museum welcomed the shift, and with an artless piece of vernacular seemed to be trying to demystify itself, repositioning the museum away from the high-brow, and into the up-market.[26]

Although humorous, the 'ace caff' campaign signalled a significant reversal of priorities: the museum was now an appendage to a commercial operation. Scholarly members of staff were unhappy with such advertising and with having to listen to simple-minded presentations by smart young men from the Saatchi agency on the need to obtain more business sponsorship, to merchandise replicas of the museum's treasures, to introduce compulsory entrance

charges, to sell assets and to become much more consumer-orientated and enterprise-minded. These developments were in accord with a Thatcherite drive to create an 'enterprise culture' in Britain. Martin Kemp, an art historian and a trustee with integrity, felt compelled to resign in protest and published an article about his concerns in the *Burlington Magazine* which also carried an editorial and letters from American scholars worried about changes at the V & A.[27]

more election campaigns

With the benefit of hindsight it seems that the fates of Thatcher and the brothers were intertwined. As her star waned in the late 1980s, so did theirs. She was deposed as leader by members of her own party in November 1990 and the Saatchis' control of their crumbling empire slipped away in the early 1990s. However, during the 1992 election they again devised anti-Labour posters for the Tories, now led by John Major. This time they played on the fears of wage-earners that Labour, under Kinnock's leadership, would increase taxes and cause prices to rise. Beneath the headline 'Labour's Tax Bombshell', was a picture of a huge black bomb emblazoned with the words: 'You'd pay £1,250 more tax a year under Labour.' The poster campaign helped the Conservatives to victory despite pollsters' forecasts.

In 1995 the brothers, plus three partners, founded a new agency called M&C Saatchi which was to serve the Conservative Party during the general election campaign of 1996–97. The Tories spent £13 million on the campaign which included M&C Saatchi's fee of £1.5 million. Labour's leader was now Tony Blair, a clever young politician who was determined to appeal to the centre ground. The Labour Party had grown weary of being out of office and had trans-

formed itself – indeed, rebranded itself like a soap-powder –
and was marketing itself as 'New Labour' (which, according
to more than one sceptic, meant 'Not Labour').

In the run-up to the 1997 general election, Tory strategists
decided that they would begin with the positive idea that life
was better under the Conservatives and then follow this
with the negative proposition that New Labour represented
new dangers.[28] In July 1996 images appeared in the press
and on 1500 poster sites showing a curtain with a vertical
(silk?) cut in the middle through which could be seen a dia-
mond-shaped, Ku-Klux-Klan-like white mask pierced by
just two, diagonal, evil-eye slits. Then, in August, the attack
on New Labour was personalised by featuring the face of
Blair. His teeth were bared in a ghoulish manner and a black
band was placed across his face with a pair of red demonic
eyes glaring out – a variant of 'Big Brother is watching you'
(from George Orwell's novel *1984*). The accompanying slo-
gan was: 'New Labour, New Danger' and beneath it was a
short text which stated:

> One of Labour's leaders, Clare Short, says dark forces behind Tony
> Blair manipulate policy in a sinister way. 'I sometimes call them the
> people who live in the dark.' She says about New Labour: 'It's a lie.
> And it's dangerous.'

Short's remarks had appeared in the *New Statesman* and this
had given Steve Hilton, an advertising agent, the idea for the
demon eyes posters.[29] Tim Bell and Brian Mawhinney, Min-
ister without Portfolio, approved the concept. But when
Mawhinney rang Maurice Saatchi at his villa in the south of
France, he had trouble persuading
him that a picture of Blair with

M&C Saatchi poster for the
Conservative Party, New Labour,
New Danger, 1996.

NEW LABOUR
NEW DANGER

One of Labour's leaders, Clare Short, says dark forces behind Tony Blair manipulate policy in a sinister way. "I sometimes call them the people who live in the dark." She says about New Labour: "It's a lie. And it's dangerous."

demonic eyes was a sensible tactic. Maurice, it seems, was against personalising the campaign.[30]

Precisely what 'the dark forces' allegedly manipulating Blair were the Tory posters never made clear. (Short had been referring to marketing experts and spin doctors such as Peter Mandelson.) As Tim Rich has pointed out, invoking demons, the supernatural, was a strange approach [or a very desperate one] given that Blair was, in reality, a church-going Christian. Even odder that the creatives responsible for the advert – Martin Casson and Nick Drummond – were active in London's Christians in Media network.[31] (Perhaps not so strange: it tends to be Christians who believe in non-sense like the Devil.)

A more subtle and obscure billboard image showed the head of a lion, symbolising Britain, with a red-coloured tear running down from one eye. This time the printed warning was: 'New Labour, Euro Danger'. As usual, the Saatchis' tactic was negative in character – it was so much easier to attack the opposition than to promote the record and polit-ical policies of the Tory government. Once again the broth-ers' advertising motto – 'the brutal simplicity of thought' – had been brutally applied.

The demon-eyes posters were certainly eye-catching and memorable – and for these reasons were much imitated by other agencies – but they were also vicious and desperate. Clare Short was naturally angry at the use of her name and responded by saying that the posters typified the way in which British politics were becoming increasingly dishonest and debased. She claimed that she had been misquoted and thought the posters 'silly, abusive and a slur'. Others who condemned them included the ex-Tory Prime Minister Sir Edward Heath and the Bishop of Oxford (the Church

objected to 'satanic imagery'). The Advertising Standards Authority received 145 complaints in total and banned the poster on the grounds that it was too personal an attack. Even though not many posters were actually pasted up on billboards before they were banned, the Saatchis again benefited from being controversial. The campaign received an estimated £5 million worth of free publicity through reports in the press and reproduction of the posters themselves for an outlay of £125,000.

More devils with glowing red eyes manipulating New Labour were to feature in the proposed television commercials. Mawhinney, a practising Christian, opposed the concept and it was rejected. He had earlier disagreed with Maurice Saatchi about a planned pre-Christmas campaign. One of those close to Mawhinney remarked: 'Maurice had no understanding of religious sensitivities: he thought Christmas was a promotional vehicle devised by retailers to advance their commercial interests.'[32]

Still, the brothers were finally on the losing side because New Labour won a landslide victory in May 1997, the scale of which surprised even Blair himself. To rub salt in the wounds, the brothers' old agency – Saatchi & Saatchi Advertising – paraded a billboard on the back of a truck outside the Conservative Party's headquarters in Smith Square. The billboard featured a photograph (in negative) of the defeated John Major with downcast eyes, plus the gleeful remark: 'John: look what happens when you change advertising agencies.'[32]

3
globalisation, accumulation, conspicuous consumption, loss of empire

During the 1960s Marshall McLuhan, the Canadian mass-media guru, popularised the idea that the world was becoming a global village, that it was 'shrinking' due to faster transportation, more telecommunications systems and the worldwide activities of multinational companies. (Marx had written about the world market during the nineteenth century.) Gradually, the notion of globalisation spread to academic disciplines such as economics and business studies. In 1983 Theodore Levitt, an American professor of business administration at Harvard University, wrote an article entitled 'The globalisation of markets' which was to prove highly influential.[1] Levitt argued that multinational companies needed to become global corporations by selling the same goods everywhere; they should treat the whole world as a single market because basic needs and desires were much the same for all consumers. Enormous economies of scale in production, marketing and management would follow which would enable price reductions which, in turn, would enable global corporations to decimate their competitors. Critics of globalisation have pointed out that it will result in a decimation of cultures, in cultural homogeneity – the same Big Macs eaten everywhere – and in non-democratic corporations whose economic clout exceeds that of many nation states.

Maurice Saatchi read Levitt's article which provided a rationale – indeed a mission statement – with which he could justify his empire-building ambitions to clients, shareholders and the managers of agencies he was hoping to take over. Global corporations would require advertising that could service them and their customers in every country. It was also important to provide clients with 'one-stop shopping', hence the need to add market-research companies, public-relations companies, media-buying companies, and so on to the Saatchi stable. Maurice Saatchi visited Levitt in the US to learn more about his theory and Levitt himself was later rewarded by being made a non-executive director of Saatchi & Saatchi PLC. Levitt later became a critic of Maurice's business methods and, in the 1990s, helped to depose him.

The first chance to demonstrate the new concept in visual terms occurred in 1983 via a series of television commercials made for British Airways. These were commissioned by Sir John King who had been selected by Prime Minister Thatcher to make BA into a commercially successful private company after it had been deemed to fail as a state-owned one. (BA was making massive losses; King set about reducing costs by sacking 23,000 staff.) According to Fallon, 'King wanted a high-profile, morale-boosting campaign that would be talked about outside the industry and lift the visibility of BA and of himself'.[2] Since King was ignorant about the world of advertising, he sought advice from a friend, the art dealer Bernard Jacobson who, as previously mentioned, had been at school with Charles Saatchi. Naturally, Jacobson suggested Charles and the three of them had dinner together, as a result of which the agency made a pitch for the account and won it. Although one might regard this occur-

rence as a matter of chance friendships, one could also view it as an instance of the interrelationship between big business, the art world and advertising.

In 1986 Carl Spielvogel, of the American agency Backer & Spielvogel, who was interested in art and who headed the business committee of New York's Metropolitan Museum, visited Charles Saatchi in order to invite him to serve on the Met's committee. Charles agreed. The British reporter Geraldine Norman has observed: 'Art has become a social ticket at the heart of American society', and she quotes a dealer as saying: 'It is the only point at which all rich Americans meet … religion is out of fashion; they don't belong to the same golf club, but they all respect art.'[3] In the same year the brothers purchased the Backer & Spielvogel agency.

In 1983 BA was a global company in that its aircraft transported more international passengers to more countries than any of its rivals, a fact succinctly conveyed via the signature line: 'The world's favourite airline'. The television commercials – which cost £25 million to make – were also global in the sense that they were to be shown on television in 29 countries around the world at approximately the same time. The *Manhattan* commercial in particular impressed King and other viewers. It was inspired by the statistic that BA carried more passengers across the Atlantic in a year than the entire population of Manhattan. A report in *Creative Review* indicates the ingenuity and skills this commercial involved:

The first commercial, *Manhattan,* concentrates on trans-Atlantic crossings and features a model of Manhattan Island – created by Robert Seaton and Associates – apparently cruising over and landing in London. The commercial's mood is directly lifted from

the Spielberg science-fiction film genre,
with accompanying dramatic lighting
and music. Astounded passersby gaze at
the spaceship/island in what, at a casual
glance, could easily be a clip from *Close
Encounters of the Third Kind.* The
model was constructed using highly-
detailed photographs of Manhattan
waterfront buildings especially shot by
Angus Forbes. Enlarged to scale size, at
£40 a time, the photos were separately
mounted to form miniature stage sets
which were then moved around during
filming to keep famous landmarks in
shot. The buildings' base is a model-
maker's impression of what we, in our
wildest dreams, might imagine the
substrata of Manhattan to be. The
quartz-like plastic moulding encased an
aluminium frame and 53 fluorescent
tubes gave an eerie glow.[4]

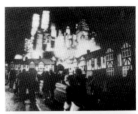

Saatchi & Saatchi for British
Airways, *Manhattan,* 1983.
Two stills from the television
commercial.

Manhattan was conceived as a 'corporate' or 'masterbrand'
commercial rather than as a 'product' or 'bums on seats'
advertisement and it was the first work of Rita Dempsey and
Phil Mason after they joined Saatchi & Saatchi. Its director
was the film-maker Richard Loncraine of the production
company James Garrett & Partners.

Fallon reports that *Manhattan* had a tremendous impact
upon New Yorkers. It won several awards and was added to
the film and video collection of the Museum of Modern Art
in New York. According to Fendley:

The *Manhattan* commercial did more than 'globalise' BA's advertising. It also reflected Saatchi & Saatchi's association with the confident new ethos of eighties Britain, fascinated by corporate identity, new logos and strategies. In the course of the decade, advertising moved into the vanguard of popular culture.[5]

Martin P Davidson thought *Manhattan* was 'a symbol for Britain at its globe-beating new best'.[6] He also pointed out that by contributing to privatisation campaigns, advertising became a tool of the Tory government's policy – the influence of Saatchi & Saatchi on British politics was not confined to general election campaigns.

hans haacke at victoria miro

Haacke renewed his critique of the Saatchis in December 1987 when he held an exhibition at the Victoria Miro Gallery in London. The show was entitled 'Global Marketing' and in an associated publication Haacke presented a meticulously researched summary of the history of the brothers' creation of a worldwide business empire.[7]

One consequence of establishing global networks of companies is that commercial relations may be formed with countries which have unsavoury regimes and a company based in Britain may find itself implicated in the abuse of human rights in foreign lands. Haacke's primary purpose was to reveal the role of Saatchis' affiliated advertising agencies in South Africa in promoting the apartheid policies of the white, ruling National Party of Pieter W Botha.[8] A second target was the neo-geo or simulationist art by American artists which Saatchi collected and showed in 1987–88. Haacke presented a mixed-media wall display entitled *The Saatchi Collection (Simulations)*

Hans Haacke, *The Saatchi
Collection (Simulations)*, 1987.
Mixed-media installation,
256.5 x 193 cm.

featuring a wood and Formica shelf (a mimicry of Haim Steinbach) upon which was a fibreglass head of Lenin with mirror coating (a reference to Jeff Koons), a bucket containing a paint roller and adverts produced by the South African agency KMP-Compton on behalf of the Botha regime, and three cereal boxes pasted with adverts wooing American tourists to South Africa.

Below the shelf was the logo of the First National Bank of South Africa – a thorn tree silhouetted against the disc of the sun – which had been designed by Siegel & Gale, a New York subsidiary of Saatchi & Saatchi, and above was a photo of Charles Saatchi in profile next to Lenin's remark: 'everything is connected to everything else'. This observation by a communist revolutionary leader had previously been used in a 1985 Saatchi & Saatchi annual report in order to bolster its globalisation policy. Haacke took the Saatchis at their word and demonstrated connections they would probably have preferred to remain unnoticed.

As Benjamin Buchloh remarked in a perceptive article on Haacke:

> His work makes one aware ... of the links between the politics of repression as practiced in remote countries of the Third World and certain individuals or corporations who figure as philanthropists and cultural patrons in various capitals of the First World – and who conceal themselves behind the liberal-democratic character masks provided by those First World cultural activities.[9]

Before leaving the topic of globalisation, it is worth noting that it is a tendency also visible in the art market. Jane Addams Allen has observed that one reason for the

continued expansion of the art market is the large-scale entrance of international funds. [Leslie] Singer [an economist] suggests that the art market follows the same patterns as the economy at large. 'As global income rises, more art is purchased,' he explains. 'More European and Oriental money has been flowing into the art market.'[10]

As Allen also notes, being in charge of a global network of companies is an advantage to a collector:

> The international nature of these businesses is a considerable asset to the supercollector. With accounts in a number of currencies, he buys where the art is cheap and sells it where it is expensive, usually the United States.[11]

As we shall see, Saatchi did indeed use an American dealer and a New York auction house in his 'dispersals', selling off works from his collection.

Writing in 1984, art critic Robert Hughes also noted that:

> Twenty or thirty years ago, dealers in New York used to struggle against dealers in Paris or London, each affirming the national superiority of their artists. These transatlantic squabbles are now extinct. What you have instead, on the multinational model, is associations of galleries selling the one product in New York, London, Düsseldorf, Paris, Milan.[12]

To meet the demand for so many shows in cities around the world, fashionable artists, Hughes observes, are compelled to raise productivity and operate on almost an industrial scale. The likely effects are a reduction in artistic quality and a rapid exhaustion of ideas.

accumulation

Although Saatchi's success in business was in the beginning
due to his hard work and copywriting flair, it was soon asso-
ciated with a process of expansion and accumulation: he
accumulated clients/accounts and then many other agencies
and related businesses. As he accumulated more money, he
purchased expensive automobiles (he owned 17 at one
point), a villa in Italy, properties in London and New York,
and works of art. During the 1980s, rapid accumulation
also characterised his art collecting.

How is it that the Saatchi brothers became wealthy in
such a short time and where did their wealth come from?
Clients of the advertising agencies would argue that they
were the source because salaries and profits derived from
their payments to agencies for services rendered. When the
Saatchis paid the American Robert E Jacoby more than
$100 million (a personal payment) in 1986 to gain control
of the New York agency Ted Bates, one major client, Proctor
& Gamble, was outraged that 'their' money had been used
in such a lavish way. Consumers can argue that the money
ultimately comes from their pockets because the cost of
advertising is built into the price of every product or service
they buy. Another source of wealth was the profit from var-
ious private investments Saatchi made in companies other
than Saatchi & Saatchi.

Supporters of the free-enterprise system will say the
brothers' wealth was due to their energy, intelligence, inven-
tiveness, vision, business acumen, their use of the stock mar-
ket to raise money to enable them to buy other companies
for millions of pounds or dollars. Critics of capitalism, on
the other hand, while acknowledging these factors, will
point to the exploitation of their employees, the unpaid

labour they extracted from them. (Even though, of course, the senior people in advertising were paid high salaries and received annual bonuses.) The critics argue that if all the surplus value created by the labour-power of workers was returned to them, then there would be no profits for owners and shareholders, ergo, *workers must be working for some of the time for nothing*. A similar exploitation occurs in respect of artists if a collector or dealer buys a painting cheaply and then sells it later at a huge profit. For this reason, some British artists are demanding *droit de suite* – resale rights payments – which, at the time of writing, artists in eight other European countries already enjoy.

The Saatchis unwittingly confirmed the above argument when they explained that their aim in life was to work themselves out of a job. (The ultimate capitalist dream is to assemble so much capital that he or she can live well on the interest generated by that capital.) As Marx observed:

> The more the capitalist has accumulated, the more he is able to accumulate[13] ... accumulation resolves itself into the reproduction of capital on a progressively increasing scale. The circle in which simple reproduction moves alters its form, and ... changes into a spiral. [14]

This aim was to be achieved by employing others to do the work for them: Tim Bell, assisted by the creatives and suits, was to run the Charlotte Street agency, Martin Sorrell was to become finance director, Anthony Simmonds-Gooding was headhunted from Whitbread to organise the dozens of companies they bought, and so on. Even when the Saatchi empire ran into trouble in the late 1980s, the response of the brothers was not to become more involved themselves but to

import a foreign manager – the Frenchman Robert Louis-Dreyfus – and a financial expert or 'bean-counter' – Charles Scott – to rescue the business. Eventually, critics of the Saatchis inside and outside the empire began to ask what they did for their high salaries and expense accounts.

Louis-Dreyfus once remarked that the brothers treated their underlings as if they were worker bees or peasants.[15] When Maurice Saatchi wanted to buy a company he would court its senior figures assiduously. Once the deal was done he tended not to see them again.

As the size of the Saatchi empire increased (by acquisition rather than by organic growth), the number of employees rose from a handful to circa 14,000. In *Das Kapital* (English edition, 1887) Marx noted:

> it was extremely important for bourgeois economy to promulgate
> the doctrine that accumulation of capital is the first duty of every
> citizen, and to preach without ceasing, that a man cannot
> accumulate, if he eats up all his revenue, instead of spending a
> good part of it in the acquisition of additional productive labourers
> who bring in more than they cost.[16]

Was this at least one book Maurice Saatchi read, we wonder, while he studied at the London School of Economics in the 1960s?

By 1986 Saatchi & Saatchi PLC had become the top advertising group in Britain, the US and in seven other countries. Full-page advertisements were placed in newspapers which showed a continuously rising graph of Saatchis' profits. In the 1986 annual report blatant examples of megalomania and powerspeak appeared. Large size, the report stated, conveys 'power of scale' and press advertising reinforced the

same argument and referred to the so-called 'law of domi-nance' (that is, it is best to be number one in any business).

Within a short time the size and global nature of their business meant that the brothers did not have the time to concern themselves with the day-to-day detail of their main London agency, nor could they possibly supervise all the companies they owned around the world. Their response was to appoint some supermanagers to coordinate and rationalise, but also to allow their subsidiaries much auton-omy, to leave them to be run by local managers. (Another reason for granting autonomy to the various agencies was to reassure clients who were worried about having an account with one Saatchi agency while their market competitors had an account with another: the clients feared conflicts of inter-est and that confidentiality would be breached.) This is how the brothers became 'backroom boys' whose eyes were fixed on grand strategy and future expansion.

What the brothers achieved during the period 1970-86 was a dizzying, upward spiral of accumulation, higher and higher annual profitability and share values. But they built an empire which – like the Roman and British empires – eventually became too unwieldy to manage.

the leisure class

During the years when a male entrepreneur or industrialist is struggling to accumulate wealth, he usually has little time to appreciate the arts and to become more cultivated. As soci-ologists and social historians have pointed out, such men often marry women who can 'civilise' their husband in this way and play the role of hostess, run the household and make decisions about interior decor. In the case of Charles Saatchi's first partner Doris, this does not exactly describe

what happened because she was a working copywriter for two years while they lived together before their marriage in 1973, but she was better educated than he, was primarily responsible for the interior design of their homes, she took him to see exhibitions, and stimulated his interest in contemporary art.

Once businessmen become millionaires, they do not really need to continue working, although many prefer to do so. When Saatchi became rich he could be said to have joined 'the leisure class' which, of course, includes many who have simply inherited wealth, properties, estates, titles, etc., and have never had to earn a living. The American sociologist Thorstein Veblen (1857–1929) analysed the habits of this class with great insight as long ago as 1899 in a now famous book entitled *The Theory of the Leisure Class*.[17] His analysis is usefully applied to Saatchi's art collecting.

During the primitive stage of human history, Veblen argued, property was booty, that is, trophies acquired during raids on enemy tribes. (Did not the brothers make many such raids – takeovers – on foreign advertising agencies?) But with cultural advance, 'property becomes more and more a trophy of successes scored in the game of ownership carried on between the members of the group ...'[18] until, by the industrial era:

accumulated property more and more replaces trophies of predatory exploit as the conventional exponent of prepotence and success ... its possession in some amount becomes necessary in order to have any reputable standing in the community. It becomes indispensable to accumulate, to acquire property in order to retain one's good name ... The possession of wealth, which was at the outset valued simply as evidence of efficiency, becomes, in popular

apprehension, itself a meritorious act. Wealth is now itself intrinsically honorable and confers honour on its possessor.[19]

Assuming wealth is procured, is this the happy end to the story? Once you have it, what do you do with it? (This is a challenge faced by winners of Britain's National Lottery – one of the Saatchi agency's accounts.) According to Veblen, certain changes in the behaviour of the rich generally occurred:

> a growth of punctilious discrimination as to qualitative excellence in eating, drinking, etc., presently affects not only the manner of life, but also the training and intellectual activity of the gentleman of leisure. He is no longer simply the successful, aggressive male – the man of strength, resource and intrepidity. In order to avoid stultification he must also cultivate his tastes, for it now becomes incumbent on him to discriminate with some nicety between the noble and the ignoble in consumable goods. He becomes a *connoisseur* [our emphasis] ... This cultivation of the *aesthetic faculty* [our emphasis] requires time and application ...[20]

This surely describes the process by which Charles Saatchi became a lover of art and Maurice Saatchi a toy collector and garden-planning enthusiast.[21]

conspicuous consumption

Veblen's key concept was 'conspicuous consumption', that is, lavish spending for the sake of social status and prestige. For the leisure class such spending was the outward expression of their material success. Wealth itself can be invisible, hence the need for public events and visual artifacts to manifest it to others. (Thus, while Marx stressed the exchange- and use-val-

ues of commodities, Veblen stressed their display-value.) Arranging costly entertainments and parties for the benefit of business associates, friends and acquaintances was one common means of advertising one's wealth and largesse – and the parties held at the Saatchi Gallery to celebrate the openings of exhibitions obviously fit this description. Generous donations to charities or to the arts was another. Veblen argued that it was characteristic of conspicuous consumption that spending was on superfluities: 'In order to be reputable it must be wasteful. No merit would accrue from consumption of the bare necessities of life ...'.[22]

Later he remarked on the usefulness of handmade goods rather than industrial, mass-manufactured goods to those seeking to engage in conspicuous consumption.

Most fine art is the result of hand (and mental) labour rather than industrial processes, hence the usefulness of art as a sign of conspicuous consumption in Saatchi's case. Hand labour also results in unique (one-off) or rare (limited edition) artifacts compared to the batches of identical items pouring from factory assembly lines. Since the former are correspondingly more expensive, they are acquired by the wealthy rather than the poor. Adverts that appear in the press are cheap and commonplace compared to works of art, consequently everyone in Britain could collect examples if they wanted. But the more commonplace an object the more it is taken for granted or despised. It should be clear by now why Saatchi decided to found a collection of art rather than a collection of advertisements.[23]

decline, fall and recovery

In the late 1980s the brothers decided they would like to acquire a bank even though they had little expertise in the

field of banking. It was another effort at diversification, at providing clients with a wider range of services. They made takeover proposals to the Midland clearing bank and to the merchant bank Hill Samuel. When these approaches failed and were judged foolish by the City of London, the stock of Saatchi & Saatchi fell. In October 1987 the stock-market crash caused economic recession and by 1990 growth in the advertising market had gone into reverse. Despite selling some of its consultancy businesses, a cash crisis developed within Saatchi & Saatchi PLC and the value of its shares fell yet again. By early 1990, Fendley reports, the company was on the brink of insolvency. One newspaper claimed it had debts of £200 million. A further humiliation was the fact that the Wire & Plastic Products (WPP), run by the former Saatchi finance director Martin Sorrell, took over from the Saatchis as the world's biggest advertising group.

Reports of the brothers' financial problems prompted one of their critics to produce a pictorial parody of the famous stock photo of two men and their 1979 election poster slogans 'Labour isn't Working, Britain's better off with the Conservatives'. The headline 'Saatchi isn't Working' and the caption 'Britain's better off with Labour' were substituted. A line graph showed profits falling and a thought-balloon issuing from Charles Saatchi's head declared: 'I can always sell my art collection'. In fact, a proportion (around 20 per cent) of the collection belonged to the company and there was press speculation that it might be sold off to help the ailing empire. According to Jay Rayner, this did occur: during 1991 and 1992 sales of art made the Saatchi & Saatchi company £1.6 and £1.9 millon respectively.[24]

In response to the crisis, the brothers had recruited a professional manager – Robert Louis-Dreyfus – and a financial

expert – Charles Scott – to please the City and Wall Street, and to rescue the company by applying financial discipline. After some years of effort the new managers achieved stability. Several hundred staff were made redundant to cut costs while the brothers enjoyed annual salaries of hundreds of thousands of pounds each. But, eventually, even Maurice Saatchi's salary was slashed from £625,000 to £200,000.

In the US, shareholders concerned about their investments had become actively interested in the fate of businesses in which they owned shares, and American fund-managers, such as the Chicago-based David Herro, began to complain about the way Maurice Saatchi was running the company. Herro objected to the cost of Maurice's plush offices in Berkeley Square, his high salary, lavish expenses and a share-option scheme designed to net him £5 million.

John A Walker, *Saatchi isn't Working*, c. 1990. Pen and ink drawing plus photocopies, 25.5 x 17.1 cm.

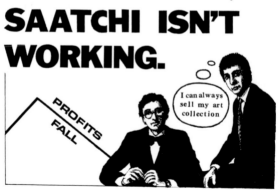

SAATCHI ISN'T WORKING.

PROFITS FALL

I can always sell my art collection

BRITAIN'S BETTER OFF WITH LABOUR

According to Herro, Maurice did not seem to appreciate that the Saatchi businesses no longer belonged to him and Charles because they had sold their controlling interest years before in order to fund the expansion/merger programme.

Maurice Saatchi resigned as chairman of the holding company in December 1994. Charles Saatchi finally resigned as honorary president after 23 years, during which time, Fendley asserts, he had not bothered to attend a single board meeting. (Goldman claims he did attend one when the going got tough.) For a while he continued to receive a salary of £312,000 for being 'a creative consultant' to the London agency Saatchi & Saatchi. The moment the brothers announced that they were leaving the holding company they sold their remaining shares – 1.8 million. This resulted in an investigation by the Department of Trade and Industry into possible 'insider trading' offences, but in the end no charges were brought.

According to one reporter, the story of the Saatchis' loss of their empire was considered dramatic enough to be made into a Hollywood movie. Robert de Niro was the actor proposed for the role of Charles.[25] Regrettably, the idea was never realised.

To some of those who had followed the rise and rise of Saatchi & Saatchi during the 1970s and 1980s it was clear that the brothers had overreached themselves and that running a global operation consisting of ten operating businesses, 400 offices, 10,000 clients and 11,000 employees was beyond their capabilities. Lesser mortals found it reassuring to learn that the brothers were not, after all, infallible superbusinessmen who lived up to their grandiose maxim 'nothing is impossible'.

A windfall cushioned the blow. In 1995, as a consequence

of a private investment share deal the brothers had made with Louis-Dreyfus and the sportswear company Adidas, they received a settlement of $38 million. This sum enabled Maurice Saatchi to feel that he could survive without the advertising empire and Charles' share, presumably, swelled the capital available for spending on art.

The aftermath of the brothers' departures was messy and bitter and damaged still further the standing of Saatchi & Saatchi PLC. Acting chairman Scott accused Maurice of removing files of company papers which, it transpired, had been moved to Charles' art gallery in St John's Wood.

The brothers, despite their faults, inspired deep respect and loyalty in some members of their staff. Unhappy at the way Maurice Saatchi had been treated, a number of senior executives and creatives from the London agency decided to resign their posts. (Around 30 people out of 5- or 600 changed sides.) After months of legal wrangling, they were able to join the new agency, M&C Saatchi which Maurice had decided to form. It now has offices at 36 Golden Square in London's Soho, employs 200 staff and its billings or client-spend for 1997 was reported to be £200 million.

Maurice Saatchi, at the age of 49, was able to start all over again and make a success of it. He still had powerful friends in the worlds of business and politics, plus a personal fortune to use as capital, and he was helped by the fact that several important accounts switched from the old Saatchi agency to the new one, including the British Airways account and the Gallaher Silk Cut account. The account for the Conservative Party did not follow immediately because the party owed the old agency £600,000 for past services, but it did switch to M&C Saatchi in time for the general election campaign of 1996–97. As a reward for his services

to the Tories, Maurice Saatchi was elevated to the peerage by John Major in August 1996. This prompted Labour MP Frank Dobson to dub him 'Lord of the lie'.

According to Fendley and other reporters, Charles Saatchi's primary interests were now his family life and his passions for art collecting and go-karting, so he did not want to become too closely involved in the running of the new agency. Nevertheless, he was to own a one-fifth share of it and he was to continue to oversee the Gallaher account.

The loss of their empire meant that M&C Saatchi had no international network of companies to service the needs of global clients like British Airways. Therefore, Maurice quickly reached an agreement with Publicis SA, a French agency which had such a network in place. The five partners – the brothers plus David Kershaw, Bill Muirhead and Jeremy Sinclair – also agreed that M&C Saatchi would remain a private company and that, if and when it grew, it would do so organically, not by acquisition. Their aim now was to be the best advertising agency in the world rather than the biggest.

The brothers also invested during the mid 1990s in the stock- market-listed company Megalomedia whose aim was to establish a network of separate but complementary businesses in the field of new media, in particular screen services and publishing. (One journalist referred to the group of organisations as 'The Saatchi Collection.')[26] In 1998 the businesses operating under Megalomedia's umbrella included: FrameStore (specialising in digital visual effects and computer animation), Computer Film Holdings Ltd (digital effects for the film industry), Forward Publishing (a contract publisher), Graduate Appointments (a media-based recruitment agency) and Webmedia Group (specialising in

the Internet/web design). Lord Saatchi, the non-executive chairman, reported in November 1997 that Megalomedia's half-year pre-tax profit was £1,169,000.[27] Could this be the beginning of a new Saatchi empire?

Another business venture is called Landau Investments, whose shareholders, besides the brothers, include Mick Jagger, Jean Pigozzi and Jacob Rothschild. Also, in May 1997 it was reported that Charles Saatchi had signed a partnership deal along with Nick Mendoza (managing director of Forward Publishing) and Roy Skeggs (a film producer) to revive the fortunes of Hammer Films by remaking British hit films of the past with top Hollywood directors and stars. Saatchi, it seems, is a big fan of horror movies about monsters such as Dracula and Frankenstein.[28]

By 1997 the majority of British voters were disillusioned by the lacklustre, arrogant and complacent Tory government led by grey-man incarnate John Major and Labour won the election by a huge margin. The demon-eyes and weeping-lion posters had been vivid but they had not turned the tide running for Labour. In October 1997 the Conservatives dropped M&C Saatchi. Meantime, Saatchi & Saatchi Advertising Ltd, whose billings in 1997 were reported to be £340 million, had recovered from the loss of the brothers and, unlikely though it would once have seemed, secretly assisted Blair's election campaign with slogans like 'Enough is Enough' and 'Britain deserves Better'.[29]

Despite Maurice Saatchi's long years of devotion to the Conservatives, he and his creative director Simon Dicketts were pleased when the new agency won a contract (budget £30 million) in 1997 to publicise the Millennium Dome project headed by the notorious Labour 'spin doctor' Peter Mandelson, then Minister without Portfolio. Dicketts

acknowledged to one reporter that he was not 'particularly political' but that it was 'fascinating ... to be able to advertise something apparently very opposite to what you've advertised before'. He also noted that New Labour and the Conservatives were in agreement on many issues.[30]

In November 1998 M&C Saatchi established a new specialist arts marketing division – M&C Saatchi Arts – with Judy Grahame as chief executive and David Kershaw as chairman. Its purpose is to employ consumer-marketing techniques to attract new audiences for major arts institutions such as the Royal Opera House, the British Museum and the National Maritime Museum.[31] We wondered if the Saatchi Gallery would benefit from this venture but Jenny Blyth, curator of the Saatchi Collection, has denied it.[32]

4
the saatchi collection

Collecting has many motives,
some of which are far from
admirable.[1]

Charles Saatchi's motives for his obsessive collecting have
puzzled many commentators even though there is a body of
literature on collecting in general and art collecting in par-
ticular. Raymonde Moulin's book *The French Art Market: A
Sociological View*, (1967/87) is especially illuminating and
useful even though her research focused on the period 1958
to 1962.[2] The chapter devoted to collectors contains a per-
ceptive analysis based on interviews with 90 chosen at ran-
dom from a list of 850 who, in the main, bought modern
and contemporary paintings. In its description of the behav-
iour and attitudes of major collectors, the chapter is virtu-
ally a blueprint for the later buying and selling habits of
Charles and Doris Saatchi. (Could Doris have read this book
when it was first published in France in 1967?)

The difficulty of understanding why collectors behave as
they do stems from the fact that their motives are as Moulin
notes 'complex and ambiguous',[3] that is, simultaneously
conscious and unconscious, altruistic and selfish, philan-
thropic and mercenary. In the case of Charles Saatchi, for
example, at one moment he buys art voraciously, at another
he sells it for profit, while at another he gives it away to
state-owned galleries and collections.

acquisition/possession/ownership
Before Saatchi collected art he collected Superman comics
and jukeboxes, and he continued collecting the comics into
adulthood, retaining them into the 1990s – his childhood
identification with this all-powerful, American, popular-cul-
ture hero must have been strong. Years later the adjective
'super' would be applied to Saatchi himself when American
journalists dubbed him a 'supercollector'.

Since virtually everyone collects sets of objects in child-
hood, acquisitiveness and the pleasures of ownership/pos-
session are clearly widespread and deep-seated human traits.
Objects can be owned and controlled far more than people.
One collector interviewed by Moulin remarked: 'With paint-
ings I experienced the lasting pleasure of absolute possession
that so long eluded me with people.'[4] Stuart Dalby has
quoted remarks by Peter Wilson, the chairman of Sotheby's,
concerning the importance of ownership: 'If human cov-
etousness were abolished, "art would come to an end. It's
very rare to be able to appreciate art without wanting to
own it".'[5] But that is exactly what most people are com-
pelled to do – because they lack the surplus cash to buy art
and why they are grateful for displays of it in public muse-
ums and galleries.

Works of art in the permanent collections of public muse-
ums appear to have escaped the art market; however, as Jean
Baudrillard has pointed out, they function like gold stored in
a national bank to ensure the value of the currency: '… the
fixed reserve of the museum is necessary for the functioning
of the sign exchange of paintings. Museums play the role of
banks in the political economy of paintings.'[6] Hence the
importance of the public sector to the economy of the pri-
vate sector.

Knowledge/Mastery/Control

There is something highly satisfying about the activity of searching for and assembling stamps, marbles, postcards, etc., and then sorting, comparing, cataloguing and classifying them, and striving to achieve a complete set of the coveted objects. Baudrillard has argued that collecting is 'qualitative in its essence and quantitative in its practice' because 'gratification flows from the fact that possession depends, on the one hand, on the absolute singularity of each item … and, on the other hand, on the possibility of a series, and hence of an infinite play of substitutions'.[7] The word 'substitutions' is particularly apt given Saatchi's habit of buying works and then, after a short while, selling them off in order to buy yet more.

The psychoanalyst Anthony Storr has noted:

> Collecting leads to classifying, and the ability to classify accurately is the beginning of scientific knowledge: the urge to make order out of chaos, to comprehend, to predict, and finally to master what had previously seemed beyond control.[8]

Knowledge, mastery and control are, therefore, three recurrent motives for collecting. Arguably, collecting contemporary art is more challenging than collecting most other kinds of material, because the field is so heterogeneous and works of art are more aesthetically and intellectually ambitious, and more intrinsically interesting.

It is a fascinating hobby for people who are not first-order creators like artists. Moulin quotes one French collector as saying:

> Collecting is lazy. It is a way of appropriating other men's work, of

embellishing oneself as with the feathers of peacock. It is a way of sharing in the artist's creative genius, his demiurgic power ... unable to create himself, the collector creates at one remove ...[9]

And, according to Storr, the special appeal of art may be due to the fact that:

Great artists, although we cannot emulate them directly, are demonstrating that even our deepest and most powerful emotions can be expressed and ordered; and when a particular work gives us so intense a thrill that we feel we must possess it, we can be sure that in some way or other it reflects our own inner world.[10]

In short, collecting art is a way of affirming one's identity. Moulin has even claimed:

The ultimate justification of the activity of collecting is metaphysical. Art is supposed to transcend the human condition ... Art is a form of, or substitute for, sacred things, and collectors use it to slake their thirst for the absolute.[11]

Buying a work or set of works by an unknown artist surely gives Saatchi an adrenalin rush because of the risk he is taking both financially and in terms of his critical judgement. (If he later feels he has made a mistake he can always unload the unwanted goods.) He must enjoy the thrill of discovery, the feeling of being in the vanguard. Saatchi himself is self-effacing about his habit: 'There's no skill in collecting. I don't take any pride in what I am doing. It's the artists who should be proud. They produce the work.'[12] Saatchi's most severe critics would agree he evinces no skills but we think he underestimates the role of the collector.

gambling/speculation

In the case of the wealthy, there are often financial reasons – such as tax incentives and investment potential – for buying and selling works of art. We have no reason to believe that Saatchi is an exception to this rule, indeed he has indulged in profit-taking a number of times. Most art collectors prefer to buy works by dead or well-established artists from auction houses and art dealers because they are safer investments. Buying art that has just been made is obviously a far riskier speculation but, as the business-world maxim has it, 'you must speculate to accumulate'. (Buying works by unknowns also means that, like new products marketed via advertising, they are more amenable to branding.) And the more extreme the speculation, the more extreme the rewards are likely to be for those who have 'backed a winner'. According to Moulin, speculators are 'imbued with the very spirit of capitalism'.[13] They are 'adventurous souls who like to gamble',[14] and those who collect art 'wager on both the aesthetic and the economic value of the works they buy'.[15] Furthermore:

> Today's rapid pace of [artistic] innovation encourages short-term speculation, and speculation, in turn, enables the market to absorb new directions in art. Artistic innovation feeds speculation and *vice versa*.[16] ... Speculators in avant-garde art are quite eclectic, ready to embrace whatever is new ... Because the collection is treated as an investment portfolio, its contents are constantly changing. The behaviour of speculators is largely governed by a simple market strategy: buy low and sell high; and buy enough paintings to be able to influence the market.[17]

A key advantage of collecting works by young, unknown

artists is that they can be obtained more easily and cheaply than, say, post-impressionist paintings. Moulin noted: 'The most common approach is to monopolise the output of a fairly young painter ... by paying him a regular stipend in exchange for the right to buy everything that he paints.'[18]

Stuart Dalby writes:

> The gospel according to Peter Wilson was that art should yield cash as well as class and the logical consequence of this philosophy was born in 1967 – the Times Sotheby's Index, which charted the progress of art prices in tables and graphs, as if paintings were commodities on the stock market.[19]

It was shortly after this Index appeared – coincidence perhaps – that Charles and Doris Saatchi began to collect art.

social climbing/prestige and competition

Robert Hughes has called private collections 'vanity collections' because they are, in his view, an expression of the owner's egoism. Making a collection public via a personal gallery, plus loans and gifts to museums, is clearly going to attract attention and impress others in the world of art. Social prestige and status will accrue to a collector who may be poorly educated and associated with a trade generally held in low esteem. Storr finds an explanation for the desire to impress in animal behaviour: male sexual display designed to attract females.

He then cites an additional reason: 'Since most of the great collectors of the past were men, it is tempting to interpret their passionate rivalries with one another as ritual contests for male dominance.'[20] This reason is more applicable

to Charles Saatchi than sexual display because his business history and his fondness for games and motor racing suggest that he is an intensely competitive individual. He cannot have been collecting for long before he learned of the existence of rival supercollectors such as Peter Ludwig in Germany and Giuseppe and Giovanni Panza di Biumo in Italy. Surely, at some moment, he must have decided to surpass them. Furthermore, it seems to us that when he opened a gallery in 1985 he started to compete with the directors and curators of public museums.

Irving Blum, an American dealer, has pointed to the social advantages to be gained from becoming an art collector:

> A collector becomes part of a network of lively people – artists, curators, writers, other collectors. One constantly receives requests for visits from people interested in one's collection. When a collector travels, he plugs into the art network, wherever he goes … It's a fascinating and highly civilized kind of existence. Art can become the reason for living one's life.[21]

Thomas Hoving, the American director of the Metropolitan Museum of Art in New York from 1966 to 1977, has also declared: 'Art is sexy! Art is money-sexy! Art is money-sexy-social-climbing-fantastic.'[22]

the love of art
The French collectors whom Moulin studied liked to think of themselves as art lovers rather than as speculators: 'the art lover is one who buys paintings for love, not money. The emphasis is on disinterested acquisition of art … none would admit to collecting because it is lucrative'.[23] Those who feel grateful to Saatchi will no doubt maintain that his

prime motive for collecting is aesthetic – a passion for art, plus the desires to associate with the creativity of artists and to assist, encourage and promote young, unknown artists and unjustly neglected older artists. He also wants to share his enthusiasm for art with others, to take modern art out of its ghetto.

Moulin contends that 'the modern collection acts as a polemic. The goal is not merely to become familiar with an artist but also to make him familiar to others and to win him recognition. The stronger the resistance to a painter's work, the more ardent the desire to convince others of its worth.'[24] We also perceive missionary tendencies in Saatchi: he makes excursions into the poorer districts of London in search of needy artists; he helps them and then he attempts to convert others to his belief that their work is worthy of attention and applause. That this selfless behaviour generally has financial implications indicates that a collector's actions can never be 'pure'.

What strikes many observers about Saatchi's affections for particular artists and art works is that they are short term. Given the turnover in objects that have taken place in the Saatchi Collection since it was founded, his love of art may be likened to Don Juan's love of women – the pursuit and conquest of one woman was simply the prelude to the pursuit and conquest of the next. Moulin remarks: 'The collector's desire, like Don Juan's, is stimulated by resistance. Possession causes it to flag. Its aim is to be perpetually unsatisfied.'[25] Baudrillard has extended the sexual simile: 'there is something of the harem about collecting, for the whole attraction may be summed up as that of an intimate series (one term of which is at any given time the favourite) combined with a serial intimacy.'[26]

neophilia

Moulin sums up certain collectors' compulsion to acquire new art:

> Change is valued in itself: it points the way toward the future. Eclectic collectors combine paintings of all the various postwar schools, like so many strata deposited by the ever–changing history of art. When the paintings in a collection are united only by the collector's desire to affirm forward-looking values, the result is incoherence.[27]

As a collector Saatchi refuses, in Moulin's words, to 'memorialise his own past'; he prefers to continue 'the adventures of his youth'.[28] In order to remain at the cutting edge, Saatchi's holdings must be regularly enlivened by the infusion of new blood. Moulin noted that in France during the modern era: 'As the pace of innovation in art increased, art lovers and snobs alike were forced constantly to revise their taste. For the avant-garde, the danger is that quick assimilation will reduce the advanced to the merely fashionable.'[29]

As he ages, Saatchi seems to be attracted more and more to young artists and new tendencies in what appears to be a desire to remain youthful. He has been dubbed a 'neophiliac' (Christopher Booker's term for a person who has an unhealthy obsession with the new). Saatchi's neophilia is shared by most of the young British artists he collects because they, of course, wish to 'kill off their fathers' in order to replace them.

A cult of the new is also characteristic of consumer capitalism and advertising: novelties of all kinds are invented and manufactured to tempt shoppers and revamped brands

and products are promoted on the grounds that they are 'new and improved'. David Ogilvy, the advertising expert, recognised years ago that the adjective 'new' was a crucial weapon in the copywriter's armoury.

There are affinities with the pop-music industry where the focus is also on the young and the latest trends. It is generally assumed that no band or style will appeal for long; consequently, A & R staff are constantly searching for fresh talent in obscure clubs and pubs. The bands seek to arouse the interest of record companies by sending them demo tapes; similarly, the artists seek to attract Saatchi's attention by sending him faxes and invitation cards to exhibitions, some of which are mounted in their studios or homes.

doris lockhart

The awakening of Saatchi's interest in contemporary art has been credited to the influence of his first wife, Doris Lockhart, born in Memphis, Tennessee, in 1938. Her father was a newspaper reporter at the time and her mother was a Russian Jew who had emigrated to America as a child. The family, which was middle-class, later resided in Washington DC and then Scarsdale, a northern suburb of New York City.

Doris recalls enjoying the rich cultural life available in central New York. She studied art history, French and English literature at Smith College in Massachusetts, and spent a year at the Sorbonne in Paris where she researched the work of the nineteenth-century neo-classical painter Ingres. In 1960 she helped with Jack Kennedy's presidential campaign. Later she obtained employment as a copywriter in the Ogilvy & Mather agency in New York where she encountered the famous British advertising executive David Ogilvy.

A woman then who had knowledge of both art and advertising, considered by many of the artists, dealers and curators she met to have a discriminating 'eye' when it came to judging new art.

Lockhart was attracted to England during the 1960s because it seemed to be a more tolerant and liberal society than the US was at the time. She and Charles first met in 1965, in 'swinging London', while they were both working as copywriters for the American-owned Benton & Bowles agency in Knightsbridge. Lockhart was several years older than Saatchi and his senior at work. She was also better educated, more sophisticated and cultured than he. She was married to a racing driver called Hugh Dibley and, after her marriage broke down in 1967, Doris and Charles became lovers. They married at the Kensington Register Office in 1973, after which Doris gave up full-time employment. They separated in 1987; a divorce followed in 1990. They had no children.

In the late 1960s the couple made a weekend trip to Paris and Doris was keen to visit art galleries. They saw an exhibition of photorealist paintings and realised that they were available for purchase and that they could afford them. It was clear that if they were to become collectors it would have to be of contemporary art because the work of older, more famous artists was beyond their pocket.

When the couple visited the US to see Doris' parents, they developed the habit of touring the art galleries of New York. Since Doris was American and American art had dominated the Western world since the era of Jackson Pollock and abstract expressionism, the styles of art that the couple looked at and bought examples of tended to be American. Charles Saatchi must also have noticed

that the contemporary art market in New York was significantly bigger and more active than that in European cities.

Robert Mapplethorpe, *Portrait of Doris Saatchi*, 1983.

Back in London they began by buying prints by minimal and conceptual artists from the dealer Alain Mertens who ran a clothing shop on the King's Road and a print gallery. Their first Sol LeWitt drawing was acquired in 1969 for £100. Then they bought examples of photorealism (in vogue

during the late 1960s and early 1970s) and then pattern painting (fashionable in the mid and late 1970s).

One gallery that exhibited the work of American minimalists such as Carl Andre, Donald Judd and Sol LeWitt, was the Lisson in Bell Street near Marylebone Station, run by the dealer Nicholas Logsdail who had once studied fine art at the Slade. In the early 1970s the all-white, starkly designed gallery was often deserted and Logsdail complained to the occasional visiting art critic about the lack of interest from British collectors. Minimal art had minimal popular appeal. The Saatchis' taste for it, therefore, was exceptional in Britain. No doubt their visits to the US – where minimalism had replaced pop art as the dominant movement of the 1960s – had convinced them it was worth acquiring. Minimal art may also have appealed to Charles Saatchi because simplicity was valued in advertising. His brother Maurice was in the habit of giving speeches to his peers in which he glibly asserted: 'In great advertising, as in great art, simplicity is all.'[30]

During the 1970s and 1980s Doris Saatchi became more and more preoccupied with developing the collection. In addition, she honed her writing skills in articles published in a variety of visual-arts magazines: *Architectural Review*, *Artscribe*, *World of Interiors* and *House & Garden*. When a collector writes art criticism, there is clearly a danger of a conflict of interest (many art critics also own works by the artists they celebrate). For example, when Doris wrote an article for the British journal *Artscribe* in 1982 (for the miserly fee of £25), the four main painters she discussed and praised – Guston, Morley, Salle and Schnabel – were all represented in the Saatchi Collection and all the illustrations were of works from the same source.[31] While other theorists

were busy trying to dismantle the myth of the male artist as hero and genius, she was shoring it up by celebrating new artist-heroes such as Julian Schnabel.

While Doris was married to Charles she was responsible for the interior design of their home at 12 Langford Place, St John's Wood, an affluent suburb situated just north of London's central business and shopping centre, near Regent's Park and Lord's cricket ground. Charles and Doris Saatchi purchased a detached house dating from the nineteenth century located behind a high wall to which an additional, more modern wing had been added. Behind the house was a landscaped and enclosed garden containing an oval, heated swimming pool.

The house was neo-Gothic in style and had begun life as a Victorian chapel. It had been called 'Agapemone' or 'The House of Love' because an Anglian priest – John Hugh Smyth-Pigott – whom his followers considered to be a reincarnation of Christ, used it to seduce females. The building was a favourite of Sir John Betjeman. An estate-agent's blurb described it as having 'an air of drama and luxury'.

There were leaded and stained-glass windows and a spectacular, brightly lit reception room (35 by 14 feet) which the Saatchis found ideal for displaying their latest acquisitions. According to Fallon, visitors coming in through the gate 'were greeted by a massive tubular sculpture' (probably a work by William Pye), while inside they encountered sculptures by Carl Andre and paintings by Anselm Kiefer, Bruce McLean and Andy Warhol. One Andre on display was *Equivalent VI* (1969), a minimal sculpture made from American firebricks, another version of which – *Equivalent VIII* – provoked a media outcry when it was exhibited at the Tate Gallery in 1976. (It had been acquired by the Tate two years

Exterior of 12 Langford Place,
1999 (Michael-Ann Mullen).

previously for a reputed £4000 and was condemned by the tabloid press as a waste of public money.) Charles Saatchi, who probably paid a few thousand pounds for *Equivalent VI* during the 1970s, sold it in 1993 for £130,000.

Another sculpture on display in the Saatchis' home was pre-modern: a metal, female figure holding an arrow in one hand and a bow in the other. The work of a French academic artist, it represented Artemis or Diana, the protectress of women, the virgin goddess of the moon and of the hunt. The statue reminded Doris Saatchi of the figurative sculptures found in Mies van der Rohe's otherwise ultra-modern

Barcelona Pavilion (1929). Doris – the huntress of art – identified strongly with the classical goddess and she retained the statue after she and Charles parted and moved to new addresses in Mayfair.[32]

In 1981 the couple acted like traditional patrons of the arts when they commissioned the American

Reception room of 12 Langford Place (1988). By the window is the Artemis sculpture; on the right-hand wall hangs a painting by Bruce McLean, and in the bottom right-hand corner is a model of a proposed addition to the existing house by Doris and Rick Mather.

artist Jennifer Bartlett (b. 1941) to decorate a room in their house. Her work was already familiar to the Saatchis: in 1977 they had bought three paintings by her in the space of

Dining room of 12 Langford
Place with decorations by
Jennifer Bartlett, 1982.

half an hour from Douglas Baxter of
the Pace Gallery, New York. Bartlett,
classed as a new image painter, is a
restless innovator who enjoys work-
ing in several styles simultaneously and has a strong interest
in interior design. She has been inspired by the garden paint-
ings of Monet and by the decorative qualities of the art of
Dufy and Matisse.

Bartlett selected a small dining room with a dark slate
floor which overlooked the rear garden. There she executed
a series of works, known in total as *The Garden*, in a variety
of media. Since the irregular-shaped and low-ceilinged room
contained nine different surfaces, Bartlett decided to create

nine images in different media. Critics have used the term 'ensemble painting' to describe her way of working. All the images were site-specific in the sense that they were generated in response to the patio, pool and trees outside the room. The pieces included a charcoal drawing of the garden's wrought-iron gate; a view of the pool in *papier collé*; a lacquer screen depicting leaves, the pool and the Saatchis' cat Buster; a depiction on mirror of a black tree; and an enamel-on-glass view of the pool with its steps. Roberta Smith comments:

> Via juxtapositions of long shots, close ups, variations in times of day and year and kinds of light, and the listing of barely noticeable details, Bartlett reveals not only what the garden looks like but different ways of seeing it and thinking about it.[33]

Since Bartlett's images reached from floor to ceiling, the result was an extremely loaded, hectic and colourful environment which may not have been conducive to digestion.

Following the breakdown of the Saatchis' marriage and the sale of the house (priced £895,000), Bartlett's work was returned to the artist. She later sold it to the American collectors Max and Isabell Herzstein, who in 1998 donated it to the Museum of Fine Arts in Houston, Texas.

Interestingly, when Charles remarried in August 1990 it was to another American with a strong interest in the visual arts. Kay Hartenstein, his new bride, came from Little Rock, Arkansas. She once worked as a sales rep. for *GQ* (*Gentlemen's Quarterly*) and, after she came to London in the early 1980s, as an art dealer in the Mayor Rowan Gallery; they have a daughter, Phoebe (b. 1994). In the early 1990s Charles Saatchi settled in a refurbished Georgian house,

designed by Munkenbeck & Marshall, in St Leonard's Terrace, Chelsea, near the King's Road. The architects' bill came to £1.1 million. Saatchi thought this excessive, offered half and the dispute had to be settled in court.[34] The house has a 60 foot reception hall-cum-gallery in which art works from the Saatchi Collection by Hirst, Hume and Patterson have been displayed, while upstairs paintings by Freud, Hodgkin and Paula Rego have adorned the walls.

Lockhart has claimed that when she and Charles Saatchi visited exhibitions during the 1970s their judgements of artistic quality were uncannily similar. Even after the separation of 1987, it seems they visited the same artists' studios in London. During 1988 and 1989 Lockhart bought works from various young British artists, including Damien Hirst, presumably to establish a private collection of her own.

In 1988 she paid a visit to the the Royal College of Art. A decade later she recalled being

> appalled at how careerist the students had become. They all wanted to get work into the Saatchi Collection, so they were making huge works to fill up all those huge spaces ... We live in a time that is heavily influenced by advertising and, as we all know, Charles Saatchi is a master of that discipline. The influence is felt in much of the art made today, and, for me, it's soft at the centre. I don't want narrative [art], but there's a lack of rigour.[35]

Perhaps Lockhart now appreciates that she, along with Saatchi, bears some responsibility for the hard-nosed commercial attitudes that she encountered at the RCA.

When the couple divorced in 1990 outsiders were uncertain as to what the ownership consequences in respect of the Saatchi Collection – then consisting of more than 800 items

worth around £100 million – were going to be. Alberge reports that since the divorce Lockhart no longer owns any of it.[36] She herself informed journalists that she did not want the collection to be broken up or divided in half, and that she was content to let Saatchi run the show – presumably in return for a substantial divorce settlement.

expanding the saatchi collection

The 'story of art' is an ongoing one characterised in recent times by a succession of new movements and styles (there are similarities to the fashion industry with its seasonal style changes), therefore when someone decides to collect contemporary art they are venturing into uncharted territory. It is an exciting experience but the chances are that new types of art will emerge which do not appeal to the collector's personal taste. If he or she is to continue, then a flexible, open mind, and a catholic or pluralist attitude are required. This Saatchi has demonstrated because he has kept abreast of most of the new trends in art since 1960: pop art and minimalism, photorealism and pattern painting, neo-expressionism and trans-avant-garde, new British sculpture, American neo-geo, school of London painting, yBa, and the new neurotic realism.

A critical assessment of the Saatchi Collection is almost impossible because the contents are very heterogeneous and simultaneously mutating and swelling in line with his attitude that the collection is a 'living' rather than a 'memorial' entity. (At the time of writing it contains 2000 items, 1000 of which are said to be by British artists. We doubt that even their owner has ever seen them all displayed in one place.) In the 1990s Saatchi has purchased works by older, established artists in order to 'strengthen'

or 'consolidate' his collection. At times it also contracts: some artists and movements that Saatchi supported, he later considered were 'mistakes' on his part and so he got rid of them. In addition, he has sold works in order to finance the purchase of brand new art.

The very pluralism of the Saatchi Collection has resulted in some observers thinking its owner has no identifiable personal taste and that his collecting is marred by arbitrariness or randomness – 'indecent capriciousness' (Waldemar Januszczak), 'haphazardness' (Sarah Kent); 'Haphazard modern art collections reflect on [sic] the collector's determination to be current,' (Moulin),[37] 'diffuseness and incoherence' (Brian Sewell) – and contradiction (it is certainly hard to envisage how anyone can possibly appreciate both Carl Andre and Lucian Freud). His collecting method has been compared to hunting animals with a scatter gun: by firing at lots of artists he is bound to bag some good ones.

Peter Watson has remarked: 'Saatchi is clearly someone with a gargantuan appetite for buying art – but maybe his chief fault lies in the fact that he is doing so when … there is little great contemporary art to buy.'[38] Of course, it is hardly Saatchi's fault if there is a shortage of quality art, but it is certainly the case that by buying so much he is bound to acquire many bad and mediocre works of art. The situation is complicated by the fact that some contemporary artists deliberately set out to make 'bad' art. It then becomes difficult to distinguish between good 'bad' art and bad 'bad' art.

Every collection is the result of a selection or editing process but this is in part contingent upon what is available in studios, galleries and auction rooms at any one time. A collector may want one particular work to complete a set

but it may not be for sale. If there is a recurrent factor in Saatchi's collecting, then it is surely an attraction to art with high visual impact and shock-value. (Bernard Jacobson once described it as 'sound-bite art'.) This, we conclude, is due to his short attention span and his years of experience judging the impact of advertisements. He also seems to have a penchant for highly illusionistic sculptures of human figures; witness his acquisition of works by Duane Hanson, Abigail Lane and Ron Mueck.

One of the reasons why Saatchi collects work from so many disparate movements is that he thinks of his collection and gallery as a rival to public art collections and museums. The latter, after all, feel it is their duty to collect representative examples of all the major trends in art regardless of the personal preferences of the directors or curators. At times he also says there are 'holes' in his collection which need filling and that some of the works he buys are of 'historical importance'. This is how curators employed by public museums think. Saatchi, of course, denies that he behaves like a museum curator and one of his buying habits – buying in bulk or 'in depth' – is certainly a sign of difference.

This particular habit has been much commented upon. While a public museum might have been content with a few Schnabels, Saatchi acquired 27 of them. He has owned 15 Warhols, 19 Richard Artschwagers, 20 Kiefers, 27 Lucas Samaras, 40 Cindy Shermans, 47 Paula Regos ... Watson observes:

> His practice of buying large numbers of works by contemporary artists irrespective of whether they show the development of those painters also suggests that he is a hoarder rather than a true collector, at least in the old-fashioned sense.[39]

It could be argued that collecting in such depth was a sign that Saatchi had great faith and interest in the artist's work but a less charitable description of his behaviour would be 'cornering the market, trying to achieve a monopoly'. If one buys a large number of works by a little-known artist while they are cheap – and one can also demand discounts when buying in bulk – then there will come a time when it will be possible to 'prune' one's holdings by selling off some of the lesser works for a profit while retaining the choice pieces for the collection.

Saatchi's buying sprees in New York attracted the attention of Robert Hughes, the Australian-born art critic of *Time* magazine, who included him in his 1984 poetic attack on the American art world centred upon SoHo (that is, the South Houston district of New York). Hughes wrote:

> Fresh talents gather on Manhattan's strand
> Where (never care how hasty, botched, or patchy)
> They're bought in loads by their *Maecaenas*, Scratchy.
> Thus is confirmed, before the sceptic's eyes,
> The motto that *It pays to advertise*,
> For if New York museums come too late,
> I foist them on the trustees of the Tate.[40]

At least one artist resident in New York – Sandro Chia, an Italian, trans-avant-garde painter – was suspicious of Saatchi's buying methods and his charm offensive. In 1985 Chia recalled:

> Mr Saatchi started to buy my paintings very early – so early that I think I was the first painter that was not American to be included in his collection. At the time of his acquisitions, I remember him

telling me how highly important he considered my work, etc.
Far from being impressed by his opinion, I rather expressed to
my dealers my concern about any person accumulating my works
in such number, thereby establishing a control and quasi-
monopoly.[41]

Chia's suspicions were confirmed when Saatchi soon dis-
posed of all the six paintings that he had bought.

art for offices

During the 1970s examples of Saatchi & Saatchi advertise-
ments were displayed on the walls of the agency's London
offices to inform and impress clients. It was a logical exten-
sion, therefore, to add works of art. There came a time when
the senior management moved out of Charlotte Street to
occupy premises in Lower Regent Street, and later, in 1989,
they moved again to Landsdowne House, Berkeley Square,
in Mayfair[42], a seven-storey, post-modern-style castle-like
building with a grand atrium by Chapman Taylor Partners.
The Saatchi holding company leased it for 25 years and
unsurprisingly chose to occupy the top floor. But since the
only name on the facade was Saatchi & Saatchi, passers-by
gained the false impression that they were the sole tenants.
The right to place their name cost the company £4.6 million
per letter. These offices too were adorned with art works
from the Saatchi Collection.

When the Saatchi business empire extended to the United
States, two large works by Frank Stella were hung in the
lobby in the new Saatchi & Saatchi building at 375 Hudson
Street, Lower Manhattan.

Many businesses perceive benefits from displaying and
owning works of art. The London organisation Art for

Offices summed them up as follows:

> Art enhances a building's design, establishes interesting focal points
> and creates interiors that fascinate, fostering pride in the
> workplace. Art demonstrates your corporate image and a caring
> attitude towards staff and clients. It can be a statement of success,
> projecting confidence to shareholders and to the surrounding
> community and competitors. Art also acts as a perfect
> counterbalance to the impersonal identity of technology, evoking a
> warmer atmosphere and stimulating interest overall.[43]

In Saatchi's case, the presence of contemporary art indicated
that it was a company with sophisticated tastes, that was in
touch with the latest trends in visual culture. Acquiring
works of art also had tax benefits and investment potential
for businesses. As Hans Haacke noted, art works were
treated initially as part of the fixed assets of the company:

> From time to time the annual reports of Saatchi & Saatchi PLC
> listed art works under the heading 'fixed tangible assets (furniture,
> equipment, vehicles, works of art).' In 1982 their combined gross
> replacement cost was stated as £15,095,000.[44]

As more and more works were acquired, Charles and Doris
Saatchi displayed them in their own home and began to
form a collection that belonged to them rather than the com-
pany. Which works belonged to him and Doris, and which
belonged to the company became a source of confusion in
relation to Saatchi's art collecting. Reports indicate that the
company owned around 18 or 20 per cent of the total
Saatchi Collection.

Separate companies were also used for art-investment

Façade of Landsdowne House,
Berkeley Square, London,
c. 1990 (Nicolas Bailey).

purposes. For example, Brogan Developers Ltd (a small property company) which was one of the first companies the brothers acquired (in 1972). According to Fallon, 'Before Saatchi & Saatchi … became a public company, some – possibly all – of the art collection was owned by a subsidiary of Saatchi & Saatchi called Brogan Developers, based in the Isle of Man for tax reasons'.[45] In 1978 it was reported that this company sold art works valued at £380,319. Fallon also asserts that 'Charles bought out Brogan Developers'. It ceased to operate in 1983.

Another vehicle for Charles Saatchi's investments was founded in February 1987, namely a company called Grandswap Ltd. Its name was later changed to Conarco Ltd. (Was 'Grandswap' too revealing?) The company's main function is to 'deal in works of art and antiques through its investment in the partnership of Conarco'. Charles Saatchi is principal shareholder and director. According to the company's annual report and financial return for 1997, there was an operating loss of £12,029 but its retained profit carried forward was £1,623,321 and its fixed assets were worth £2,842,913.[46] The paucity of detail in Conarco's accounts limits their value in clarifying Saatchi's transactions.

The convoluted situation that can arise when a corporate collection exists was indicated by Amanda Atha in 1984 when she commented:

> They [the brothers] can, of course, buy and sell pictures in their roles as directors, but if they sell pictures *to themselves* [our emphasis] there is obviously a conflict of interest, and they are obliged to declare their transactions.[47]

Another reporter claimed in 1995 that Charles Saatchi had

indeed acquired some of the company's paintings,[48] and Fallon wondered if he had picked the best works and left the company with the duds.

Since Saatchi's annual salary plus dividend amounted to £625,000 before tax in 1984 it puzzled Saatchi-watchers how he was able to spend an estimated £1 million on art, that is, more than his income. Fallon concludes that some company money was used to buy art for the company and that stock-market sales of Saatchi & Saatchi shares was another source of finance. Auction houses such as Sotheby's in New York are also willing to defer payments of monies owed to them or to loan wealthy clients the money they need to buy expensive art works. Banks too will advance lines of credit. According to one news report, Saatchi had £100 million worth of credit to spend on art.

By seeking out new art before it became well known and expensive, Charles and Doris Saatchi were able to buy it relatively cheaply. If and when it increased in value they could re-sell it and use the profits to buy yet more new, cheap art. As an example, the Saatchis sold 11 works by the German painter Anselm Kiefer to the Japanese businessman Harunori Takahashi for a reported £8 million in 1988.[49] (Actions such as these were to lead to the accusation that Saatchi was a dealer rather than a collector.) To some extent, therefore, the operation was self-financing. The beauty of the scheme, from their point of view, was that the increase in fame and monetary value of the art they had acquired was due in part to the very fact that they had bought it and – once they had a gallery of their own – exhibited it and memorialised it in catalogues. Like British commercial television in the 1950s and 1960s, it was 'a licence to print money'.

patrons of new art and the schnabel incident

During the early 1980s Charles Saatchi became involved in the activities of two of London's major public galleries: the Tate and the Whitechapel. He was a member of the steering committee of the Patrons of New Art, a group established by the Tate in 1982. Alan Bowness, the gallery's director, wanted the financial assistance and expertise of a smaller group of people than those who were Friends of the Tate Gallery, that is, people who were specifically interested in helping to increase the Tate's holdings and exhibitions of contemporary art. One anonymous, disenchanted Friend described the group as 'a vehicle for power, prestige and social climbing'.[50] The same critic noted that Saatchi had never donated a work to the Tate. This was to be remedied in 1992 when he gave the Tate nine works by British artists valued at £100,000.[51]

Frances Spalding reports:

> By June 1983 the Patrons had nearly 100 supporters, each of whom had pledged more than a £1000. Within four years it had 200 members, who each covenanted between £250 and £1000 for four years. These subscription fees were directed towards the purchase of contemporary art … and in time also contributed towards some educational and exhibition projects, while all administrative costs were funded by tax reclaimed from covenants … London dealers made up about 20 per cent of the Patrons' membership.[52]

Permitting dealers to become Patrons was surely an indication of possible conflicts of interest because by selling works of art to the Tate, dealers could gain profits from their membership. Another conflict of interest arose in relation to Saatchi the collector.

In 1982 the Tate mounted a solo exhibition of the work of the young American painter Julian Schnabel (b. 1951), a rising star of the New York art world who was little known in Britain. At that time Schnabel specialised in huge canvases quoting self-portrait drawings by Antonin Artaud and in reliefs made from broken crockery which were then painted over with a mélange of imagery appropriated from a variety of sources. While touring the galleries and studios of New York in 1978, Charles and Doris Saatchi visited Schnabel in the company of his thrusting dealer Mary Boone. The artist says the collectors 'changed his life' because they made it possible for him to continue to paint. He recalls that they said little but did indicate that they considered his work 'beautiful'. In general, they were 'enthusiastic and supportive'.[53] One of the paintings they were shown and decided to buy was *Accatone* (1978). (Schnabel was upset when he learned later that the Saatchis had sold it.) Thanks to Boone's energetic promotion, by the time Schnabel had his first one-man show in New York – at the Mary Boone Gallery in 1979 – every work on display had been sold. The Saatchis bought Schnabels in bulk and they were thus able to lend nine works to the 1982 Tate show out of a total of 11. The paintings had been produced between 1978 to 1982, during which time their prices had increased from $2000 to $50,000. In 1992 two Schnabels from the Saatchi Collection were sold in New York for $319,000 each.

Leo Castelli, the famous New York dealer who briefly showed Schnabel, claims that the sudden arrival of the Saatchis – collectors with lots of money to spend – had a significant impact on the New York art market: prices rose steeply.[54] This even applied to the work of established artists such as Warhol. Castelli thought that 'Warhol was a bit in

the dumps before Saatchi intervened'. Charles wanted 'rare pieces that were very expensive. When he next found a painting he wanted, well, we were perfectly aware of the price that he had paid for certain paintings, and the price would go up.'[55]

Reviewers of the Tate's Schnabel show had a number of complaints: first, it seemed unfair that a young American painter was being given a one-person show when so many worthwhile British artists had been waiting years for such an opportunity; second, the artistic quality of the Schnabels was in doubt (the paintings were judged to be 'bombastic'); third, most of the imagery Schnabel used was borrowed (he was accused of 'cultural necrophilia'); fourth, promotional hype was being used to turn Schnabel into a macho, super-star artist comparable to Pollock; fifth, the high proportion of works from the Saatchi Collection meant that its owners would benefit financially because the value and prestige of Schnabel would be enhanced as a result of appearing in the Tate.[56]

In December 1983 Schnabel was given a one-man show by the Waddington Gallery, London. Peter Fuller, a tren-chant critic who began his writing career as a committed left-winger, accused the Saatchis of having no taste or having degraded taste and of having – with dealers – too much influence over the Tate's exhibition programme:

> The Saatchis spend their working lives promoting a dominant cultural form, i.e. advertising, which allows no space for the social expression of individual subjectivity. It is therefore predictable that, unlike merchant princes, aristocrats, Dutch innkeepers and others who possessed both wealth and taste, they prefer fine art forms which are *nothing but* a solipsistic, infantile wallowing in the

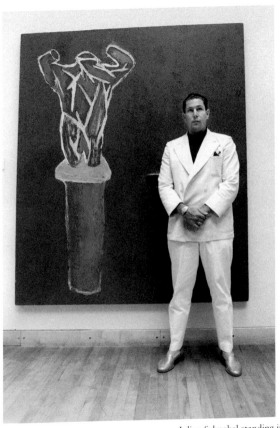

Julian Schnabel standing in front
of *Accatone* (1978) at the Tate
Gallery, 1982 (Susan Adler).

excremental gold of the otherwise excluded subjective dimension. Schnabel and Waddington are entitled, if they so wish, to serve the tasteless sensibilities of the advertising tycoons. But it is one thing for such people to pursue their degraded tastes in private, it is quite another for our leading modern art institution, the Tate Gallery, to indulge those tastes in public.[57]

Three years later the Whitechapel honoured Schnabel with a retrospective. This time seven out of the 34 paintings on display came from the Saatchi Collection.

After the Schnabel show, the Tate mounted an exhibition of paintings by another American artist, Jennifer Bartlett who had decorated the Saatchis' dining room. The Saatchis also possessed several of her paintings but only one of the six works on display at the Tate was borrowed from the Saatchi Collection.

It seemed to British critics that Charles Saatchi had taken advantage of his membership of Patrons of New Art and that the two shows were clear indications of a conflict of interest. Of course, Saatchi protested his innocence; he simply thought he had being doing the Tate a favour. In addition it was noted that Saatchi & Saatchi had the publicity account for the Tate at this time. Hans Haacke made these connections explicit in *Taking Stock (Unfinished)*. The Tate's willingness to display this work must have compounded Saatchi's disenchantment with the public institution.

As a trustee of the Whitechapel (funded by the Arts Council and the Greater London Council, later abolished by the Conservative Party the brothers served so well), Saatchi had knowledge of future exhibitions planned by the gallery's curators. In February 1983 the Italian artist

Francesco Clemente showed a cycle of paintings entitled 'The Fourteen Stations' which had been executed in New York during 1981–82. Nick Rosen reported: 'He [Charles] recently bought a set of 12 paintings by Clemente "after the gallery decided to exhibit them," said the Whitechapel's director Nicholas Serota, but before the show was opened.'[58]

It was later alleged that Saatchi also bought work by the British-American photorealist Malcolm Morley just before he had a Whitechapel show in June/August 1983. Of the 52 paintings in the Morley show, seven were from the Saatchi Collection and the conflict-of-interest charge was again pertinent. Once future shows have been firmly scheduled by public galleries members of the public can find out about them but wealthy individuals such as Saatchi can take advantage of such advance information.

As a result of all the public criticism of his actions, Saatchi decided to resign from the Patrons of New Art and to cease being a Whitechapel trustee. 'Helping' public institutions was clearly more trouble than it was worth. (Of course, the Saatchi Collection has continued to lend items to exhibitions held in public museums around the world.) He also made a decision then to establish his own gallery which led some to conclude that revenge was one of his motives.

A key advantage for Saatchi in having his own collection and gallery was the greater freedom he enjoyed compared to the trustees or curators of public institutions. The latter are inevitably bureaucratic and slow-moving, whereas Saatchi could buy what he liked, as much as he liked, whenever he wanted. He did not have to consult anyone else; he did not have to bother with committees, nor was he held back by the financial constraints which

plagued most public museums in Britain. He could take risks and buy new art while it was still cheap. He could also sell it a short time later if he became dissatisfied with it. (Deaccessioning is much more difficult for public museums.) Best of all, his critics could no longer accuse him of conflicts of interest.

the saatchi gallery

Doris Saatchi once explained that one reason why she and her husband decided to open a gallery was that she was becoming embarrassed by having to show art-loving strangers around their home – including the bedroom which had an Anselm Kiefer painting hanging above the bed. Another reason, given by Charles Saatchi to an American writer, was 'the personal gratification of viewing the work as it was meant to be seen'.[1] It seems that he also recognised a social duty to make the collection more accessible to the public. In so doing, he hoped that the spotlight of publicity would turn away from him to the art. It annoyed him that journalists wanted to write about the collector rather than the collection.[2]

Wealthy individuals often own apartments or houses in several countries. Even so, if an art collection becomes so large that it cannot be accommodated in their homes – one Donald Judd wooden construction from 1981 that the Saatchis bought was nearly 12 feet high and 80 feet long – then collectors must choose between keeping it in storage, loaning it to existing museums, or establishing a specially designed gallery. Saatchi chose the latter option. Its major advantage was that he could view his works of art at leisure and the public could enjoy the same pleasure. This would bring honour and prestige to Saatchi and it would also help

to increase the value of the works themselves by publicising them. However, the Saatchi Collection is now so large it cannot all be shown at the Saatchi Gallery; most of it has to be expensively stored in Momart's east-London warehouse.

By establishing a museum or foundation which carries their name, the Gettys, Guggenheims, Sainsburys, etc., achieve a form of immortality. Even the rich eventually realise that they cannot take their property with them when they die . Consequently, many decide to become public benefactors by leaving their museums to state authorities in their wills. Saatchi may do the same with his collection and gallery. We suspect that certain directors of British public museums are counting on it and the gifts he has made to the Tate and the Arts Council Collection encourage this assumption. Nevertheless, some of his actions – such as selling off works – indicate that this is by no means a foregone conclusion. Saatchi may decide to sell off/disperse all his collection before he dies or he could decide to leave it to a foreign country or to his daughter.

In 1999 the journalist Godfrey Baker reported that Saatchi had expressed the hope that his collection would end up as a national museum in Britain. But there is little point in giving a collection to the nation unless there is also an endowment to sustain it. Lord Jeffrey Archer, the well-known Tory politician, popular novelist, erstwhile collector of Warhols, and candidate for the new position of mayor of London, thought money ought to be found for such a museum. In contrast, the Labour politician Ken Livingstone, who is also hoping to become mayor, considered that a world-class aquarium for the East End of London was a higher priority.[3] Of course, there are certain works by Hirst owned by Saatchi – those featuring

Installation shot of Saatchi Gallery interior with paintings by Andy Warhol, 1985 (Adam Bartos).

fish and sharks – that would be suitable exhibits for both venues.

designing the gallery

Another benefit to be gained from having a gallery was that an architect could design the interior to Saatchi's own specifications and he could then display the art he owned in any way he liked. In 1983 Saatchi discovered and bought, for an estimated $2.5 million, a large disused warehouse hidden behind a terrace of houses and shops at 98a Boundary Road, St John's Wood that was suitable for turning into an art gallery and conveniently near his and Doris's private home. The gallery stands apart from the rest of the capital's art world, in a quiet, upmarket residential area several miles from the centre of London, located away from the concen-

tration of private art galleries in Cork Street near Piccadilly and Burlington House. Appropriately, in view of its later use as display space for paintings, the building had earlier functioned as a storage depot for industrial paint. It dated from the 1920s and was originally used as a motor-repair shop. Since the building was at ground level and was one storey, it was suitable for pedestrians, and – most important for a future gallery – it was well lit from the top: the lightweight roof was glazed and supported by thin, steel trusses.

Max Gordon (plus John MacKenzie of Max Gordon Associates) was the British architect chosen to convert it into a gallery. He was a friend of Charles and Doris and the latter had written about his American-style house in a 1983 issue of *The World of Interiors*. Gordon was also one of the Patrons of New Art at the Tate and the Arts Council's representative on the Whitechapel's board of trustees. It is widespread human habit to give commissions to friends, but in the late 1990s these mutually supportive links between influential people were criticised and called 'cronyism'.

Gordon was born in Cape Town, South Africa, in 1931 and trained at Oxford and then at the Architectural Association in London. Like Saatchi, he spent time in New York during the 1960s and he too developed a keen interest in contemporary art, becoming friends with many of the artists whose work the Saatchis were later to collect: Jennifer Bartlett, Brice Marden, Richard Serra and so on. The design work he undertook for the Saatchis received much publicity, helped to make him internationally famous, and brought him many commissions for the design of galleries and museums. After Gordon died in London in 1990, at the age of 59, Doris Saatchi wrote an affectionate appreciation for a national newspaper.[4]

Gordon did not have to make that many changes to the Boundary Road building. The floor level of the largest gallery was lowered by four feet to provide more height and the walls, with their uneven brickwork, piers and plumbing, were disguised by panels placed several feet in front of them, yielding a smooth, uninterrupted surface for hanging paintings. The hollow, corridor-like space left behind the panels could then be used for services and storage, and it allowed access to the rear of the panels for fixing purposes. Fluorescent tubes concealed in metal troughs laid along tie beams provided additional lighting, so that the light reaching the exhibits was indirect, even and shadow-free. The walls were painted semi-matt white and the cement floor covered in grey tennis-court paint.[5]

In one of most perceptive accounts of the building, the design historian Adrian Forty commented: 'This continuity of finish throughout is an important device in achieving the building's illusion of simplicity.'[6] But Forty also noted the architect's lack of consideration for disabled visitors (there are steps down to one gallery and no ramp) and argued that the layout of the building was analogous to that of a church. He also discussed the curiously ambiguous character of the gallery: a mixture of private and public. Even so, he concluded 'there is little doubt that this is the best gallery in Britain for contemporary American art'.

Clearly, the common aim of both patron and architect was to provide an unobtrusive setting that would show off the exhibits to best advantage. This was in accordance with the space considered ideal for displaying modern art, that is, an empty, white cube.

The building's space is now divided into seven galleries. There is also a reception area, office space, toilets, plant

room, workshop, storage space and a caretaker's flat. Since its total area is 30,000 square feet, the impression is one of generous amounts of space. Nothing impedes the visitor's gaze or movement because, unlike many public museums, there are no seats in the middle of the galleries. While there is no sculpture garden outside, there is a courtyard big enough to accommodate huge sculptures such as Charles Ray's *Firetruck* (1993) – a toy American firetruck enlarged to the size of a real one. (This work is no longer in the Saatchi Collection.)

Charles Ray, *Firetruck* (1993). Painted aluminium, fibreglass, plexiglass, 366 x 244 x 1417 cm.

responses to the gallery

A sense of mystery and anticipation is prompted by the fact that visitors

cannot see the gallery building from Boundary Road. What confronts the visitor is a discreet grey-coloured metal access gate plus a security camera, which is remotely controlled from the reception area. Once past the gate the gallery is reached via a short sloping L-shaped driveway (which reminded one visiting critic of a prison yard). These details are relevant because they indicate the low-key, reticent way in which Saatchi presented the gallery to the public when it opened during February and March 1985. At first there was little publicity – it looked as if Saatchi was relying on word of mouth, which can be an extremely effective means of advertising. As more information gradually became available, it seemed as though he was imitating one of those 'teaser' campaigns in which information is released slowly via a sequence of adverts.

Leading figures in the British art world praised the gallery's interior design and welcomed the significant increase in exhibition space devoted to contemporary art in London. Richard Cork thought it was 'a building where bold, simplified and forthright images stand out with the greatest conviction' and summed it up as 'one of the most compelling exhibition spaces in Britain'.[7] Brian Sewell considered the gallery's location to be South Kilburn rather than St John's Wood but he did express admiration for the exhibition space. However, his judgement of the contents of the first exhibition – American minimal and pop art – was extremely negative: 'rubbish ... Never have I seen anything so spiritually arid, so draining to the soul.'[8] Other critics, photographers and magazines in Europe and the United States helped the gallery to become internationally known via articles illustrated by shots of the interior.[9]

Initially members of the public were allowed entrance

only by appointment but then the gallery was thrown open on two afternoons a week. At first there was no entrance charge but at the time of writing there is a fee of £4. Within a few months of opening the gallery was attracting more than 600 visitors on Saturdays. A recent information leaflet issued by the gallery claims that since 1985 it has attracted over a million visitors and 750 school parties from Britain and overseas. As in public galleries, there are books, post-cards and other merchandise for sale and a number of talks are delivered about the exhibitions.

One role that the Saatchi Gallery has performed which perhaps the supercollector did not anticipate was to serve as a venue for parties and receptions. For example, on 19 June 1996 it was used to celebrate the first birthday of the adver-tising agency M&C Saatchi. More than 1000 guests attended including the Prime Minister John Major and sev-eral members of the cabinet. All the partners of the new agency were there except, of course, for Charles Saatchi who was nowhere to be seen.

display conventions

Kenneth Baker, an American writer, recalls that when he first entered the Saatchi Gallery he felt as if he had 'stepped out of England into some denationalised zone of the Intercontin-ental Art World, where art-in-itself is fully manifest and all else is mere distraction'.[10] His reaction was due to the man-ner in which exhibits were shown – in isolation with lots of distance between them – in galleries 'purged of nonesthetic information'. This manner conformed to the standard dis-play conventions of museums of modern art. (In contrast, in the Paris Salon exhibitions of the nineteenth century, pic-tures were crowded together so that the whole wall was cov-

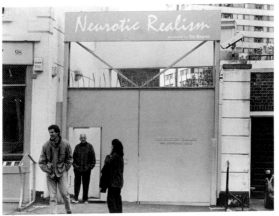

Entrance gate to the Saatchi Gallery at the time of the first 'Neurotic Realism' exhibition (Michael-Ann Mullen).

ered with them.) Indeed, the sheer professionalism of the way art works were presented and exhibitions hung in the Saatchi Gallery put to shame many existing museums. Don Hawthorne reports that Saatchi – assisted by the collection's first curator Julia Ernst (who had previously worked at the Sperone Westwater Gallery in New York) – agonised for hours over the arrangement of the abstract, minimalist paintings by the American Brice Marden.[11] Hawthorne also noted Saatchi's preference for 'eye-level installation', that is, paintings were hung only a foot or so off the floor so that the entire canvas was brought within the spectator's reach.

Keeping art works far apart reduces the interplay between

them and their isolation tends to divorce them from any socio-historical context. (There are alternative, contextual ways of displaying art. For example, a pop painting from the 1960s could be presented as part of a room setting alongside consumer goods, furniture and posters from the same decade.) A second consequence is to prioritise the autonomy and aesthetic characteristics of the art objects and to reinforce the quasi-religious aura surrounding them that Walter Benjamin thought, in 1936, was going to be destroyed by photography and the mass media.[12]

There are certain artists – like Hans Haacke – who deliberately set out to challenge autonomy and aesthetic pleasure. And even in the Saatchi Collection there are certain works whose vulgarity of content is such that the effects of the display context cited above are reduced, such as Sarah Lucas' 1990 photocopy enlargements of *Sunday Sport* double-page spreads featuring images and stories about topless midgets and grotesquely fat women.

exhibitions and jamie wagg

Possession of a gallery also enabled a series of temporary exhibitions to be organised of work from the Saatchis' growing and changing collection and from other, external sources. This meant that the contents of the gallery did not become a fixed, static body of material that encouraged only a few visits. Some consider the absence of a display of permanent works – aside from one gallery-size installation – a drawback because a virtue of public museums is that one can return over and over again to view important works from the permanent collections. Some early reviewers used the term 'museum' but, arguably, the Saatchi Gallery is more like an institute of contemporary art than a museum because

of its succession of shows of new art. Art lovers were thus encouraged to visit the gallery over and over again, and the turnover of exhibitions meant that it and the name 'Saatchi' were constantly in the news. In short, the gallery became a publicity machine in its own right.

Jamie Wagg (b. 1958) is a British artist who became notorious for his computer-enhanced prints based on media images of the 1993 murder of the toddler James Bulger by two boys.[13] The media furore Wagg's prints provoked in 1994 may well have been the inspiration for Marcus Harvey's painting *Myra* (1995), owned by Saatchi, which aroused a similar outcry when it appeared in the 1997 'Sensation' show at the Royal Acad-

Jamie Wagg, proposal to Charles Saatchi for a portrait installation inside the Saatchi Gallery (1995).

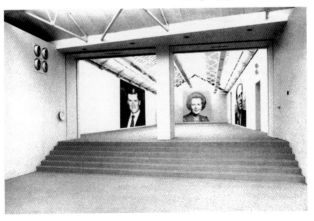

emy (see page 188). Wagg, a left-wing artist, is like Haacke, highly critical of the 'robber barons' of capitalism and their political allies. The addition of false walls in the re-design of the Boundary Road building prompted Wagg to submit an installation/site-specific proposal to Saatchi in 1995.[14]

Wagg proposed removing the wooden panels at intervals in order reveal large-scale portraits painted – in fresco for the sake of permanence – on the real walls of the building of major figures in politics, industry, education, and so on, of the previous 15 years. These included several senior members of the Conservative Party: Margaret Thatcher, Cecil Parkinson, Norman Tebbit and Lord Gowrie. After the portraits had been exhibited for a time, the panels would be replaced and the gallery would resume its normal appearance except that the portraits of the powerful who had assisted the brothers, and whom they themselves had served, would persist as a hidden presence. Wagg's kind offer was not taken up.

public/private

The Saatchi Gallery is a clear-cut instance of the shift from public to private support for the visual arts that occurred during the 1980s. It paralleled the Conservative Party's programme of privatising nationalised industries and utilities. British public galleries could not afford to buy the amount of contemporary art that Saatchi did, nor did they have the same amount of space to devote to it. There used to be a comment about British society which ran: 'private affluence, public squalor.' Certainly, in this case, private wealth cruelly exposed the limitations of public institutions.

When one man decides everything, democratic control and accountability diminishes and the arts become overde-

pendent on the whims of an individual. Furthermore, the continuity, availability and conservation associated with public museums cannot be relied upon in relation to private collections. Nevertheless, because Saatchi opens his gallery to the public it is a curiously hybrid phenomenon: partly private, partly public. Business critics of Maurice Saatchi used to accuse him of running a public company like a private one. In the case of the Saatchi Gallery, one might invert this comment and say that Charles Saatchi was running a private gallery like a public one.

catalogues and criticism

When the Saatchi Gallery opened, a four-volume catalogue in a boxed set was for sale at reception priced £80: *Art of Our Time: The Saatchi Collection* (1984). This catalogue was not limited to the exhibits in the opening show. In fact, it contained information and pictures of works by 51, mainly US artists. The publication was expensive because it made use of gloss paper and was lavishly illustrated in colour. The volumes were issued by respected art book publishers and contained essays written by noted art critics from Europe and the United States: Peter Schjeldahl, Robert Rosenblum, Rudi Fuchs, Hilton Kramer, Lynne Cooke, etc. These volumes established a formula for the future, witness Dan Cameron's NY *Art Now: The Saatchi Collection* (1987), Alistair Hicks's *New British Art in the Saatchi Collection* (1989), Sarah Kent's *Shark Infested Waters: The Saatchi Collection of British Art in the 90s* (1994), Brooks Adams's and Lisa Liebmann's *Young Americans 2: New American Art at the Saatchi Gallery* (1998), and Dick Price's *The New Neurotic Realism* (1998). In 1999 Booth-Clibborn Editions published a heavily-illustrated book costing £75 entitled

Young British Art: The Saatchi Decade. Saatchi himself selected the 800 works included while Dick Price wrote an introduction and the critic Richard Cork conducted interviews with the artists. This book seemed intended to redress the lack of a permanent collection by revealing, via imagery, the extent of Saatchi's holdings of young British art. In London's art bookshops the Saatchi volumes are privileged by being displayed on their own specially designed stands.

One of the most detailed and thoughtful responses to the first, four-volume catalogue was by J W Mahoney.[15] After summarising the contents of the catalogues – volume one: pop and minimalism; volume two: six artists whose work is characterised by mutilation; volume three: neo-expressionism; volume four: a miscellany of works by fashionable artists of the 1980s – Mahoney reached some surprising conclusions. First, the 'classical power' of minimalism was 'a powerful contrast to the world of advertising in which Charles Saatchi makes a living. It may well serve as a kind of escape-valve of certainty ... an antidote to a business that is all deceptive surfaces and facades that shift constantly according to public trends'. Second, the theme of mutilation signified 'a further revulsion against advertising'. Third, the neo-expressionist canvases spoke 'through the emptiness of their symbols, of the end of time-honoured values, the end of culture as we know it'.

When Mahoney considered the contents of the collection as a whole, he perceived a pessimism that was the antithesis of the optimism of advertising and consumerism: 'Death, decline and decay ... Culturally their collection is a dance of death ... a gentle surrender of art to kitsch and chaos in order to forestall the bitterness of high culture's irrelevance in a world without myths or lasting human values.'

Mahoney ended by saying:

> Doris and Charles have made history. They are the only collectors
> since the Rockefellers who have taken art seriously enough to
> dedicate their fortune to it, to use every resource at their disposal
> to discover or uncover a passionately felt cultural attitude ... For
> the consuming public, his [Charles'] advertising creates fantasies of
> order and good will: it legitimises conspicuous consumption. In his
> art collection, he steels himself against the possible onset of real
> chaos and despair by promoting an art based on personalised
> reactions to the 'death' of culture and the end of faith.[16]

Mahoney's analysis was ambitious and intriguing but surely
far-fetched, and when it was written there was no way of
knowing that the contents of the collection would alter con-
siderably in the future.

The catalogues were bought by many libraries and thus
spread the fame of the Saatchi Collection far and wide, but
they also reinforced the impression that it was a permanent
collection. As Saatchi sold more and more of the art works
featured in the catalogues, they became increasingly inaccu-
rate and out of date. To discover what has been deleted, a
researcher would have to compare a list of what is currently
in the collection with the published catalogues. The fact that
the contents of the collection have changed so much over the
years has prompted some writers to use the plural term 'col-
lections' and others to prefer the description 'dealer's stock'.

The critics who contributed essays about the various art
movements were paid to do so. They were cautious and
compliant, that is, they had nothing negative to say about
the art works and – with few exceptions – nothing to say
about the tastes or collecting habits of Charles and Doris

Saatchi. In other words, the majority of the critics were not self-reflexive. As Jon Bird confirmed:

> These essays are singularly unreflective in their descriptions and
> evaluations, addressing their selected objects with little or no
> reference to the syntagmatic relations of the collection as a whole,
> and falling between the connoisseurship of the auction catalogue
> and the interpretations of the exhibition essay.[17]

Although most artists despise and fear art critics, they also court them because they understand their vital importance in publicising and validating new art. (Many exhibitions mounted by private galleries attract only a few visitors and without catalogues and reviews it is as if they had never happened.) Both the Saatchis knew this too, which is why they commissioned the critics in the first place. Doris, given her record of publication, could have written the essays herself but clearly it was better for public relations that the critics were seen to be outsiders, 'independent' experts.

Sarah Kent, a British art critic, was highly critical of Alistair Hicks's text for the *New British Art* catalogue when it appeared in 1989. She accused Hicks, editor of *Antique* magazine, of superficial understanding, banal generalities and gobbledygook. Her attack was then extended to the man who had commissioned Hicks: 'Shame on Charles Saatchi for selling our artists short with shabby amateurism that trivialises the work and makes British criticism seem ridiculous.'[18] The supercollector did not hold this public chastisement against Kent. Indeed, five years later he commissioned her to write about the even newer British art he had added to his collection. Kent, an ex-painter, was happy to write a book for Saatchi because she has been an enthusi-

astic supporter of contemporary art for many years. She has claimed that her writings on young British artists were not censored in any way by him but that she overcame the problem of negative value judgements by avoiding discussing artists whose work she did not respect. Jenny Blyth, the second curator of the Saatchi Collection, observed that 'at least half as much again' was not covered by Kent.[19]

Shark Infested Waters (1994), the title of Kent's book, derived from one of Damien Hirst's most notorious works: a real but dead shark preserved in a glass tank containing a formaldehyde solution. Kent gave intellectual credence to each young British artist by drawing upon texts by leading theorists in the fields of literature and criticism. Saatchi's patronage was described as of 'incalculable value' in sustaining the 'energy and optimism' of artists who no longer had to struggle in a 'soul-destroying vacuum'.

Kent currently edits the arts pages of the London listings magazine *Time Out* and uses them to promote exhibitions of innovative art in little-known galleries. *Time Out* was also – along with the London auction house Christie's – a sponsor of the 1997 'Sensation' show of work from the Saatchi Collection held at the Royal Academy and the magazine issued a special supplement all about Saatchi and his collection. *Time Out,* then, had a stake in the success of the exhibition and Kent, as one the magazine's employees, was hardly a disinterested commentator on 'Sensation'.

programme of exhibitions

For detailed descriptions of all the exhibitions mounted at the Saatchi Gallery, readers can consult the various catalogues that have been published, and a chronological list of the 29 shows held between 1985 and 1998 can be found in

The New Neurotic Realism. What the exhibitions chart, of course, is the changing character of the Saatchi Collection as its owner's interests altered and he responded to wave after wave of new art. They are also indications of his ability as a curator of exhibitions, though he employs a full-time professional curator – typically female – to assist him.

Most of the exhibitions were group shows unified by stylistic or nationalistic themes. For example, the first exhibition featured works by Judd, Marden, Twombly and Warhol. These four artists were all American and the main art movements their works exemplified were minimal and pop art. At first sight, these movements may appear to have nothing in common but simplicity and repetition are two shared elements. In 1985 the Saatchi Collection boasted 15 Warhols while the Tate Gallery owned two. Isolated on a wall in a far gallery was displayed a giant, silk-screened portrait of Chairman Mao Zedong, part of a series Warhol produced in 1972–73. At least one reviewer was struck by the strangeness of the appearance of this icon of a great communist leader, painted by the Western advocate of ' business art', in the gallery of a British advertising tycoon.[20] Capitalism, the message seemed to be, could appropriate and recuperate its opposite. An analysis of both social systems' propaganda revealed similarities, such as the cult of personality conveyed by mass-media images.

The second exhibition was again devoted principally to minimalism and the artists were again all American. In the third show the German figurative painter Anselm Kiefer was contrasted with the American abstract sculptor Richard Serra. Kiefer was an indication of the Saatchis' holdings of neo-expressionist paintings (Georg Baselitz was another

example) and, of course, the similar work of Schnabel had been displayed at the Tate Gallery in 1982.

Between September 1987 and April 1988 a two-part exhibition entitled 'New York Art Now' introduced Londoners to the recent American tendency called 'neo-geo' or 'simulationism', that is, the work of Jeff Koons, Ashley Bickerton, Robert Gober, Peter Halley, Haim Steinbach, *et al*. Koons, a brash individual who even devised and starred in his own adverts, who had previously worked as a salesman and whose art celebrated American kitsch, was naturally a particular favourite of Charles Saatchi. These shows were important in terms of their impact on young British art students such as Hirst.

In 1989 and 1990 the gallery began to show work by British artists, namely the figurative painters Frank Auerbach, Lucian Freud and Leon Kossoff (who were all deemed to be members of the 'school of London'), and the sculptors Richard Deacon and Bill Woodrow. (Woodrow represented a new, *bricolage* type of sculpture that was proving internationally successful and was associated with the Lisson Gallery's stable of artists. Saatchi, of course, had been familiar with the Lisson for some years.)

This signalled a (temporary) shift away from American art towards British art which may have been due in part to Peter Fuller's proselytising of this country's native traditions plus R B Kitaj's and Robert Hughes' praise for the school of London painters. (Saatchi had to pay much more than usual to acquire the Freuds because this respected and established realist works slowly and has a queue of collectors waiting for new paintings which, at the time of writing, are the most expensive by any living British artist.) Compared to the neo-expressionists, they were more au-

thentic and skilful in terms of their painterly techniques. Also, their painting was of high aesthetic quality but it was hardly radical or avant-garde. As one reporter noted, it looked as if Saatchi had, for the moment, become a follower rather than a leader of taste.

Then, in 1992, the first of a series of exhibitions was mounted devoted to young British art (this was the origin of the acronym 'yBa'). According to Simon Ford, the shows 'cemented the label and defined the movement's parameters. It was possibly the first movement to be created by a collector'.[21] The yBa shows helped artists such as Simon Callery, Damien Hirst, Sarah Lucas, Marc Quinn, Jenny Saville, Rachel Whiteread and Mark Wallinger to become famous and they indicated that Saatchi's commitment to British art had become even stronger.

'Young British Artists VI' (1996) featured works by Jordan Baseman, Daniel Coombs, Claude Heath, John Isaacs and Nina Saunders, all virtually unknown and not yet signed up with any dealers. We assume Saatchi acquired the works direct from the artists' studios – also commissioning new works – and relied on his own aesthetic judgement. Of course, he may also have depended on the recommendations of other, more senior artists or the individuals one journalist referred to as his 'sniffer dogs'. (The 'dogs' in question have denied this.) By cutting out the middleman – the dealer – Saatchi could obtain works of art even more cheaply than before.

His continued interest in developments in German art was manifest by the the one-man show he gave to the sculptor Stephen Balkenhol (1996) and the survey show 'Young German Artists II' (1997). The shows of German art did not mean, however, that Saatchi's attachment to American art

had faltered, witness the shows 'American Art in the Twen-
tieth Century' (1993), 'Young Americans I and II' (1996/98),
and the one-man exhibitions devoted to the sculptor Duane
Hanson (1997) and the painter Alex Katz (1998). In 1997
Saatchi had bought a collection of 26 Katzs covering 25
years of his career from the Marlborough Galleries in New
York. Although Katz (b. New York, 1927) was an older,
established artist, Saatchi thought he was underrated; his
work was certainly little known in Britain before the Saatchi
Gallery display.

'American Art in the Twentieth Century' was unusual in
that it was an extension of a blockbuster exhibition of paint-
ings and sculptures from the US covering the period 1913–93
held at the Royal Academy of Arts. (A bus ferried visitors
between the two venues.) On display at Boundary Road
were works produced after 1970 by such artists as Jean-
Michel Basquiat, Jonathan Borofsky, Philip Guston, Dan
Graham, Keith Haring, Koons, Schnabel and Sherman. A
stringent critique of the whole exhibition was written by
Professor Francis Frascina of Keele University who objected
to its omissions, historical inadequacy and the way in which
it 'whitewashed' American culture.[22] The co-operation
between Saatchi and Norman Rosenthal of the RA was to be
repeated to even greater effect four years later.

'Young Americans I' (1996) featured works by Janine
Antoni, Gregory Green, Sean Landers, Charles Long,
Charles Ray and Kiki Smith. Antoni attracted press cover-
age with sculptures made from chocolate, lard and soap
which she had shaped by licking with her tongue and gnaw-
ing with her teeth. Smith's life-size bronze figure of the Vir-
gin Mary astonished viewers because she was represented
naked with all her veins showing. Green too attracted head-

lines with a mixed-media and morally suspect installation entitled *Work Station No. 5 (London)* (1994) which simulated the workshop of a terrorist bomb-maker.[23] *Mega Magnum*, another work by Green – a guided missile complete except for explosives – which Saatchi acquired sometime later, disturbed local residents when it was mounted pointing skywards on the roof of the gallery.[24]

Sometimes the gallery mounts shows of non-Saatchi material which it refers to as 'guest' exhibitions. One example was 'Out of Africa' (1992) which featured items from the Jean Pigozzi collection of contemporary African art based in Lausanne, Paris and New York. Pigozzi was inspired to found a collection of Third World art after visiting the exhibition 'Magiciens de la Terre' (Paris, Pompidou Centre, 1989). André Magnin, one of the show's curators, agreed to help him and then spent two years travelling around Africa acquiring examples. Pigozzi also collects photos by Arthur Weegee and paintings by Basquiat, Clemente and Schnabel. Pigozzi comes from a rich family and is a friend, games partner and business associate of Saatchi. He is also a fashionable photographer of dogs, artists and other celebrities. A snap he took of Saatchi with seafood in Nice in 1988 appears in Pigozzi's book *A Short Visit to Planet Earth* (1991); the photo's title is *Wild dead lobster attacking Charles Saatchi*.

The Saatchi Gallery has also occasionally mounted exhibitions of non-fine-art material. For instance, in September 1994 a photographic show was presented in association with *Vogue* magazine. Of course, there are some artists collected by Saatchi who employ photography as a medium: Richard Billingham, Mat Collishaw, Sarah Jones, Tom Hunter, Paul Smith, Hannah Starkey, Sam Taylor-Wood and

Cindy Sherman, for example.

Even advertising once made an appearance: in July 1995 the show 'British Design and Art Direction 1995 Festival of Excellence' was organised with Design and Art Direction (D&AD) which gives annual awards for the best graphics, photographs and commercials. (For some reason this show is omitted from the listings of Saatchi Gallery exhibitions printed in recent catalogues.) To advertise this exhibition a poster/press advert was created by Nick Welch and Billy Mawhinney of S P Lintas that parodied Hirst's *Away from the Flock* (1994), a dead lamb floating in a glass tank filled with formaldehyde, which is in the Saatchi Collection. The advert depicted a lamb inside a tank of Boddington's beer and used a similar strapline to that used to promote the drink: 'The cream of British Design & Advertising.' Hirst and his dealer Jay Jopling were upset by this breach of copyright and threatened to sue D&AD. An out-of-court settlement was reached and the adverts were withdrawn or blacked out. This legalistic response by a contemporary artist to an instance of plagiarism (or homage) was rich given the number of times fine artists have borrowed imagery from the mass media without obtaining permission or paying for the privilege.

The press coverage of this show was also hijacked by Tony Kaye, the advertising-film director who wishes to enjoy the status of a fine artist, when he offered Roger Powell, a tramp in his fifties, for sale as 'a living work of art' priced £1000. Kaye subsequently paid Roger a wage to visit public galleries like the Tate to remind visitors of the plight of homeless people.

wilson's installation

One art work which has been on view in the Saatchi Gallery since 1991 is Richard Wilson's *20:50* (1987). This impressive work by a British sculptor occupies a whole gallery and is an example of 'installation art', a trend increasingly fashionable in recent decades. It consists of a wood and steel structure which reaches half-way up the gallery upon which a pool of black sump oil (2500 gallons of used engine oil) rests at chest height – the visitor is able to walk into the centre of the piece via a narrow, tapering walkway. The still, level surface of the oil acts like a mirror so that the roof skylight and metal girders are reflected in it. As Sarah Kent has noted, viewers may experience vertigo due to the illusionistic effect of being suspended in space with the ceiling reflected far beneath one's feet.[25] Kent has justly cited its spectacular appeal and ravishing beauty. Of course, visitors are tempted to dip their fingers in the viscous liquid and so the sense of touch is stimulated as well as the sense of sight, as is the sense of smell because the oil has a pungent odour.

20:50 was first presented at Matt's Gallery in east London, a space which specialised in installation and/or site-specific art. Robin Klassnik, the gallery's founder and director, encouraged artists to make one-off pieces that were responses to the interior space and physical structure of the gallery. At first it seemed that such art works would resist commodification and portability but the fact that Saatchi bought and moved *20:50* demonstrated that this was a premature assumption.

Richard Wilson, *20:50* (1987).
Used sump oil and steel,
dimensions variable. Installation
in Saatchi Gallery, since 1991
(Anthony Oliver).

6
art as investment, sales and gifts

Kunst = Kapital.
Joseph Beuys, 1979.

In the last three decades the size and activity of the art market, especially that of New York, has increased dramatically, due to a growing, better-educated audience for contemporary art and rising living standards that have enabled more and more people to afford works of art. The wealthy have also recognised that speculating in art can be highly rewarding and a hedge against the inflation which would otherwise gradually erode the value of their savings. According to Nicholas Faith,

> from 1971 to 1984 [a period when Charles and Doris Saatchi were building their collection] investments in art were more than twice as profitable as investments in corporate shares in both the United States and Britain. They also kept ahead of inflation by almost a two-to-one margin.[1]

Of course, prices in the art market can fall as well as rise. One such collapse occurred during 1990–91 and since then prices have struggled to regain their 1980s' levels. However, a 1998 report based on the *Daily Telegraph* Art Index, compiled by Art Market Research, claims that in the year July 1997 to July 1998 contemporary paintings increased in value by 26.9 per cent and modern American paintings by 30 per cent.[2]

To many ordinary people the operations of the art market are a mystery. How is it that in the long term prices keep going up and up, and fantastic sums are paid for canvases by modern masters such as Van Gogh and Picasso? In essence what happens is that a powerful and wealthy elite, following the lead of a small number of tastemakers,[3] 'agree' to pay higher and higher prices for certain works of art because so long as the bubble inflates and never bursts or deflates (as it does sometimes), then they all benefit. We are not postulating a consciously planned conspiracy amongst the buyers and sellers, but a pattern of behaviour based on common instincts and interests. Furthermore, wealthy people of middle- or upper-class origin generally have a much better understanding of business, finance, markets, stocks and shares, and investments than those at the bottom of the social scale.

As Gordon Gekko, the ruthless stock-market trader and art collector, explained to his novice Bud Fox, played by Charlie Sheen, in Oliver Stone's movie *Wall Street* (1987):

> It's all about bucks kid, the rest is conversation ... Money itself isn't lost or made, it is simply transferred from one perception to another. [He points to a Joan Miró painting on the wall of his skyscraper office.] This painting here, I bought it ten years ago for $60,000. I could sell it today for $600,000. The illusion has become real and the more real it becomes, the more desperate they want it – capitalism at its finest ... the richest one per cent owns half our country's wealth: five trillion dollars ... [he gestures out of the window] you've got 90 per cent of the American public out there with little or no net worth. I create nothing, I own. We make the rules pal, the news, war, peace ... we picked the rabbit out of the hat while everyone out there wonders how the hell we did it.

You're not naïve enough to think we live in democracy are you buddy? It's the free market …[4]

In this scene, therefore, art is cited as the quintessential commodity, the ultimate exemplar of the wonders of the capitalist system.

commodification

A commodity was defined by Marx – following a distinction made by Aristotle – as a product of human labour that simultaneously had use-value and exchange-value. Markets develop when people produce more food and goods than they need for their personal use and they then offer their surpluses to others. Transportable art works such as marble and bronze statues were bought and sold or exchanged in ancient Rome: the history of the commodification of art is a long one, though the modern market in paintings as portable commodities is generally dated from seventeenth-century Holland which had an affluent bourgeois class. The contemporary art system involving artists making works 'on spec' and then being dependent on a whole marketing/distribution apparatus – dealers, gallery and museum shows, critics/the art press, and private/state collectors – was established during the nineteenth century in countries such as France and Britain.

Since the price for a painting can rise and fall as time passes, the painting's use or aesthetic value cannot be reduced to its exchange-value (unless we assume its aesthetic value changes in tandem). Nevertheless, there can be a correlation between use- and exchange-values: a consensus is often reached within the art world that paintings by Van Gogh, Matisse, Picasso, Pollock, etc., are of high aesthetic

surely be more than offset by the profits gained from selling Freuds, Hirsts, Warhols, Whitereads ...

Saatchi has also pointed out that any increase in monetary value is a mixed blessing: 'On the one hand, it's confirming to see an artist's work appreciate, but the very rise in prices makes it more difficult to go on collecting.'[13] This explains why it is sensible, from his point of view, to seek out, again and again, new art made by young, unknown artists.

Jane Addams Allen has characterised Saatchi as a 'supercollector'. Such beings, she claims, 'can make prices jump just by looking at works of art'.[14] Peter Ludwig, a German equivalent, once complained that he had only to walk into a gallery for prices to double. The ability of supercollectors to drive up prices causes problems for public museums with more limited funds because it makes it harder for them to purchase works for their collections. They then become more dependent on private collectors for gifts and loans. The danger here is that the contents of national museums may be determined by the particular tastes of the supercollectors rather than by the selections of professional curators who, we believe, are more disinterested and more accountable to the public than dealers and private collectors.

'dispersals'

Information about Saatchi's habit of selling off items from his collection – also described by such euphemisms as 'deaccessioning, dispersal, pruning, purging, rationalising, rebasing, refining and slimming down', also used when sacking staff – is patchy and derives from scattered statements in magazines, newspapers, company reports and auction catalogues. Here is a chronology:

interested in commodification are buying art commodities made to suit those people whose interests lie in commodification. It's a really unbelievable cycle.'[11]

Saatchi is not only interested in the exchange-value of art but he has certainly taken advantage of the increasing commodification of art associated with the boom periods of the art market during the 1980s and 1990s. Genuine art-lovers who cannot afford to dabble in the art market, and who rely mainly on public museums to gain access to art, cannot help distrusting the motives and protestations of dealers and collectors because they have a commercial interest in the art they acquire and promote, and often dispose of the art they profess has such aesthetic and emotional value for them.

art as investment

To many observers it seems obvious that Saatchi buys art for investment purposes and uses the whole apparatus of gallery, loans, exhibitions and catalogues to increase the status and value of his holdings. One, anonymous writer in *Art Review* remarked in February 1999 that 'all the evidence points to him being a commodity trader in art futures'. The fact that he has sold many works of art for significant markups appears to confirm this view. But, as one might expect, Saatchi denies it. In 1992 he told Dalya Alberge: 'My art collecting has nothing to do with price … If I was buying for investment, I would be doing it very differently. A lot of the work I buy isn't saleable.'[12] There is a logical contradiction in the last sentence: if Saatchi has bought a work of art, then it has proved to be saleable at least once. Much of what he has bought might not make a profit if offered for resale – and he has made losses in some sales – but losses would

buy a name and a date – artist such-and-such in his such-and-such period.'[7] The British dealer Bernard Jacobson, Saatchi's friend, also told one reporter that clients would ring up, ask what Saatchi was buying, and then order one for themselves.[8] What the so-called 'trend collectors' – those who buy with their ears not with their eyes – did not appreciate was that Saatchi had probably already snapped up all the best works by the artists they were suddenly interested in.[9]

In an article written in 1989, Peter Fuller compared Saatchi to the trend collectors and those who used investment funds in excess of £1 billion to trade in art:

> These days multi-million dollar purchases of art are made week in and week out, by buyers acting without any aesthetic motivation whatsoever; indeed, such is the philistinism of many of them that they make Saatchi look like a genuine eighteenth-century *amateur* of art. Or, to put this another way, Saatchi was without doubt a 'pioneer' of the new-styled operator who is replacing the old-styled collector, who possessed taste, passion and genuine discrimination for the works he acquired. But, like many pioneers, especially in the field of taste, he still has something of the old-school about him. He is effectively being displaced by a new breed of faceless corporate art buyers and know-nothing gold-diggers and fashion freaks; for them, expertise, scholarship, what used to be called in that quaint phrase 'art appreciation' (except that is of a purely monetary kind), even that pumped out by the hacks and hicks of this world, is quite simply irrelevant.[10]

Phyllis Kind, an American dealer, complained about auction houses because they deal in 'one-shot commodities' and then added: 'It becomes more and more offensive that people

value and this value is then reflected in the high prices they fetch in auctions. Variations in price for paintings by the same artist can also be explained by the fact that there are qualitative and size differences between them.

Once artists become aware of the power of the art market, they respond in various ways: they may decide to ignore it (making art regardless of whether or not it will sell), or to tailor their work to prevailing tastes, or to make art that attempts to resist commodification (or which offers a critique of it), or to abandon the realm of art altogether (as John Heartfield, the German photomontagist, did).[5]

trend collectors

Collectors may acquire works of art for their aesthetic character or their investment potential, or both, as in the case of Saatchi. If the investment motive takes precedence, then the art work is treated purely as a saleable item capable of generating a profit. When news of high prices fetched by contemporary art spreads, people who have little or no interest in art as such are attracted to the art market. As Joseph Alsop has remarked:

> ... there are more and more art collectors today who merely look upon works of art as a better investment than, say, pork-belly futures. In every major city of the West you can find totally uninteresting rich men and women who have cold-bloodedly used art collecting for no purpose except to make themselves interesting places in the world.[6]

In 1988 Holly Solomon, a New York art dealer, stated: 'Certain contemporary works are traded on the phone, without anyone actually seeing what they're buying. They

1978	Brogan Developers sells artworks to the value of £370,319.
1985	exchange of six of Sandro Chia's paintings for others by different artists.
1988	11 Kiefers sold to a Japanese collector for an estimated £8 million.
1989–90	Between 70 and 100 works sold including 17 by the German artist Sigmar Polke and ten Anselm Kiefers. A Kiefer painting, *Meistersinger* (1981), which Doris Saatchi had bought for $65,000 in 1982, was sold for $1 million. A Cy Twombly painting was sold for $3.5 million.
1991	70 works sold for £10 million. Some of Julian Schnabel's paintings were sold and 11 by the British abstract painter Sean Scully bought for $250,000 were sold to the Swedish dealer Bo Alveryydd for $4 million. In New York 32 items sold in November for $8 million included works by Philip Guston, Howard Hodgkin, R B Kitaj, Leon Kossoff, Brice Marden, Bruce Nauman, Richard Serra and Cy Twombly. Saatchi & Saatchi PLC sold art from the corporate collection to the value of £1.6 million to reduce their annual loss of £32 million.
1992	Saatchi & Saatchi PLC sold art to the value of £1.8 million. Sales took place at Sotheby's (although the name of the seller was not printed in the catalogue). Warhol's *Marilyn X 100*, bought in 1984 for an estimated $850,000, fetched $3.74 million, Lichtenstein's *Girl with Piano* fetched $1.6 million, Malcolm Morley's *S S Amsterdam* (1966) was bought by Jeffrey Deitch for $440,000. In New York during May two Schnabels from the Saatchi Collection were sold for $319,000 each. Charles Saatchi gave nine works valued at £100,000 to the Tate Gallery.
1993	Spring sale in New York. Carl Andre's *Equivalent VI*, (1969) was offered for sale at estimated value of $3–350,000 but failed to sell. However, after the auction it

was sold for $198,000 (£130,000). Losses occurred too: Richard Artschwager's *Chair* (1963) was sold for £160,000 but reputedly it had cost Saatchi £203,000 in 1990. Richard Tuttle's *Green Triptych* (1965) was sold for $96,000 but it had been bought for £121,000 in 1990.

1995 Turner prizewinner Grenville Davey's *Red Giant* (1988) sculpture sold at Christie's for £6800. Several works owned by Saatchi failed to sell or were sold below estimate. Saatchi & Saatchi PLC was renamed Cordiant. Company reports show a £2.5 million profit due to art sales from the corporate collection. Frank Auerbach's *Summer Building Site* (1952) was sold for £89,500.

1997 Saatchi sold Lucian Freuds to Joseph Lewis (holding company Abel Inc.), Britain's wealthiest tax exile, reputed to be worth £1–2 billion. Lewis lives in the Bahamas, breeds horses and collects modern art. At Christie's in London paintings by Frank Auerbach and Patrick Caulfield and sculptures by Richard Wentworth were sold by Cordiant. In the same sale Saatchi himself sold paintings by Cameron Galt and Lisa Milroy.

1998 Various works thought to be from the Saatchi Collection were sold at Christie's, London, in April within or beyond their estimated values. A second Christie's auction in December yielded £1.6 million (see page 172).

It seems likely, then, that sales from the corporate collection were prompted by the period of economic crisis of the Saatchi & Saatchi holding company. At other times Saatchi unloaded works in which he had lost interest so that he could buy into new movements and acquire the work of selected older artists such as de Kooning, Freud, Johns, Lichtenstein, Magritte, Rauschenberg and Stella.[15] As he

told Alberge, 'the collection has to be self-financing. Otherwise it would be a bottomless pit'.[16] Further reasons were adduced by Roger Bevan:

> his divorce from Doris and the financial obligations which it entailed; and the sheer enjoyment of trade itself, the final link in the chain of discovery, negotiation and ownership. 'Charles is a commercial creature', explains London dealer Victoria Miro. 'It does not detract from his passion for looking at art, but he is not searching for a religious experience. He is aware of the marketability of art. Other collectors want to hide that side of their activity.'[17]

angry artists

Artists whose finances and reputations had benefited during the 1970s and early 1980s from the patronage of Charles and Doris Saatchi had been under the impression that their works had entered a permanent collection, though of course Charles had made no promise that he would never sell them. News of his sales prompted some angry reactions. There was a feeling that a betrayal of trust had occurred. Sean Scully accused Saatchi of being a 'superdealer' rather than a collector and claimed he had broken a promise that one day Scully's abstract paintings would be bequeathed to the Tate Gallery. Scully remarked:

> I thought Saatchi had good intentions. Now it turns out he's only a superdealer. These guys create price levels for themselves. They put one painting in a sale and bid it up to huge levels. And the artist loses control of his work, while his relations with the dealer he has worked with so long go for nothing, absolutely nothing. We are just pawns.[18]

Regarding the negative impact on artist/dealer relationships, Robert Hughes pointed out that 'new traders can move in and, by buying blocks from Saatchi, bypass the artists' dealers and force prices up out of all proportion to those of their new work'.[19]

Schnabel also expressed disappointment, especially at the sale of key early works like *Accatone*. Such actions did not, in his view, constitute 'pruning' a collection. If this was pruning, he remarked sardonically during a televised interview, then Saatchi was doing it while wearing a blindfold. The four-volume *Art of Our Time*, Schnabel added, had turned out to be 'a mail-order catalogue'.

Sandro Chia was perhaps the most aggrieved artist and he made his objections public in a letter to *Art News*. Compared to Count Giuseppe Panza di Biumo, a noted Italian collector who in Chia's view had assembled a collection of integrity and coherence:

> Mr Saatchi buys paintings by quantity, with the possibility of promoting his 'product' with his advertising acumen, thereby creating areas of influence and private interest, tantamount to manipulation. The result is a heretofore unparalleled joining of advertising and art values.[20]

He went on to complain about Saatchi's disposal of six of his paintings and for giving the public the impression that this was done as a 'purge' of the collection rather than to obtain money. Chia claimed he had asked to buy the paintings back and when this request was refused he had fired off a telegram to Saatchi telling him he was 'not a positive influence in the art world'. The supercollector did not reply to these criticisms but his curator Julia Ernst did in a letter pub-

lished below Chia's. She maintained that Chia's request had arrived too late and that his paintings had in fact been exchanged, via Chia's dealers, 'for works by other artists more strongly represented in the collection', hence they had not been sold on the open market 'for the best possible profit'. In her opinion, care had been taken to avoid offending Chia and publicising the 'dispersals'.

According to the painter, the impact of news of the 'dispersals' upon his career was dramatic: 'At that moment I understood the power of the guy. I thought I might as well go and paint in Alaska. My telephone was ringing constantly and from that moment no one was ringing any more. It was unbelievable …'[21] Art magazines ceased to publish reviews of his exhibitions and dealers ran away 'like cockroaches when the lights go on'.[22] It appeared that Saatchi had the power to damage artists as well as make them. Five years later Chia declared that he had survived without a dealer and was making a good living due to the support of loyal patrons.[23] In his case, any damage seems not to have been permanent.

testing the supercollector's temper

The art critic Matthew Collings has recalled that when criticisms of Saatchi surfaced in the press because of his 'dispersals', the supercollector was furious. Indeed, Saatchi thought he deserved praise not blame for the good he had done and for buying Freud's paintings. Speaking on the telephone to Collings, he threatened to close the Saatchi Gallery and behave like most millionaires, that is, 'buy a yacht and be selfish'.[24]

Saatchi's temper was tested again in March 1990 when BBC2's arts review programme *The Late Show* produced

an illuminating Saatchi special consisting of two filmed reports. The first concerned the history of the advertising empire and its current financial problems, while the second considered the history of the art collection. The beginning of the first film – reporter Tim Kirby, director Martin Davidson – was highly effective and amusing because of the way in which it imitated the visual and sound style of the *March of Time* American newsreels of the 1930s and Orson Welles's famous movie *Citizen Kane* (1941), about a megalomaniac press tycoon and voracious collector of art objects.

The second film, directed by Peter Lydon, had a more conventional style, similar to most television arts documentaries. The researcher/presenter was Collings whose career as a critic had begun on *Artscribe* magazine. A wide range of artists, collectors, curators and dealers – though not Saatchi himself – were interviewed in London and New York and they both praised and criticised his buying and selling habits. In Collings's book *Blimey!* (1997), a survey of London's art scene, he describes Saatchi as 'A hedonist millionaire suntanned designer groovy guy' and recalls that Saatchi had been encouraging and supportive towards him until the television programme was screened, 'After which he never spoke to me again.'[25] Nevertheless, in 1998 Saatchi bought, from 'The Whitechapel Open' exhibition, a portrait head of a smiling Collings entitled *Matthew* painted in acrylic in a 1970s' photorealist manner by Jason Brooks (b. 1968, Rotherham, MA Fine Art, Chelsea 1992) for inclusion in a future show. A detail of it is reproduced in *The New Neurotic Realism* book.[26]

the secondary market

J A Allen has explained:

> Implicit in the gallery business is a turnover, not just from new
> exhibitions [the primary market] but also from secondary sales
> and resales ... consummated in a gallery's back room ... Dealers'
> fees on secondary sales typically run about 20 per cent, and in
> many galleries these fees account for 50 per cent to 75 per cent
> of total income. [27]

Auction houses, even more than dealers, are concerned with
resales so they too are part of the secondary market. Dealers
and auction houses are closely related and have interests in
common but there can also be tensions between them.[28]
Prices fetched in auction sales seem to be more objective
than those set by artists or dealers because they are out in
the open and the result of the free play of the market, that is,
collectors and dealers competing against one another. Any-
one familiar with the practices of auction houses – pretend-
ing, for example, that a work of art has been bid for and
sold during a sale (so-called bidding off the wall, ceiling, or
chandelier), lending money so that buyers can afford exces-
sive prices when the auction houses are supposed to be act-
ing for sellers rather than buyers – plus the ability of rings of
dealers to fix prices, knows that the market is not nearly as
'free' and 'transparent' as it appears.

Saatchi at first used an American friend and advisor called
Larry Gagosian to handle sales in New York which offended
some artists and their dealers because Gagosian was 'a sec-
ondary market or resale dealer', who did not deal directly
with artists. (Artists and their regular dealers thought that if
Saatchi was reselling, they deserved first refusal.) Like

Charles, Los Angeles-born-and-bred Gagosian is a self-made man, an art collector and a fan of fast, expensive cars. Now he operates contemporary art galleries in New York. In the late 1980s, Gagosian organised an exhibition of Jasper Johns' map paintings, none of which were for sale, in order to impress the art world and potential clients.

Peter Watson, an expert on the art trade, comments: 'That Saatchi should sell via a dealer was not surprising; he wanted secrecy and at first he got it. The art world was thick with rumours for months about his "de-accessioning" before it was finally confirmed. What was more surprising was that he should sell to a relatively new dealer, Larry Gagosian.'[29] Writing in 1991, at a time of recession in the American art market, the British reporter and sale-room correspondent Geraldine Norman described Gagosian as follows:

Larry Gagosian, 1988 (Ivan Dalla Tana).

... a brash Californian dealer who has settled in New York. He climbed to fame by selling paintings which were not on the market; the technique was to enthuse a billionaire client with the colour illustration of a painting in a book, then ring up its owners so often, with increasing offers, that they would finally give way and sell. [This method of 'cold-calling' was one Maurice Saatchi used effectively in the 1970s when he was seeking agencies to buy.] Mr Gagosian, or 'Go-Go' as he is known in New York, is looked upon as the heir apparent to Mr Castelli's business. Mr Gagosian's style has also made him the boon companion and advisor of Charles

Saatchi. In the boom years [1988–90], Mr Saatchi used to sell off the art he tired of through Mr Gagosian – a strategy that caused anger from artists and dealers who had been nursing their reputations. Now the market is so thin Mr Gagosian cannot find buyers for Mr Saatchi's pictures, so they are being sold in bulk at Sotheby's [the New York branch] instead. Mr Saatchi has apparently decided the post-war names of American art, notably Johns, Rauschenberg and Lichtenstein, are going cheap, and he is ditching more recent art to buy them. According to *The New York Times*, Mr Gagosian is in debt to Sotheby's, while Mr Saatchi owes Gagosian; so Mr Saatchi's art gets sold at Sotheby's to help pay off Mr Gagosian's debts.[30]

As an example of Saatchi's purchase of works by older American artists, he paid $7.2 million for Rauschenberg's *Rebus* (1955) in May 1991. The winning bid was made on the telephone anonymously (but via Gagosian who, mysteriously, was seated in the saleroom at the time.)[31] If *Rebus* was really bought to consolidate the Saatchi Collection, why was it sold again less that a year later to François Pinault of the Artemis Investment Group? Pinault (b. 1936), France's richest man, is a ruthless businessman and collector of modern art, who purchased Christie's International auction house for £721 million in 1998. Perhaps the Rauschenberg purchase and sale had more to do with Saatchi's complicated financial arrangements with Gagosian and Sotheby's.

Artists were not the only ones who were upset by Saatchi's sales, especially those of 1992. Art dealers considered that Britain's loss of paintings by Warhol was a national tragedy and they feared that the sales would unsettle other collectors, cause a fall in prices, and even destablise the market.[32] Saatchi's defenders – like his friend and fellow collector

Janet Green (now known as Janet Wolfson de Botton)[33] – have argued that private collectors have a perfect right to dispose of their property as they see fit, that historically most collectors have sold as well as bought work, and that, consequently, there was nothing strange or unethical about his actions.

What was unusual in this instance surely was the scale of Saatchi's operations: he bought and sold in such high quantities that collecting was bound to become blurred with dealing, and the power he exercised over the careers of living artists seemed to be excessive. The artists who had so happily and uncritically accepted his largesse when times were good did not deserve or receive much sympathy when Saatchi turned against them. Furthermore, a substantial body of opinion in the art world held that the work of artists such as Chia, Clemente and Schnabel was extremely poor and that their inflated reputations deserved to be punctured.

impact on the art market

Besides Saatchi's impact on the careers of individual artists, what also needs to be considered is the impact of his trading on the art market in general because, as Moulin noted in 1967: 'Major collectors may not be in the majority among art buyers, but it is their tastes, financial resources, and rate of acquisition that set the tone for the art market as a whole.'[34] In a 1997 article Patricia Bickers, the editor of *Art Monthly*, also addressed this issue and remarked: 'When a collector is also a dealer, his ability to manipulate the market, as Saatchi has shown, is potentially greater than that of a mere dealer.' After mentioning previous British collectors, she commented:

It is only in the case of Charles Saatchi that one collector's personal 'take' on the art of his day has come for many to stand for a whole period, the gold standard against which all contemporary practice is to be judged. Saatchi's dominance does not merely support, but possibly distorts, the nascent market both here and abroad for contemporary art from Britain but, much more importantly, it suggests a consensus about the relative significance of the work he collects. Worse, despite the apparent variety of work in the collection, it in fact subsumes the real diversity of contemporary art practice into a false homogeneity. [35]

According to Bickers, Saatchi was not entirely to blame for this situation because there had also been failures by other art-world powers such as public museums.

Brian Sewell, art critic of the *Evening Standard*, is regarded by most of the London art world as an eccentric reactionary who has no sympathy for avant-garde art. In many respects he is a reactionary, but one of his strengths is his independence from dealers, collectors and curators; another is the trenchant prose in which he delivers his negative verdicts, such as this evaluation of Saatchi:

So dominant a collector disrupts the market. So ignorant, wilful and whimsical a collector, acting without reason, deforms the taste of others, for he is inevitably followed by the rich and foolish of equally uncertain judgement, the blind led by the blind. Charles Saatchi has long been, and without doubt will long be, so compliant are the rest of us, a major influence for good or ill in the visual arts. Utterly frivolous, brash, superficial, ostentatious, the author of incalculable damage, he is the collector for our time. A century hence posterity will marvel, not at his so-called works of art, but that we were so credulous and gullible. [36]

the sale in december 1998

On 8 December 1998 a major sale of works – 130 items by
97 yBa artists – from the Saatchi Collection was held at
Berry House, a Clerkenwell warehouse, by the London auc-
tioneers Christie's. It attracted so much media attention both
before and afterwards that other December sales which
raised far more money were overshadowed.[37] The art
objects represented four to five per cent of the total collec-
tion and Saatchi's goal was to raise £1.3 million. According
to the expensive, fully illustrated sale catalogue, all of the
money raised was to be used for bursaries to assist art stu-
dents and young artists.[38]

Journalists noted the 'neat circularity' of the plans. An
editorial in a national newspaper described Saatchi's value-
adding apparatus as 'a perpetual motion machine for inno-
vation'.[39] By using the proceeds of sales of art that has risen
in value to buy yet more art, Saatchi could be said to be recy-
cling wealth – but without diminishing his overall fortune or
compromising his affluent lifestyle.

The sale was not without risk because it was held at time
when an economic recession in the West – following one in
the Far East – was being widely predicted (though some
investors shift their money from shares into art during reces-
sions because they believe art maintains its value better). If
the work of the yBas had remained unsold, then the art mar-
ket would have been seen to reject Saatchi's artistic judge-
ments. According to Graham Southern, director of Christie's
Contemporary Art division, the items in the sale were 'unag-
gressively' priced – that is, below retail figures – in order to
appeal to museums as well as private collectors. Another
reason for the low estimates was surely a fear that higher
ones might not be met.

In the event, the sale exceeded Saatchi's expectations: 90 per cent of the items were sold and the total sum raised was £1.6 million (which means that the Saatchi Collection as a whole is worth £32 million). Hirst's *The Lovers*, estimated value £80–100,00, fetched £139,000; Mueck's *Baby 2*, estimated at £6–10,000, was sold for £41,000; Whiteread's *Untitled (Square Sink)* (1990), estimated value £40–50,000, was sold for £135,000 (having been acquired for £4500); Saville's *Prop*, estimated value £10–15,000, fetched £51,000. These prices were inflated by the buyers' premiums (sums paid by the buyers to the auctioneers which are a percentage of the hammer prices). Out of 130 lots, 109 were sold, two were withdrawn and 19 failed to reach their estimates and were 'bought in'. Many of the abstract paintings sold within their modest estimates.

At Berry House it was standing room only as an 'enthusiastic' audience dressed in fashionable black witnessed the spending spree. Saatchi was reported to be delighted.

One of the more amusing and interesting works sold was Dinos and Jake Chapman's *Übermensch* (1995), a fibreglass, resin and painted sculpture representing the famous British physicist and cosmologist Stephen Hawking in his wheelchair perched on a crag. His body may be crippled and earthbound but his mind soars to the stars as he seeks to comprehend the whole universe. (This sculpture inevitably recalls Caspar David Friedrich's romantic painting *The Wanderer Above the Mists* (1817–18), which shows the lone figure of a man, seen from the rear, standing on a mountain top gazing at a vista of peaks.) The sculpture's value was estimated at between £10,000 and £12,000, and it was purchased by the London collector Nick Silver for £10,350.

What was unusual about the December sale was its open-

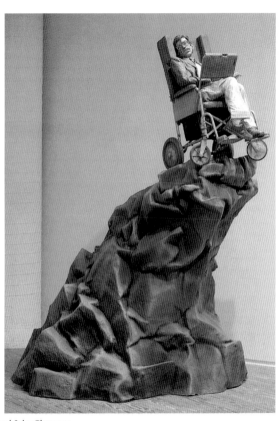

Dinos and Jake Chapman,
Übermensch, (1995). Fibreglass,
resin, paint, 366 x 183 x 183 cm.

ness and transparency – for once Saatchi abandoned his secrecy. His admirers could once again praise his philanthropy in respect of future generations of young artists but sceptics considered that the bursary schemes provided a public alibi for selling and profit taking. (If the bursaries attract charity status, then Saatchi would not have to pay income tax on the profits made.) Having promoted Hirst *et al* in the 'Sensation' show of 1997, Saatchi took advantage of their recent high profile only a year later by seeking to maximise their financial potential. The fact that buyers from Britain and other European countries were willing to pay high prices for the Saatchi Collection works indicated that there were many speculators who were content to allow Saatchi to lead the way – to take the risk of identifying and legitimating new talent – so that they could occupy the slipstream in his wake. One of keenest bidders was a Greek collector called Dimitris Daskalopolous; others included London dealers who were supporting the artists in their stables. Colin Gleadell considered that artists without representation were at a disadvantage. He listed the benefits of the sale for Saatchi as follows:

> ... it would balance the rate of acquisitions with disposals, clear his accountant's books, and determine the value of the rest of the collection. It would also test the worth of the Saatchi provenance, particularly for work by artists with no known resale value.[40]

As if to counter in advance any accusation that Saatchi was losing interest in previous favourites, Christie's reported that 'in the run up to the sale Charles acquired further works by Damien Hirst, Gary Hume, Nicky Hoberman, Jason Martin, Ron Mueck, Chris Ofili, Jenny Saville and others'.

The sale was featured on BBC2's *Newsnight*, a television programme which attracts around one million viewers. A voice-over to film of the exhibits in the warehouse expressed concern that Saatchi's buying power made it difficult for other galleries to compete when it came to defining contemporary British art. Matthew Flowers, managing director of the Flowers East gallery, objected to the fact that the Royal Academy had given Saatchi such an important platform to publicise his collection of works by the yBas. Other private art galleries, such as Flowers East, were not given the same opportunity to promote their stables of artists – most of whom Saatchi did not collect. Consequently, Flowers was critical of the concentration of power in the hands of one man. As the journalist Andrew Marr has remarked: 'Is it really healthy for British art that we have so few small collectors? Wouldn't it be better to have 10,000 collectors, putting their savings into living art ... rather than a few modern Medicis?'[41] If one agrees with Marr, then it surely follows that wealth has to be distributed more widely so that more Britons can afford to become collectors.

John Keane, a figurative painter noted for his images of the 1991 Gulf War who exhibits at Flowers East, appeared on *Newsnight*. In his opinion Saatchi was an art-market Svengali comparable to George Soros (a financial wizard capable of destabilising whole economies). Keane considered that the very early success Saatchi could provide for young artists might well have a detrimental effect on their artistic development and a distorting effect on the monetary value of their work.

A short studio debate then ensued between Lisa Jardine, a Saatchi enthusiast who is Professor of Renaissance Studies at the University of London, and David Lee, a Saatchi

critic, editor of *Art Review*. Jardine claimed that the very fact that television was covering the sale was a tribute to Saatchi's achievements in raising the public profile of contemporary British art. She also argued that buying in bulk and dealing in art were nothing new, that in fact they were common practices in Renaissance Italy. (Jardine is an academic intoxicated by men of power and wealth. She seems to think such unequal distributions are inevitable, eternal and perfectly acceptable.) Lee countered by saying that Renaissance patrons commissioned most of their art. In addition, he thought Saatchi's taste was 'execrable' and that the supercollector had no discernment or affection for the art that he acquired. Saatchi was, in reality, a dealer/speculator who was 'distorting' the art market. The buyers who slavishly followed Saatchi, Lee dismissed as 'credulous imbeciles'.

the bursaries

Two kinds of bursary were planned with the sale proceeds:

1 Scholarship Bursaries, commencing in September 1999, for selected art students at four London fine-art institutions: Chelsea, Goldsmiths', the Royal College and the Slade (all of which have post-graduate, MA courses). The Royal Academy school may also be included. Each art college will receive £10,000 per year but the sum will be reviewed annually. (The total annual sum is thought to be the interest on the capital sum raised by the sale.) According to Graham Crowley, professor of painting at the RCA, staff will be free to determine how the money is allocated.

2 Young Artists' Sponsorship Bursaries to support artists' projects and commissions. The fortunate recipients would then be given shows at the Saatchi Gallery and their works

would be purchased by the Saatchi Collection (and then, presumably, sold off a little later).

While these bursaries could be viewed as a positive helping hand to young artists, they could also be regarded as a means of creaming off talented individuals just as they are leaving art school and a way of tying them into the Saatchi Collection/Gallery. The scheme will enable Saatchi to gain access to artists even before they have signed with a dealer/art gallery, hence it will serve to tighten his grip even further. In reality, the scheme will formalise what Saatchi had been doing for years on an *ad hoc* basis. Patricia Bickers commented: 'He will have the pick of the work of the new London graduates in the future. In this way, Saatchi could be said to have taken control of both the means of production and distribution, which should not surprise us about a collector/dealer who has been described … as the Rupert Murdoch of the artworld.'[42]

When told about the scheme, some recent graduates from art school welcomed the prospect of financial help towards the cost of final shows and during the period of struggle afterwards. (Most leave with debts and have to perform menial jobs to stay alive.) However, those based in the provinces expressed dismay that only a few prestigious London colleges were going to benefit from Saatchi's largesse.[43]

Paul Bonaventura, a research fellow in fine-art studies at Oxford, expressed the view that art schools should shelter (rather than expose) novice artists from the worst excesses of the art market.[44] He also thought Saatchi's private initiative was not a solution to the state's underfunding of fine-art education. Bonaventura was worried too about the impact of the bursaries on the nature of the work of the student artists. In addition, we presume that art students who think

they can succeed in the marketplace are less likely to con-
sider radical, alternative modes of artistic practice.

the gift of 1999

In February 1999 Saatchi prompted yet another round of
press coverage by giving 100 works by 64 young artists from
his collection to the Arts Council Collection.[45] Twenty-five
of these artists were already represented in the ACC which
contains 7000 items and is devoted to British art produced
since the Second World War. It was founded in the 1950s
and is stored and administered at the Hayward
Gallery/South Bank Centre, but since it does not have a per-
manent display space of its own, selections from its holdings
are made available to the public via loans and travelling
exhibitions. The total monetary value of Saatchi's gift was
estimated to be £500,000 and the artists involved included
Rose Finn-Kelcey, John Frankland, Siobhan Hapaska, James
Reilly and Richard Wilson. Art-world commentators judged
them to be 'second-division' artists – in market terms – com-
pared to the top-rank names Hirst, Ofili, Saville and
Whiteread. Saatchi's declared motive for the gift was that
the Arts Council Collection was supporting young British
artists and disseminating their work across the country. The
transfer from private to public sector would also serve to
reduce his storage, insurance and transportation costs.

7

the patron and the 'sensation' and 'neurotic realism' exhibitions

Although Saatchi dislikes attending private views – even those lavish ones organised by his own gallery – over the years he has inevitably become acquainted with a number of artists. He met Schnabel in the 1970s, Chia in the 1980s, Hirst and Martin Maloney in the 1990s. Saatchi has also been seen in the company of Michael Craig-Martin, an artist who trained in the United States and who is now a professor at Goldsmiths', the south-London art college which trained so many of the yBas. Social contact and conversations with artists has sometimes resulted in ideas for new works being realised. Hirst's tiger shark – *The Physical Impossibility of Death in the Mind of Someone Living* (1991) – reputed to have cost Saatchi £50,000, was the result of one such conversation.

In pursuit of established and new artists, Saatchi makes a point of visiting both mainstream and 'alternative' galleries, artists' studios, and art schools. In 1994 he paid £20,000 for five paintings by the then little-known abstract artist Simon Callery (b. London, 1960), from an exhibition at the Anderson O'Day gallery, Portobello Road. (The artist received half.) Callery's work was later featured in the 'Sensation' show in 1997.

During the 1990s Saatchi took to visiting artists' studios in the more marginal districts of London, especially the East

End – which hosts one of largest concentrations of artists in the world – in a chauffeur-driven black Lincoln Towncar on Saturday mornings. At other times he travelled by taxi accompanied by the art critic and television personality Waldemar Januszczak and the artist Maloney. For some obscure poverty-stricken artists his visits were nothing short of miraculous because they offered the chance of a transformation of their lifestyles and career prospects.

Nicky Hoberman, a painter of strangely distorted children set against blank backgrounds, was born in South Africa in 1967 and gained an MA Painting from Chelsea College of Art and Design in 1995. Saatchi first visited her in her King's Cross studio in April 1996. At the time Hoberman was feeling ill and depressed but unsurprisingly she perked up when he bought 11 paintings. Examples of Hoberman's work were illustrated in *The New Neurotic Realism* book.[1] In 1997 Saatchi and Maloney visited the artist-duo Tim Noble (b. Gloucester, 1966) and Sue Webster (b. Leicester, 1967) who both trained at Nottingham Polytechnic, at their home in Rivington Street, Hoxton. They had previously tried to attract the collector's attention by sending him fax messages. Saatchi inspected their work while they watched from the next room through a spy-hole. He bought two items for inclusion in future shows.[2]

Since so many British art students and artists live on the breadline – often on state benefits – they tend to be pathetically grateful to Saatchi,[3] and perhaps do not see the parallel between him and employers who exploit the existence of a reserve army of unemployed people, and pay low wages.

It is the would-be artists who make sacrifices and subsidise the production of art out of their meagre incomes – more than the British state or private patrons. Little progress

can be made until the division between contemporary fine art and society is addressed. The existence of one wealthy patron is not a real solution to the deep-seated and long-term economic problems faced by living British artists. Paradoxically, the British state funds art schools which overproduce artists for which society in general has little use. Most art school graduates are eventually compelled to abandon their dreams and find other employment as teachers, or librarians, or bricklayers, or guides and security guards in art galleries.

saatchi as a patron

Theoretically, a distinction can be made between collectors and patrons. The latter have a closer relationship with artists from whom they commission works of art. The former buy works of art and, if they do so from private galleries and auctions, they may never encounter the artists who made them. Saatchi has acted as both collector and patron.

Once Saatchi began to focus on young British art he became conscious of the new talent graduating from Britain's art colleges every year. Jenny Saville (b. 1970), a student at Glasgow School of Art from 1988 to 1992, who specialised in enormous paintings of obese female flesh seen in close-up with feminist-inspired comments scratched in the surface, was one of his protégés. After seeing one of her degree-show paintings in a London 'critic's choice' exhibition, he commissioned 15 new paintings for the Saatchi Collection. They were exhibited as part of the 'Young British Artists III' show held in February/July 1994. (It seems Saatchi was concerned that she should find the right commercial gallery/dealer.) Saville acknowledged that her future plans changed as a result of the patron's intervention.[4]

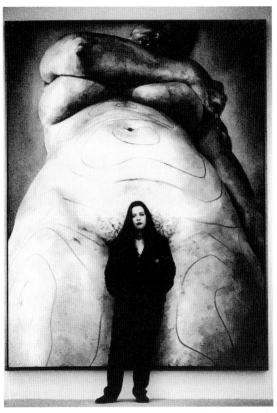

Jenny Saville in front of
her painting *Plan* (1994)
(Glynn Griffiths).

In certain instances then, Saatchi has behaved in a manner typical of the patrons of Renaissance Italy: supporting an artist financially for months or years while he or she produces a body of work. Patrons who operate in this manner, rather than buying 'ready-made' from a gallery, have more opportunities to influence the end result. They can supply a brief and visit the artist's studio while work is in progress and make suggestions for changes if they so desire. David Cohen has commented on the Saatchi/Saville relationship:

> There is not a little irony in the fact that a political artist, whose work is so much about women's control of their bodies and the problematic identification of paint with possession, should bond herself to a capricious collector in an almost feudal arrangement. Recently, a solo exhibition offered to her by the Gagosian Gallery in New York was vetoed by her patron.[5]

(At the time of writing though a Saville show at Gagosian's is expected to take place during 1999.)

Hirst, whose British dealer is Jay Jopling, did exhibit in the Gagosian Gallery, Manhattan in May 1996. It was a sell-out show. Saatchi purchased *Some Comfort Gained from the Acceptance of the Inherent Lies in Everything* (1996) – two cows sliced into 12 parts preserved in steel and glass cases – from this exhibition for an estimated $400,000 in order to strengthen his Hirst holdings.

When artists sell their works to collectors they cede control of them. In 1994 Saville remarked:

> I just heard today that Saatchi has put frames round most of my paintings ... Now that's not the point – the figures are supposed to challenge the edges of the canvas. Putting a boundary around them

just gets them wrong ... I want to make an installation out of this painting [that is, *Strategy,* 1994] – put a mirror across the gallery so the viewer can read the reversed text. But I'm having to really fight to make that happen.[6]

Saatchi's interest in the hyper-realist figures painstakingly created by Ron Mueck from clay and silicone was aroused as a result of seeing the life-size figure of a boy in Y-fronts – representing Pinocchio – in the studio of the painter Paula Rego (Mueck's mother-in-law) during 1996. Saatchi bought this figure and subsequently visited Mueck's studio where he saw and acquired another sculpture of a sinister-looking, two-foot high baby as a birthday present for his wife Kay, who had earlier given birth to a real baby daughter. Saatchi also commissioned four more sculptures but left Mueck free to decide the subject matter. Mueck was born in Australia in 1958 and until Saatchi started to buy his work had earned a living making puppets for films and models for use by photographers working for advertising agencies. It is ironic that it was the support of an advertising tycoon that rescued Mueck from the world of advertising and enabled him to make the transition from anonymous model-maker to a sculptor of some renown and swiftly rising value.[7] One of Mueck's baby sculptures – *Baby 2* – which belonged to the Saatchi Collection was sold at auction in 1998 for £41,000.

'sensation'

Hirst, Mueck and Saville were all represented in 'Sensation', subtitled 'Young British Artists from the Saatchi Collection'. It merits separate consideration because it was mounted – in the autumn of 1997 – at Burlington House, Piccadilly rather than at the Saatchi Gallery. A display at such a prestigious

and venerable venue in central London could only benefit his collection. Apparently Saatchi suggested the idea of lending works to the Royal Academy to its exhibition secretary Norman Rosenthal during a casual conversation. Rosenthal was only too pleased to agree because a gap had appeared in the RA's exhibition schedule. The 'academy', as it were, would be endorsing and validating 'the avant-garde' and Saatchi's preferences in art. Adrian Lewis described it as 'institutional consecration'.[8] And as Kitty Hauser remarked, using Hirst's preserved shark as emblematic of the show: 'The shark, it seems has been domesticated. Stamped with the approval of the Establishment (it's art!) and honoured by record numbers of visitors (it's popular!) …'[9]

The RA is a private institution controlled by a self-selecting committee of artists, the academicians, who also run an art school. Besides galleries, Burlington House boasts a restaurant and a shop which sells books plus a range of art-related merchandise. (Artists such as Hirst and the Chapman brothers have been quite willing to devise merchandise such as T-shirts to accompany their exhibitions.) Despite its private status, the RA has a high public profile because of its impressive central London premises, its programme of blockbuster shows and its popular annual summer exhibitions. The RA 's exhibitions have to attract business sponsorship and large numbers of paying customers to cover the institution's running costs (for some years it has been in debt). 'Sensation' was a cheap show for the RA to stage because the exhibits all came from one source and only needed transporting a short distance; even so, sponsors were still thought necessary. Initially, there were problems obtaining them because of the controversial and morbid nature of the contents of 'Sensation'; in the end Christie's, the auc-

tioneers, and *Time Out*, the London listings magazine, were signed up. Both had an interest in the success of a show of contemporary art. In terms of media coverage and the number of visitors the show was indeed a success.

According to a publicity leaflet, 'Sensation' was 'both an attempt to define a generation and to present Charles Saatchi's singular vision in an established public forum'. On display were 110 works by 42 artists – 18 of whom had been trained at Goldsmiths' and about half of whom had not featured in previous shows of yBas held at the Saatchi Gallery. Given the title of the show, the selectors, Rosenthal and Saatchi, were both looking for works that evoked powerful visual and emotional reactions. (The word 'sensation' alludes to both bodily experience and public impact: 'it created a sensation, it was sensational'.) Lewis commented: 'The show's title conceals its organisation of box-office success under a naturalising description of the cultural effect of the avant-garde.'[10]

Whatever the artistic merit of the individual pieces, the exhibition as a whole provided an entertaining spectacle because of the sheer variety of objects, styles and media represented, and the piquant contrasts that were established, for example, placing Richard Billingham's photographs next to a sculpture by Rachel Whiteread. Saatchi worked for hours alongside RA staff to ensure that the hanging and positioning of the show were as striking as possible.

The public's appetite was whetted by advance publicity which included reference to Marcus Harvey's *Myra* (1995), a huge portrait based on a police mugshot of the 1960s' serial killer of children Myra Hindley, still in prison and still a hated figure. Harvey painted her face by imprinting the canvas dozens of times with the paint-covered cast of a child's hand.

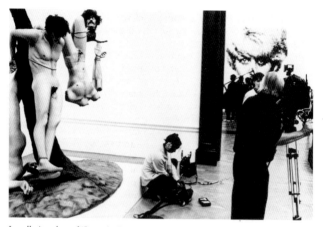

Installation shot of 'Sensation' exhibition, Royal Academy, 1997. On the left is part of Dinos and Jake Chapman's *Great Deeds against the Dead* (1994), and on the right is part of Marcus Harvey's painting *Myra* (1995) (John Reardon).

This action added some value to what would otherwise have been a mere copy of a photograph, but it also prompted problems of interpretation regarding the implied meaning.[11]

Myra, like the exhibition as a whole, produced mixed reactions. When the show opened in September a queue formed outside Burlington House. Relatives of the murder victims protested against Harvey's painting and pleaded with those waiting not to enter. Most ignored this request but two men did side with the protesters, defacing the painting by throwing eggs and ink at it. This act, of course, generated yet more media coverage. For a time the

portrait was removed for cleaning and when it returned it was protected by sheets of clear plastic and flanked by security guards.

Other controversial works on show included sliced-open animal 'sculptures' by Hirst (which have prompted protests by animal-rights activists), deformed, violent and erotic mannequins by Dinos and Jake Chapman and paintings of children by James Reilly (which have given rise to accusations of paedophilia), a self-portrait, frozen head made from pints of his own blood by Marc Quinn, explicitly sexual images and sculptures by Sarah Lucas, and colourful paintings by Chris Ofili showing the Virgin Mary alongside photos of female genitals clipped from pornographic magazines with elephant dung additions. Ofili is a black artist who was born in Manchester in 1968 and who trained at Chelsea and the Royal College of Art. Saatchi's acquisition of Ofili's work was endorsed by the British art establishment in 1998 when the painter was given a one-man show by the Serpentine Gallery and awarded the Turner Prize.

Four academicians – the painters Craigie Aitchison, Gillian Ayres and John Ward, and the sculptor Michael Sandle – were so offended by the content and aesthetic standard of the exhibits that they resigned. Sandle thought that the RA members, by voting to include Harvey's *Myra*, had 'done something bordering on evil'. In his opinion the RA had gone rotten at the top and there was little democracy because the arrogant and conceited Rosenthal ruled the roost. Sandle had no wish to be 'a stooge of Rosenthal' or a stooge of the 'propaganda salesman' Charles Saatchi.[12]

Not everything in 'Sensation' was outrageous: abstract paintings by Mark Francis and Jason Martin were sober works with little popular appeal. If they had been given a

show by themselves, few people would have bothered to attend. Whiteread was represented by several cast sculptures and these were generally praised by the critics. Also, there were certain items of a hyper-realist character which stopped viewers in their tracks: *Dead Dad* (1996–97) – a naked but less than life size simulated corpse (representing the artist's recently deceased father) lying on the floor – by Mueck the ex-model maker who had never attended art school, *Misfit* (1994), a similar male figure by Abigail Lane, and the devastatingly frank colour photographs by Billingham of his dysfunctional proletarian family and their squalid living conditions.

As usual the RA exhibition was accompanied by a glossy, well-illustrated catalogue prefaced by several prestige-building essays.[13] Lewis described them as follows:

> First there are the grand celebratory claims (Norman Rosenthal's essay), followed by a short-term art history (Richard Shone), critical expatiation (Martin Maloney), an American perspective (Brooks Adams) to prove this is world-class stuff, and a big-wig cultural historian (Lisa Jardine) to add the respectability of past cultural comparisons to the current situation.[14]

The purpose of commissioning Jardine's essay, according to Lewis, 'was clearly historically to relativise criticisms of the power of Saatchi as collector and the relation between public and private arenas in the artworld.' But,

> The fact that the biggest collection of British art has been made by an advertising mogul is not developed by Jardine. It does more than tell us where profits are greatest in our economy; it tells us something about the approach to collecting (in dramatic bulk

purchases), display (large-scale and visually dramatic) and taste itself (an attraction to what Maloney calls 'the art of ideas with a high visual impact').

Maloney also argued in his essay that the work in 'Sensation' was marked by 'radicality of content, not radicality of form'. Several writers claimed that the artists frequently responded to everyday life and events but while this was true of Billingham's photos, it was not true of the abstract paintings; and fabrications such as Tracey Emin's 1995 tent embellished with the names of every person she had ever slept with was hardly a profound insight into the realities of life in Britain. As a sculpture it was also puerile. Emin gained further notoriety by appearing drunk and inarticulate on a television arts programme discussing the moribund question: 'Is painting dead?'

In a perceptive article, Simon Ford and Anthony Davies noted that until recently contemporary British art had suffered from an 'image problem: it just wasn't sexy enough. Art had to get younger, more accessible, more sensational. In short, it had to *become more like advertising* [our emphasis]'.[15] Lewis agreed:

> If early modern art aspired to the condition of music, this art aspires to the condition of advertising or its medium of graphic design, a quick image, shocking, thought-provoking, inspiring interest and advertising copy, gaining attention in a world where that in itself seems to mean value.[16]

And who better to stage-manage the promotion of hot, young, British art stars than a man with years of experience of the creative side of advertising?

'Sensation' was attended by 285,737 people (this was more than any other exhibition held during 1996 and 1997, but a show of Monet's impressionist paintings some years before had attracted 700,000), but what was the character of the audience? Normally, those visiting the Saatchi Gallery would be somewhat different from those attending the RA. The latter tends to attract older people and more foreign tourists whose taste can be defined as middlebrow. The influx of younger, more fashionable people with a penchant for art with shock-value served to enliven and rejuvenate the RA, at least temporarily. (Crowds of teenagers attended and this age group now expect art exhibitions to be as entertaining as the mass media.) But, as Lewis pointed out, given the middlebrow character of the RA, a minor crisis over 'Sensation' – the protests, the internal wrangles, the resignations – was inevitable. Although willing to exhibit in Burlington House, Whiteread refused an invitation to join the RA on the grounds that she was too busy. Hirst remarked that he would not become an academician if he was asked because it would undermine his 'avant-garde' reputation. The show, Lewis argued:

> provided the cross-over point of two different audiences, one
> sharing the modern art world's disposition towards distantiation,
> the other disposed to treat image as presence and to register
> immediacy of effect ... those who enjoy its play with
> sensationalism ... those who find the show shocking.[17]

Another art expert claimed that 'there is now a new public for art, formed by our new TV culture, content to accept the short rations from sensation which hype advertises'.[18]

All in all, 'Sensation' served to bring a proportion of the

British contents of the Saatchi Collection to the notice of a much bigger constituency of art lovers and, as a result of the extensive coverage in the press and on television, to millions of people who never visited the show. Rosenthal and Saatchi had every reason to be satisfied with the result of their joint effort and the latter was particularly pleased with the high attendance figure. He told Lisa Jardine: 'For a show that was roundly rubbished before it even opened, "Sensation" has confounded its critics by attracting record numbers of visitors, who have responded 85 per cent in favour of the Royal Academy mounting the exhibition.'[19]

He should know that high box-office figures are not automatically a guarantee of the quality of the art or the aesthetic experience. Many people must have visited 'Sensation' out of curiosity – just to see what all the fuss was about and to make up their own minds about the art on display.

A range of reviews appeared in the art press including some that were highly critical of the 'sado-kitsch' exhibits and the two organisers.[20] One article, by the veteran British curator and Jackson Pollock expert Bryan Robertson, was entitled 'Something is rotten in the state of art'. Peter Simple, a gossip columnist, dismissed the work on show as 'rubbish art' and John Ward, a traditional artist, complained that the yBas could not draw or paint. Several reviewers also complained about the way so many of the yBas recycled ideas from earlier modern movements, or from the 1960s, or derived them from recent American art. David Cohen commented:

The cool school has not pioneered a style of its own so much as knowingly distilled various avant-garde movements of the preceding generation – conceptualism, minimalism, pop – imbuing

the retro fusion with a distinctly British, yobbish, post-punk 'attitude'. In other words, just like Mr Saatchi's trade, their art is cannibalistic, ephemeral, gratuitous.[21]

Two further points about 'Sensation': the concentration on young artists can be considered an example of ageism (just like the Turner Prize which excludes artists over 50 from consideration), and the stress on British artists – strange in an age of supposed globalisation – encourages chauvinism. Saatchi once stated that he is not particularly interested in the nationality of the artists he collects – modern art is generally thought of as international rather than national – nevertheless, the titles of many of his exhibitions have included the adjectives 'American', 'British' and 'German'. In one of his few public speeches (at the Turner Prize award ceremony held at the Tate in 1994 when he announced that Antony Gormley – a sculptor whose work Saatchi does not collect – had won the £20,000 prize), he remarked:

I'm not sure what today's young British artists are putting in their porridge in the mornings but it seems to be working. They're providing the most striking new art being made anywhere in the universe, and it seems every museum, from Nebraska to Alaska, is ringing up trying to organise shows of their work. Now I don't know, any more than you, what has made our young artists suddenly so supercharged, but I am certain that teachers like Michael Craig-Martin at Goldsmiths' College have had a tremendous effect. [Applause.] Now Goldsmiths', and in recent years the Royal College, and some other art schools, they have set a tone and a level of ambition that has stimulated not just their graduates, but young artists all over Britain who are producing work that is challenging, articulate and relevant. Now if sometimes

that work appears tasteless and cynical and uncouth, I think it's because sometimes we all are. [No applause greeted this admission.] I think that the

Charles Saatchi (left) and Antony Gormley at the Turner Prize presentation in the Tate Gallery, 1994 (Richard Young).

Turner Prize has itself become an inspiration and a catalyst. It's a cliché, but it is nevertheless true, that we all welcome the wider interest and debate in contemporary art that the Turner Prize generates. At the very least it gives four young artists every year the chance to exhibit their work here at the Tate ...[22]

Rosenthal too has no qualms about trumpeting the achievements of BritArt and has even claimed that, as a result, London has overtaken New York as the world's art capital: 'For the first time this century, London is where it is at on the art scene, without rival.'[23] Modesty – once a British virtue – no longer seems to be valued and patriotism no

longer seems to be considered 'the last refuge of the scoundrel'. Sceptics think that not all the art produced by the yBas is worth bragging about and that the 'ascendancy of London' may be disputed by other cities around the world, but the promotion of British culture – in which government ministers also indulge – is part of the marketing and rebranding of the nation which must attract tourists and succeed in a global market.[24]

After its London showing, 'Sensation' moved to Berlin where it was shown at the Hamburger Bahnhof, Museum für Gegenwart, from October 1998 to January 1999. According to Nicola Kuhn, a German art critic for *Der Tagesspiegel*, there was no shock, 'no sensation about "Sensation"'.[25] Berliners, she claimed, found the work of the yBas 'more sad and serious than irreverent, funny and dazzling'. In her view, one reason for the rapid fame and success of the yBas was the smallness of the London art scene but ultimately this hemmed them in. She added: 'Like the punks before them, BritArt's working-class image has dissolved with success. To many it is yet another example of the Thatcherite paradigm of talented rebels who were happy in the end to take the money and run.' For Kuhn, an awkward question remained unanswered, namely: 'How could a movement with such an enormous international impact have just one collector?'

While the crowds inside the galleries of Burlington House were still assimilating 'Sensation' during the autumn of 1997, Saatchi was already preparing his next move in the artopoly game by 'scouring small, alternative artist-run warehouse and studio shows to find the next generation of trend setters', who turned out to be the proponents of New Neurotic Realism (NNR).[26]

The new neurotic realism

Months before any work by the NNRs was visible at the Saatchi Gallery a hardback book was published – by the gallery itself – and preview articles appeared in the press, just as adverts often precede the arrival of new products in the shops. The book was, in effect, a substantial press release; signalling the existence of a 'new movement' well in advance. Perhaps too far in advance because some people felt the first of a series of shows, held from January to August 1999, was an anti-climax.

Who coined the problematic label NNR? There were three candidates: Martin Maloney, Dick Price and Charles Saatchi. Opinions were divided: the British critic Januszczak was convinced Saatchi christened it, while the German critic Kuhn maintained that Maloney was responsible. We suspect it was cooked up by all three. The adjective 'new' – used *ad nauseam* in advertising – implied that there had been an 'old' neurotic realism but since no such movement was known, 'new' became an embarrassment and was dropped from the title of the first exhibition. The NNR label reminded art historians of the German new objectivity movement of the 1930s and the European *nouveau réalisme* of the early 1960s, but what it meant in the British context was a puzzle. What was clear was that some name was needed to differentiate the latest manifestation from the 'Sensation' artists even though three of them – Peter Davies, Maloney and Mueck – were common to both.

Thirty-four artists featured in the book, 11 of whom were born in countries as far afield as Australia, Japan and the US; though almost all of them lived and worked in London, they were not exclusively British. Their work was executed in a variety of forms: assemblage, mixed-media installation,

painting, paper cut-outs, photography, and sculpture. Stylistically it also ranged from cartoon fantasy to construction, from photorealism to neo-naïve. The disparate nature of the work made the label NNR hard to justify except as a brand name or marketing tool. A hostile writer in *Art Review* proposed the alternative label 'frenetic opportunism'.

Jonathan Jones, a freelance journalist, penned a more thoughtful critique of the NNR label or 'ism'.[27] He thought Saatchi had every right to name a new art movement but could discern no common denominator. Earlier modern movements such as dada, futurism and surrealism had been accompanied by manifestoes and bodies of theory, they had been 'ideologies' and had spoken 'the language of revolution' – realism in art had also been associated with movements such as socialism – whereas 'the movement Saatchi has pasted together travesties the history of modern art by stripping it of its politics'. Jones concluded that there was 'something deeply reactionary about neurotic realism's melancholia'. Other critics dismissed the label as 'hype', 'a joke', but, as one pointed out, if its purpose was to be a talking point then it certainly succeeded.

An introduction to the book was provided by Dick Price (an alias for the painter Dexter Dalwood), a reviewer for the British fashion magazine *i-D*. Price argued that the NNRs rejected the cynicism, shock tactics, ironic posing and the role of art star associated with the yBas. They were 'a group of artists who use strange psychology as an accepted subject', who were interested in fiction and collective memory, the subjective relationship to movies; there was a 'shabby-ragged realism' but also 'elegance and sophistication', and a return to traditional artforms such as painting and sculpture and more emphasis on craft skills. He traced the origins of

NNR in Britain to the influence of American artists such as John Baldessari, Chris Burden and William Wegman.

But what was neurotic about NNR? From the book's illustrations, the only rational answer seemed to be the anxious facial expression of Charlotte, a woman portrayed by Victoria Chalmers, the disturbed children depicted by Nicky Hoberman, and the creepy column of dead rats built by David Falconer. But these had nothing in common with Mark Hoskings's parodies of Caro's metal sculptures or Peter Davies's cheerful, art-world league-tables and text paintings, or Ian Dawson's sculptures made from piles of everyday plastic products that had been partly melted with a blowtorch (the result was a kind of abstract-expressionist sculpture). Arguably, some of the artists were neurotic in the sense of being 'obsessive' in their detail and creative procedures.

What, then, was realist about NNR? A number of artists did produce mimetic images and figures – Mueck for instance – while others were realist in the sense that they depicted certain facets of daily life in the 1990s such as domestic leisure, office work, pornography and tower blocks. Many NNRs took it for granted that today's reality is as much the artificial or virtual worlds of images and the mass media as it is nature. Simulation was a recurrent characteristic: Tom Hunter used a camera, an actress, a baby and staged-photography to produce a variant of a Vermeer showing a pregnant woman reading a letter (he gave this beautiful photo a critical edge by titling it *Woman reading a possession order*). Paul Smith also employed a camera to imitate common photographic genres while Brian Griffiths copied industrial plant in different, everyday materials.

Hunter and Maloney referenced famous masters from the history of art. According to Price, Maloney tran-

scribed 'Poussin through rave culture'; however, such intertexuality seemed perfunctory. In the cases of Katia Lieberman and Dexter Dalwood, the sources of inspiration were the mass media. Liebermann devised photos employing the comic and movie hero Batman (transmuted into Batgirl), while Dalwood painted famous real and fictional interiors found in novels and television adverts and series: Uncle Tom's Cabin, Laboratoire Garnier. Dalwood had not seen any of these interiors, only imagined them, though collages of images cut from glossy magazines had been used as starting points.

Perhaps the most accomplished and painterly painter in the NNR camp was Cecily Brown (b. London 1969, trained at Epsom and the Slade). She derived her iconography from pornography but buried it under hectic brushwork indebted to de Kooning. In 1994 Brown moved to New York for a while because painting was more respected there than in London. Her first solo exhibition held in New York in 1997 was a sell-out and she also penned a self-promotional article in *Flash Art* about the latest 'revival of painting'.[28]

'die young stay pretty'

Earlier we claimed that the Saatchi Collection/Gallery resembled an institute of contemporary art more than a museum; London already has its ICA with a history of supporting experimental art dating back to the late 1940s. In some respects the Saatchi enterprise can be considered the ICA's rival and competitor (plus the Whitechapel and Serpentine galleries). The Saatchi Gallery has far more display space than the ICA and greater financial resources. (The ICA's funding stems from membership fees, entrance charges, Arts Council grants and business sponsorship.) The result has

been that, in terms of shows of new art, the Saatchi Gallery has overshadowed the ICA. In November 1998, immediately preceding the first display of the NNRs, the ICA fought back with a show of new art – mostly British – entitled 'Die Young Stay Pretty', evoking the fate of movie stars who had died tragically early but thereby achieved an ever-young, perenially beautiful posthumous media existence. The show was commissioned by Emma Dexter, ICA exhibitions director, curated by Maloney, and sponsored by Habitat.

Exhibiting at the ICA were 12 artists who included the sculptors Steven Gontarski, Caroline Warde and Gary Webb, and the painters Jane Brennan, Dexter Dalwood, Peter Davies and Michael Raedecker. Collage and video were also represented plus canvases by Maloney. (Incidentally, few people in the art world seem to find it strange or unethical that an artist who curates a show includes works by himself in it.) Works by two of the contributors – Davies and Maloney – had previously appeared in 'Sensation' and works by six of the artists had been purchased by Saatchi and labelled NNR; consequently, there were significant continuities and overlaps between the RA, ICA and Saatchi shows – Maloney being the principal connection. Perhaps 'Die Young Stay Pretty' did not so much steal the thunder of the Saatchi Gallery as act as a trailer for its 1999 exhibitions.

The catalogue included an introduction by Patricia Ellis – a Canadian who gained an MA at Goldsmiths' – and interviews with the artists conducted by the English artist and writer Gemma de Cruz.[29] Ellis's text was heavily footnoted but the references were overwhelmingly to websites, pop music and mass-culture sources. Her overwrought prose style also echoed that typical of promotional publications:

'Tragically hip, their work is posed: beautiful, profound, seductive, edged with just enough trauma to make it truly glamorous ... Emulating simulation, this generation cherish the Novocain hum of the synthetic ... In the thrust towards tomorrow, they are racing to immortalise the Now.'

According to Maloney, the 'dreamy qualities in the art-works' he had selected stemmed not from 'a personal poetic' but from 'the commercial exploitation of our desire for that poetic'; they evinced 'the blank beauty of a generation seduced by the romantic poses of people, places and things from TV and magazines'.

Maloney (nicknamed 'Baloney' by the magazine *Art Review*) was born in London in 1961 and trained at a number of art colleges, including Goldsmiths', over a long period (1980–93). During the mid 1990s, he organised a series of group shows in Brixton at Lost in Space, a 'gallery' which was actually his own flat. These shows gained him public attention and commissions. Important influences in his own artistic development and that of other British artists were shows of American art, such as 'True Stories' and 'Bad Girls' (ICA, 1992, 1993), which introduced the new American 'teen art' of John Currin, Karen Kilimnik, Raymond Pettibon, Elizabeth Peyton, Jim Shaw, Jack Pierson and Sue Williams. Maloney was encouraged by this work to try his hand at figurative, nar-rative art. In his view, British artists 'can look at things around the world and they can make a British Art ver-sion', therefore, 'The conservative streak of British art and British culture can be put to good use, and be a strength not a weakness. That is what makes it radical. It's not a culture that invents new art forms, it refines them ... American art kicks the ball, and British artists grab it'.[30]

Because Maloney is multi-skilled – curator, teacher, writer, painter – and Saatchi's friend (but he has denied advising Saatchi or 'shopping' for him), he exercises considerable influence in the London art world. Overnight, it seemed, his voice replaced Damien Hirst's the brash bad boy of BritArt.

Adrian Searle, *The Guardian*'s critic, responded to the 'Die Young Stay Pretty' and 'Dumbpop' (Jerwood Gallery, 1998) shows by dismissing most of the exhibits as 'visual Valium' and by declaring that BritArt had 'lost its brain'.[31] In 1999 the alleged 'dumbing down' of culture in Britain became a matter of general public concern; for some this was also applicable to the art world.

the first 'neurotic realism' exhibition

A curious feature of this show was that it was sponsored by *The Observer* Sunday newspaper. Does even a wealthy collector like Saatchi need business sponsorship? The exhibition featured paintings by Maloney, photographs by Paul Smith, sculptures by Gontarski and Brian Griffiths, and an extensive, messy installation entitled *Line-Out (1998)* by Tomoko Takahashi. This installation spread across the floor while its maintenance instructions were crudely written on the walls, and so the normally pristine appearance of the central gallery space was dramatically altered.

Takahashi, who has categorically denied being a neurotic realist, was born in Tokyo in 1966 and trained at Goldsmiths' and the Slade. It took her days to gather and arrange her materials and so she kipped in the gallery. Tom Lubbock described the result of her labours as follows:

> ... miscellaneous junk, huge quantities of it, arranged in an
> archipelago of tableaux-dumps, and in each dump there's an

electric gadget, like a TV or a tape recorder or an adding machine, still working away, but pointlessly (nothing on TV, no tape in the recorder) ... a techno-dystopian vision of our culture of consumption and waste ...[32]

Like an actual rubbish dump, it proved a fascinating spectacle. Visitors wandered among the mounds of debris along pathways left for the purpose while sharp-eyed attendants made sure no one stole the new tools and equipment that were also scattered across the floor.

Paul Smith was born in Bradford-on-Avon in 1969 and gained an MA in photography at the Royal College of Art. Like Cindy Sherman, he played most of the roles in his colour photos himself, using digital computer technology to achieve this end. Smith had once been a soldier and in one sequence of prints – *Artist Rifle Series* (1997) – he recreated photos of war and army-recruitment-style pictures of squaddies on manoeuvres. One reviewer was offended by Smith's battle scenes because they lacked 'the passion and horror' of authentic war photographs. In another series of colour prints – *Make My Night* (1998) – Smith imitated snaps of lager louts clowning around and gesturing aggressively at the camera. Since these images merely relayed boorish, laddish behaviour, the redemptive function of art seemed to have been abandoned.

Brian Cyril Griffiths (b. 1968) hailed from Stratford-on-Avon and was a Goldsmiths' MA student. He painstakingly reproduced industrial control panels from cardboard, parcel tape, bottle tops, old umbrellas, etc. The gallery filled with his bulky fabrications resembled a deserted set for *Star Trek*. In his case, a self-therapeutic do-it-yourself aesthetic was carried to a manic extreme. Play is often a factor in artistic

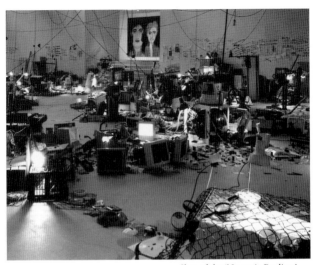

Shot of the 'Neurotic Realism' exhibition, Part One, 1999. In the foreground is the installation work *Line-Out* (1998) by Tomoko Takahashi, and in the background a Martin Maloney painting from the *Sex Club* series (1998) (Stephen White).

creativity but the playfulness of many of the NNRs seemed to continue the kind of projects set by primary schoolteachers and by children's television programmes like *Blue Peter*. 'Infantilism' was one critical response.

Steven Gontarski is an American sculptor (b. Philadelphia, 1972) who studied for an MA at Goldsmiths' in 1997. His work continued the tradition of Western erotic art: standing and reclin-

ing figures that intertwined and even merged. According to Price, his rubbery figures fetishised 'nightclub posing and distorted copulation'. Gontarski himself considered them both humorous and grotesque. In terms of composition, there were tributes to famous marbles of the Italian Renaissance, but the bodies were highly generalised and abstracted, as in the case of Henry Moore's work. What was unusual about Gontarski's was the fact that they were made, not from wood or stone, but from fabrics, PVC, polyester wadding, synthetic hair, transfer tattoos and real, mundane clothes such as socks. They were the result of sewing rather than carving skills. For this reason lines on the sculptures – that is, the seams – were as important to the artist as lines in his drawings. Gontarski combined opaque and transparent materials that were often shiny – giving them a space-age look. 'Mutant' and 'humanoid' were two adjectives critics used. At a distance certain sculptures were attractive and complex, but close-up some viewers found their plastic skins repulsive and their pretty pink and blue colours cloying.

Maloney showed a new (1998) series whose extravagant size , we suspect, was due in part to the fact that the Saatchi Gallery walls were huge and required filling. In our view, their monumental, public scale was inappropriate given the intimacy of their subject matter – gay sex in clubs – but perhaps that was Maloney's intention. Besides their sexual explicitness, what was distinctive about his figurative paintings was their style; it has been described as 'amateurish, artless and artful, bad, botched, cack-handed, cartoon-like, child-like, *faux naïf*, ham-fisted, informal, sloppy and ugly'. The hands of Maloney's figures reminded one critic of bunches of bananas and the artist himself freely admits he finds hands difficult to paint. He told one journalist: 'I do

the best I can. Nobody's perfect. Maybe that's one of the things we're trying to say.'[33] It would seem, therefore, that those interested in new art must now adjust to low horizons and expectations.

Maloney's neo-naïve mannerisms seemed designed to foil critical condemnation in advance: it was hard to dismiss his paintings as 'bad' knowing that they were self-consciously clumsy. Similarly, it was futile to attack Takahashi's installation on the grounds that it was 'a load of rubbish!' because that is literally what it was.

press reactions to nnr

An early, gushing response was provided by Tina Jackson:

> The work is serious in intention and fun in execution. It is vibrant, electrically alive and, paradoxically, given its use of traditional artforms, bursting with innovation, surprise and excitement. Most reassuringly, it points not only to a fresh direction for British art, but to a new surge of vitality and creativity.[34]

Most evaluations were negative; arguably, many artworks were aesthetically and intellectually weak. To cite some examples: *Chair* (1997) by Andreas Schlaegel (b. Zaire 1966, studied in Germany and at Goldsmiths'), was a sculpture shaped like a modern chair but made from polystyrene and household sponge scourers in various colours. This object resembled a one-line joke or quickly consumed graphic image. Like the pop sculpture of the 1960s which it recalled, it raised a smile but did not detain the spectator long and surely few would want to view it again. The work had no complexity of form, no profound or challenging content, no potential for repeated aesthetic pleasure.

Jason Brooks's monochrome portraits executed in acrylic were competent versions of photorealism – but what was the point in repeating the characteristics of that minor 1970s' tendency? It is surely insufficient to justify such repetition by reference to the vogues for retro and remixing in the world of entertainment. In Jonathan Jones' opinion, Saatchi had inadvertently exposed 'a sad decline in the intelligence of the London art scene that might otherwise have gone unnoticed for a few more years'.[35] For Jones, NNR was 'minor art' and he advised Maloney to return to art school in order to learn to draw. NNR, he concluded, punctured the nationalist delusion that art in Britain was better than that being produced abroad. Kuhn, the Berlin critic, concurred. In her opinion, Saatchi had tried to repeat the success he had achieved with the yBas but NNR 'felt desperate' and was 'doomed to failure'.[36] One journalist considered that the NNR did not warrant having a view about, but such was the effectiveness of Saatchi's advance publicity and the ensuing media coverage that it was hard for followers of contemporary art to resist at least sampling the new art on display.

In a perceptive summary of the transition from yBa to NNR, J J Charlesworth argued that:

> The theme of amateurism has been gradually gaining momentum on the London art scene for three or four years. Often referred to as 'Slacker' or 'bedroom' art, it was initially perceived as a reaction to the slick, high-finish professionalism that was evident in much of the work of the 'Sensation' artists. To the more radically minded, the possibility of making things badly, even cack-handedly was seen as a way of snubbing the art market's hunger for the elitist luxury object, the logic being that if you made something badly enough, you could not run the risk of being assimilated

by the art market and so maintain a degree of artistic autonomy and integrity.[37]

While amateurism may supply 'a kind of non-specialist accessibility', its downside is that 'the artist cannot offer a vision of experience which is any more valid or insightful than anyone else'. A 'trivialisation of art' occurs and, as part of a 'process of minimisation, amateurist art represents a further retreat from the risk of failure; by lowering the stakes, it becomes impossible to lose'. Matthew Collings also thought artists were not trying very hard; he also blamed the international art audience because they wanted to be entertained 'as if they were children'.[38] Charlesworth concluded:

> Once again, Charles Saatchi has proved himself an excellent barometer of contemporary sensibilities – the joke is that, at a time when the audience for contemporary art has never been greater, new artists should have so little to say.

The NNRs, Charlesworth noted, 'are at home indulging their sentimental nostalgia for the pop culture of their collective childhood memories'. The convergence between fine art and pop culture which began with pop art in the 1950s and 1960s has continued apace, but one danger is that the art can become as ephemeral, disposable and shallow as the majority of last month's records and movies. Distinctions of kind and quality between art and showbusiness dissolve and critical distance is lost. Given the wide appeal and power of the mass media, such a development may be hard to resist but we wonder if the majority of fine artists have the abilities and resources to compete on equal terms with such pow-

erful rivals as advertising agencies, record companies, Hollywood studios, and so on. Increasingly it seems as though the only role left for new art is to serve as a low-pay 'research and development department' for the mass media.

What the NNR episode made clear was Saatchi's ambition to channel the course of art's history. By selecting particular art works and then grouping, labelling and publicising them, he attempted to orchestrate a whole new movement. If NNR is accepted as a significant development by leading critics, curators and art historians, then Saatchi will have succeeded in adding a new chapter to 'the story of art'. Professor Jardine, Saatchi's academic supporter, remarked admiringly in 1997: 'Charles Saatchi appears to be successfully inventing the history of British art before it has even happened.'[39]

But whether or not Saatchi can repeat the financial success he achieved with the yBas remains to be seen. We await his next sale with interest. If his critics are right about the spurious character of the label NNR and the generally low quality of the art subsumed by it, then perhaps Saatchi's value-adding machine has at last faltered.

8
absences and alternatives

In spite of the considerable size and diversity of the present Saatchi Collection, anyone familiar with contemporary art can point to absences. When J W Mahoney reviewed the first, four-volume catalogue he noted the absence of any works by John Baldessari, Joseph Beuys, Peter Blake, Jim Dine, Richard Diebenkorn, the Fluxus group, Helen Frankenthaler, Richard Hamilton, David Hockney, R B Kitaj, Joseph Kosuth, Jasper Johns, Barbara Kruger, Kenneth Noland and Robert Rauschenberg.[1] Later, some of these 'gaps' would be filled.

It took Saatchi a long time to recognise the importance of Francis Bacon as a painter and as a crucial figure in the history of post-1945 British art. Warhol was preferred to the British pop artists of the 1950s and 1960s – although in 1998 Saatchi bought a whole exhibition of new works by Patrick Caulfield – originally considered a British pop artist – from the Waddington Gallery. (We presume this was in anticipation of a major show of Caulfield's oeuvre held at the Hayward Gallery from February to April 1999. The final room in this show was hung with Saatchi-owned paintings.) Peter Blake was one of the founding fathers of British pop art during the 1950s. He trained initially in graphic design and has been willing to undertake a number of commercial commissions over the years in

order to supplement his income from fine-art sales. We do not know if Saatchi appreciates Blake's paintings or wishes to acquire them, but in any case Blake has instructed his dealer not to sell to Saatchi. In 1998 Blake told Caroline Marshall:

> I have nothing against Charles Saatchi or the agency he started, but I formed the opinion very early on that he wasn't collecting for the love of art. I disapproved of his policy of the blanket-buying of one artist's works, which I think creates a false market. I didn't want to end up as a commodity, so I asked my dealer, Leslie Waddington, not to sell to Charles Saatchi.[2]

As a consequence of his fastidiousness, Blake confessed he had no money and was in debt.

Artists who have had the temerity to criticise Saatchi – like Haacke and Wagg – have naturally been excluded. His purchase of Ashley Bickerton's painting *The Patron* (1997), a very harsh portrayal of a social type shown almost naked and fondling his genitals in front of a television set flanked on one side by a Brancusi sculpture and on the other by a Mondrian painting, is perhaps a sign of growing self-aware-ness and a willingness to tolerate criticism. Apparently, Kay Saatchi found *The Patron* so repulsive that she banned it from being hung in their bedroom.

Identifying gaps in respect of any collection is an easy enough task, especially if the policy, period and scope of the collection is spelled out, and few, if any, art collections can claim to be comprehensive or complete. In the case of an on-going open-ended project such as Saatchi's, the idea of completion becomes absurd. What we wish to consider here is a rather different matter: the relation of the Saatchi

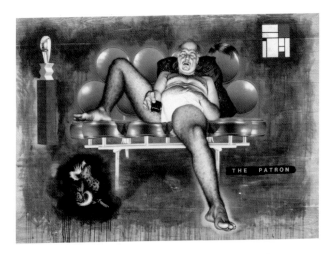

Collection to the field of contempo-
rary art as a whole and especially
its relation to radical artists and art
movements which have sought to
challenge the object/commodity
nature of art and the associated auction-house/gallery/
museum system. Two examples from the 1960s will serve
as illustrations.

Ashley Bickerton, *The Patron*
(1997). Oil, acrylic, pencil and
aniline dye on wood panel,
167.5 x 228.5 cm.

dias and apg
In 1966 artists including Gustav Metzger, John Latham,
Hermann Nitsch and Yoko Ono participated in the Destruc-
tion in Art Symposium (DIAS) held in London. They used

destructive materials and methods, such as acid, explosives and fire, to make art and events motivated by political and social issues. Forms of art were made in public places that existed for only a short time and were simultaneously creative and destructive. Since the art object was literally annihilated in the process, nothing remained for dealers to exhibit or sell. A critique of commercialism and the artwork-as-commodity was a deliberate intention on the part of some of the artists – Metzger especially – concerned.

Latham was also one of the founders of the Artist Placement Group (APG) an artists' organisation designed to provide an alternative to the gallery system as a means of livelihood. The idea was to 'place' artists within industries, businesses, government departments, hospitals, etc., for periods of time as independent observers or researchers who would then respond to the people and institution in some manner. The result might be a sculpture but it could also take the form of a film or a report. In other words, the end result was not decided or prescribed in advance of the placement. One objective of APG was to heal the rift that had developed between artists and society by inserting the artist into the latter's power structures.[3] During the 1970s, therefore, a fine artist could have been 'placed' within the Saatchi & Saatchi agency if the brothers had known about APG and been sympathetic to its aims.[4]

Latham (b. 1921), some critics believe, is the most extreme, genuinely avant-garde artist working in Britain during the second half of the twentieth century. Charles Saatchi has ignored him even though Latham has exhibited his paintings and relief sculptures a number of times at the Lisson Gallery. Younger British artists such as Hirst and Anish Kapoor (a star of the Lisson stable) also respect him

highly. Latham's art is informed by a complex theory of time and the cosmos which is intellectually demanding and time-consuming to assimilate. Perhaps it is this which has put Saatchi off.

performance and public art

A major genre of post-war contemporary art has been performance (or live or event) art. Since this kind of art occurs in time and involves the actions and bodies of artists (as does so-called 'body art'), there is no 'object' – aside from documentation – for collectors to acquire. Thus a whole genre of contemporary art is of little interest to Saatchi because he cannot own, exhibit or sell it – he could sponsor a performance artist or group if he wished. Performance and conceptual artists strove to transcend the art object but Saatchi's decisions to buy and exhibit works of art, and trade in them, contributed to a renewed emphasis on material artifacts, a 'return to order'.

Alternative ways of supporting new, experimental art do exist. For example, the London organisation Artangel Trust finances a series of temporary time-based works by radical artists in non-art-gallery venues. The Trust's funding derives from both public and private sources such as the London Arts Board, the Arts Council, the Henry Moore Foundation, individual patrons and Beck's beer company. So, even this organisation is dependent to some extent on business sponsorship. Beck's, a German brand, supports exhibitions/galleries and commissions limited-edition bottles with labels designed by leading British artists such as Gilbert & George, Richard Long, Bruce McLean and Rachel Whiteread. Absolut Vodka is another foreign drinks brand, from Sweden, that uses contempo-

rary art – by commissioning artists to design adverts for glossy art magazines.

Jon Bird, a university professor and author of a critique of the Saatchi phenomenon, has been involved in the work of Artangel for many years. Perhaps its best-known venture was Whiteread's *House* (1993–94) – a concrete cast of the interior of an east London home – which was planned from the beginning as a short-term structure. Since Whiteread is a sculptor who does make objects, Saatchi can and does collect them. He owns several Whitereads including the sepulchral *Ghost* (1990), the plaster cast of the negative space of a room in a derelict house on the Archway Road, London. Plaster is a fragile material and *Ghost* was damaged in storage. It seems that after Saatchi bought it, he had to spend as much as the price he had paid on repairs and crating.

Whiteread's *House* proved controversial and generated much media attention. In 1993 she was nominated for and won the Turner Prize worth £20,000 (a scheme operated by the Tate Gallery and sponsored by Channel 4 Television) and the K Foundation prize worth £40,000 (a booby prize for the worst contender). Events in the public sector thus helped to make her famous and thereby increased the value of Saatchi's privately owned holdings – one consequence of 'the mixed-economy' is that there is considerable interaction between the public and private sectors.

House reminds us of the whole category of public or civic art. Many leading contemporary artists have produced permanent or temporary sculptures or monuments in both urban and rural settings in order to enhance the environment and to communicate with an audience far wider than that which visits galleries. (In the past, many monuments were paid for via public subscriptions; Frederic-Auguste

Bartholdi's *Statue of Liberty* [1886] was one example.)
Again, this was a form of art that Saatchi could have funded
if he had wanted to and if he had wished to avoid the bur-
dens of maintaining a collection and running a gallery.

art beyond the gallery

In addition to examples of public sculpture, other kinds of
visual culture appear in the street: murals, graffiti, and bill-
boards. During the 1970s an active community-arts move-
ment existed in Britain led by artists who were dissatisfied
with the existing gallery/museum system which they con-
sidered promoted bourgeois art for a bourgeois audience. A
community mural was not portable – it could not be bought
and sold for profit. Consequently, it was despised by deal-
ers and ignored by collectors. The political issues and
soicalist perspectives that generally informed such murals
were another reason why they were anathema to right-
wingers.

Graffiti writing/imagery created by young people using
cans of spray-paint was a vibrant, subcultural phenomenon
that emerged in New York during the 1970s and then spread
throughout the world. This was a grassroots example of
street art that, initially at least, had nothing to do with the
art world. (Later the New York art market did succeed in
appropriating it.) Graffiti highlights the issue of who has the
right to 'speak' in public places. Generously funded by busi-
ness and political parties, Saatchi's agency generates offi-
cially approved commercial and ideological messages that
appear everywhere – graffiti is considered by the authorities
to be vandalism. Some writers have been arrested and
imprisoned for insisting upon their right to express them-
selves in public places.

The imbalance of power can be redressed by attacking or changing billboard advertisements. Since the 1960s a number of artists and groups have engaged in subverting adverts by making additions or alterations to them in a way which imitates their design and typography. (This has been termed 'refacing' as against the 'defacing' of spray-painted graffiti.) Viewers may thus be puzzled and disconcerted by the new or contradictory messages of the adverts. (This tactic derives from the situationist practice of *détournement*.) The artist retains the existing power and public presence of the advert while disguising the extent of the changes made. One such individual – David Collins, plus various assistants – calling himself 'Saatchi & Someone', was active in the Leeds and Bradford areas during the summers of 1990 and 1991.[5]

Politically motivated artists such as the British duo Peter Dunn and Loraine Leeson (of the London Docklands Community Billboard Project) and the Irish-American artist Les Levine are just three examples of artists who have tried to compete with the mass media by using billboards. Other artists have employed the technique of collage or photo-montage to generate images designed not for frames but for mass reproduction via books, magazines, newspapers, pamphlets, posters, postcards and demonstration placards. Peter Kennard is a well-known example of this kind of artistic practice in Britain. (Saatchi owns a work by Kennard but it is not one of his political photomontages.) Another is the 1999 British organisation calling itself 'SAS – Socialists Against Saatchi' (a spurious mass movement of artists and workers formed in response to the equally spurious art movement the 'New Neurotic Realism').

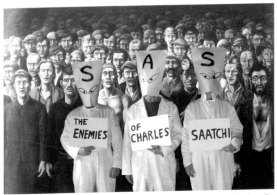

new media and edition art

A further characteristic of contemporary art has been the willingness of many radical artists to embrace new media and technologies: video, photocopy, slide-projection and computers. Sculptures generated via the programmes and memory banks of computers by artists like William Latham are virtual objects capable of mutating in time. They can be viewed on computer monitors in the home. Latham's researches have been sponsored by the global company IBM rather than by Saatchi.

Some radical artists have also adopted modern means of communication/distribution such as the postal system (mail art, for example), fax transmissions, compact discs, broadcasting channels and the internet – giving rise to so-

SAS (Socialists Against Saatchi), *The Enemies of Charles Saatchi* (1999). Digital photographic montage/print. The painting in the background is Otto Griebel's *The Internationale* (1928–30). Oil on canvas, 127 x 186 cm.

called 'net' or 'web art'. Clearly, the artists making use of such systems feel that galleries and museums are increasingly irrelevant.

Photocopy machines are commonplace and they can be used either to generate unique, one-off art works or multiple copies. The cost is low and therefore such reproductive media have a wide democratic potential. Videotapes can also be produced and duplicated fairly cheaply, sold via shops or mail-order, and viewed at home rather than in a gallery. In other words, any art that is produced in an edition (for example, book art and multiples) can reach a wider audience depending, of course, on its size, price and the popular appeal of its content. The bigger the edition, the more the art approaches the condition of mass culture which is the form of culture experienced and appreciated by the majority of the population.[6] 'Edition art' – unless it takes the form of strictly limited editions of prints and bronzes – undermines the whole value structure of private galleries and the art market because the latter generally depends upon the buying and selling of unique, highly priced luxury goods. (Art fairs, which are held annually and which consist of displays by dozens of galleries, attract large crowds and do offer works – especially drawings and prints – by little-known artists at relatively low prices.)

Upmarket dealers and rich collectors, therefore, have no desire or incentive to see art becoming cheap and available to the masses if this means the demise of private galleries and public museums. It should be remembered that the founders of one of the major movements of modern art – futurism – advocated the destruction of museums. Other twentieth-century revolutionaries, such as the Berlin dadaists and the situationists, demanded the abolition of art altogether on the grounds that it was a bourgeois construct.

minimal art

It is also worth recalling that minimalism (and conceptualism) – one of the first art movements collected by Charles and Doris Saatchi – had a significant democratic potential. Minimalism certainly involved objects such as drawings on walls or constructions made from bricks or wood or steel, but these objects were often the result of executing a set of instructions devised by artists. The objects were thus like meals or music produced in response to recipes and scores. Sets of instructions can be made available widely and cheaply by means of printing, and anyone following them could thereby acquire a minimal art work. Sol LeWitt typed sets of instructions for producing some exquisite abstract line drawings and they were often executed on the walls of galleries by others, hence they were not dependent upon the craft/hand skills of the artist. Therefore, anyone who accurately followed LeWitt's instructions surely obtained a LeWitt drawing.

Minimalists such as Carl Andre and Dan Flavin used readymade materials and goods such as bricks found in builders' yards and fluorescent light tubes sold in hardware stores. Logically, therefore, anyone who buys 120 of the same American firebricks and arranges them in two layers, as Andre did to create *Equivalent* VIII (1966), would acquire, for the cost of the bricks, a sculpture that was just as good and authentic as the one in the Tate Gallery's collection. (The only difference would be the absence of a 'provenance' certificate from Andre.) The democratic potential of minimal art was not realised because, first, the style had no popular appeal – indeed, it prompted public scorn ('I could do that') and vandalism – and second, the private galleries, public museums and auction houses recuperated it by con-

tinuing to treat minimalist objects as if they were rare, hand-crafted, 'signed', expensive items. The very nature of the art itself was denied in the process.

Minimalism was severely abstract – no illusion, no allu-sions – and left-wing critics objected to its lack of content in the traditional sense because this meant it lacked the ability to comment on events. (Unless, of course, silence is consid-ered a comment.) Much of it had been produced by Ameri-cans at the time of the Vietnam war but their 'primary struc-tures' had nothing to say about the carnage in South-east Asia and in appearance they often resembled the stripped-down industrial design and architecture of corporate and government office buildings. When Charles and Doris Saatchi began to collect American art, they ignored the work of artists like Nancy Spero and George Maciunas who had protested against the war in Vietnam.

leon golub and mark wallinger

There did come a time when the Saatchis collected figurative paintings by Leon Golub, a politically conscious American history-painter who had also represented scenes from the Vietnam war. Among the other themes that Golub addressed between 1979 and 1985 was the use of torture by repressive South American regimes (some of which were backed by the US government) and by mercenaries helping them to interro-gate suspects. The Saatchis bought *Mercenaries IV* in 1982, raising the question of the use-value of paintings even when 'framed' by the Saatchi Collection and subject to exchange-value in the marketplace. In 1987 Golub was asked about this very issue by the authors of *State of the Art*. He replied:

I can't put a means test on anybody that might purchase a painting.

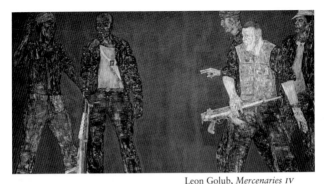

Leon Golub, *Mercenaries IV* (1980). Acrylic on canvas, 305 x 586 cm.

You can say Saatchi or anybody else who buys a work owns me, takes possession of my mind, so to speak, of my art. But then I enter his home or his situation or his environment. I put my mercenaries there. Not just Saatchi, but anybody else, including myself, has to deal with the presence of these mercenaries and interrogators.[7]

It is clear that Golub was fully aware of the contradictions and paradoxes experienced by a socialist artist living in a capitalist society ruled by the bourgeoisie. He wanted his art to be seen and to have a public impact, not for the sake of personal glory, but because he hoped to contribute to social change. Since a painting on canvas is portable, it can be viewed in many different locations. The relative autonomy of Golub's paintings means that people can derive meanings from them which may well extend their knowledge and alter or disturb their worldviews. Viewers who saw them in the

Saatchi Gallery might have been able to 'bracket out' the issue of ownership and the display context or, if this was impossible, to recognise that there was a conflict between the picture's space and the space outside. The Saatchi Collection no longer contains any Golubs.

Another example of figurative/political art is a series of paintings about homeless people entitled *Capital* (1991) by Mark Wallinger (b. 1959). He explained to Paul Bonaventura how his seven large oil-paintings showing full-length, standing figures who appeared to be homeless people (exhibited at the ICA in May 1991 and at the Saatchi Gallery in 'Young British Artists II', February–July 1993) came about:

> *Capital* began after I encountered someone sleeping rough in front of the Bank of England, a pretty ironic image. That series of paintings was very much a response to a whole history of measures which had been brought in throughout the previous decade and which had led to this kind of thing becoming commonplace. Margaret Thatcher probably lost precious little sleep over it, but the rise in homelessness came about as a direct consequence of the ways in which her government restricted benefits to teenagers and reduced the provision of mental care within the community. *Capital* was developed in order to function as a stimulus for some kind of debate about how the homeless are represented.[8]

Wallinger was hesitant about depicting the homeless directly, and so he opted for an indirect means of representation – using friends to pose dressed as homeless individuals – precisely in order to problematise the issue of how the homeless are to be pictured. Normally, such individuals

Mark Wallinger, *Capital* (1991). 'Pete', one of a series of seven paintings. Oil on canvas, 266.5 x 144.75 cm.

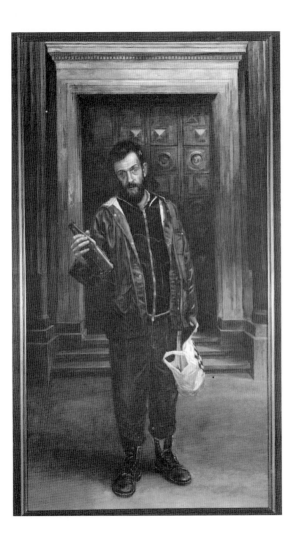

are depicted in the media via black-and-white documentary photographs. Wallinger chose to employ a traditional, academic manner of painting and a traditional genre of portraiture usually reserved for civic dignitaries such as the Lord Mayors of London. The resulting amalgam was certainly disconcerting and thought-provoking. Three critics reviewing these paintings on television found them difficult to appreciate; they described them as 'theatrical, a serious joke, bland and conservative'. One thought the images resembled too closely the very thing they were attacking.[9]

It seems curious, to say the least, that Saatchi was willing to buy and exhibit *Capital* when he had assisted the very political party blamed by Wallinger in the above quotation. It follows that the Saatchi Collection does contain a proportion of art works that are critical in respect of the economic system and society which has enabled the brothers to flourish. The majority of the art Saatchi has bought by the yBas – though considered radical, avant-garde, shocking by some viewers – was not politically radical in the sense of the original avant-garde in France at the time of Gustave Courbet. The anarchist philosopher Pierre Joseph Proudhon – best known for his slogan 'property is theft' – considered Courbet to be not only a pioneer of realism, but also a socialist painter.

Writing in 1986, J W Mahoney asked: 'Has the union of leftist politics and avant-garde art finally been severed?' and answered: 'Certainly, the avant-garde the Saatchis have sponsored has no philosophical compatibility with the left.'[10] There are some exceptions to Mahoney's generalisation, but the general conclusion to be drawn is that the various challenges radical, politically committed artists made towards the art system during the 1960s and 1970s tended,

after a while, to be frustrated. This was because revolutions in the realm of culture – part of the superstructure – cannot be sustained in the absence of successful revolutions at base level, that is, the spheres of economics and politics. Another reason why initiatives falter is that they are often adopted by the arts establishment; for example, the idea of artists' placement proposed by APG was taken up and diluted by a number of other institutions.

painting returns yet again

In 1981, two years after the Conservative government headed by Thatcher came to power in Britain, the Royal Academy mounted an influential exhibition entitled 'A New Spirit in Painting'.[11] This show was the brainchild of Norman Rosenthal, Christos Joachimides (a Greek critic resident in Germany) and Nicholas Serota (then director of the Whitechapel). It signalled that the guardians of the art system were tired of radical tendencies that refused visual pleasure, or denied the visual altogether, and that resisted commodification. Their reactionary solution was a return to hand-crafted objects that could be consumed by the eyes and bought and sold.

The RA exhibition brought American and European examples together but all 38 contributors were men. It was as if there were no women artists of any merit and as if the feminist art movement of the 1970s had never happened. As a consequence of the presence of new German and Italian artists such as Baselitz, Chia, Clemente, Fetting, Kiefer, Lüpertz, Paladino, Penck, Polke and Richter, Doris and Charles Saatchi became interested in collecting them. Neo-expressionist and trans-avant-garde paintings were thus represented in their collection during the 1980s. Much of this

work was slapdash in execution, intellectually shallow and of poor artistic quality, and it soon became dated. It was not long, therefore, before Saatchi dumped it.

the ybas

Part-time employment in British art schools had been one of the ways radical artists had been able to live and still produce work that was non-commercial. Under the rule of the Conservatives, student numbers in higher education vastly increased while many staff were made redundant. Business studies also became part of the curriculum. Students at London colleges – the prime example was Goldsmiths' – were compelled by worsening career prospects to seek success in the marketplace and to take charge of their own promotion.

Despite the fierceness of competition, groups of art students and young artists did, however, form alliances in order to share studios and mount group shows. While still a student at Goldsmiths', Damien Hirst masterminded a legendary group exhibition entitled 'Freeze' (1988). He found and refurbished a derelict building in London's Docklands, obtained sponsors, commissioned a catalogue, organised an opening party and personally drove Rosenthal to the exhibition to make sure that he viewed it. Dealers became interested and soon Saatchi was investing in the work of young British artists such as Hirst and his friends.

Simon Ford, in a perceptive essay analysing the 'myth' of the yBas, remarked that their self-help shows did not mean that artists were now independent of the existing market because the 'shows were easily assimilated into the prevailing dealer and gallery system which welcomed them as a form of research and development of new products and personalities'.[12] Ford concluded that the emergence of the yBas

was 'not a case of the "establishment" recuperating "dissent", but of the establishment fostering a manageable dissent. The yBa is recuperated from the start'.

According to the performance artist and Slade School of Art tutor Stuart Brisley, British art in the 1980s had a special energy because of a shift from the welfare state to the free market. Without the constraints of state patronage, there was an 'atmosphere of libertarianism and a release from social responsibilities'.[13] No wonder then that Hirst's dealer Jay Jopling, the son of a Tory Member of Parliament, declared that he had no interest in 'issue-based art'.

The yBas appealed to Saatchi because they were kindred spirits. This emerged in an interview he gave to Catherine Milner (an interview which she said took three years of negotiation to achieve): 'They are perceived as part of a Thatcherist legacy. They have an entrepreneurial spirit that is very new for British artists, and indeed unique throughout the world.'[14] The entrepreneurial spirit is older than Saatchi thinks: Courbet mounted his own one-man exhibition in Paris in 1855 and the impressionist exhibitions of the late nineteenth century were artist-organised shows designed to outflank the Salon by appealing directly to collectors and the public, and in London during the 1960s groups of young British artists mounted exhibitions of their own work with titles like 'Place' and 'Situation'. The 'Young Contemporaries' exhibitions of the 1950s and 1960s were also largely organised by art students representing different art schools.

The delight in bad taste, sensation and shock associated with the art of such yBas as Hirst, the Chapman brothers, Marcus Harvey, Sarah Lucas and Tracey Emin, was due in part to a desire to rival the popular appeal of the mass media and in part to grab the attention of critics, curators, dealers

and collectors such as Saatchi. The vulgarity of so much of the art produced has also been interpreted as a consequence of Thatcherism.[15]

Some members of the London art world have claimed that cynical yBas 'make what they think he [Saatchi] will go for'.[16] Manipulation, it seems is mutual: yBa Jake Chapman once boasted 'manipulating art people is like falling off a log'. It follows that Saatchi does not simply respond to what is happening in new art, he influences its very formation. Saatchi might well deny this, but even if he does not influence the creative process, by purchasing and packaging the results in thematic exhibitions – as occurred in the case of neurotic realism – he has the power to invent whole movements which may then become part of the history of art.

Our argument has been that the turn towards Conservative politics in Britain during the 1980s was paralleled by a conservative turn in the realm of the fine arts, and that the Saatchi Collection, considered as a totality, served to reinforce that conservatism. The effect of the existence of the Saatchi Collection and the presence of the Saatchi Gallery from 1985 has been to marginalise even further the efforts of radical artists who continue to challenge the art system and to seek alternatives to it.

power and culture

Power belongs to the one who
can give and cannot be repaid.
Jean Baudrillard.[1]

Some people maintain that a rich person who supports art
can't be all bad, though this assumes that art is an unalloyed
good, when much of it is aesthetically poor and/or politi-
cally reactionary in content. In addition to assisting living
artists, Saatchi has made gifts (and loans) of their works to
national galleries and collections; he has also made a gift to
the public by making his privately owned collection avail-
able via exhibitions in his privately owned gallery. Those
who are suspicious of free gifts perceive that a kind of bribe
is being offered in order to disarm analysis and criticism of
an unequal society. Furthermore, acts of charity are often
resented and gifts normally entail reciprocal obligations.
Recipients of gifts sometimes wonder what the giver wants
or gains in return for their generosity

Every adult in Britain enjoys some measure of power – if
only the right to vote in general elections once every five
years or the ability to throw ink and eggs at a Marcus Har-
vey painting – but power, like beauty or income or property,
is not evenly distributed. There are certain individuals and
groups in whom power is concentrated. Charles Saatchi is
one of those individuals even though there are disagree-
ments about exactly how much power he commands. In
November 1998 *The Observer* newspaper in association
with Channel 4 Television produced a list of the top 300

Portrait of Charles Saatchi with bow tie, 1994 (Sean Dempsey/PA).

people who daily influence the lives of the British people.[2] The list was compiled by a panel of experts in different fields who deliberated for six months. Lord Maurice Saatchi appeared at number 99; in a brief profile, his role in advertising was stressed and he was said to be worth £200 million. The artists Lucian Freud, Damien Hirst and David Hockney appeared at numbers 163, 149 and 160 respectively. Nicholas Serota, director of the Tate Gallery who was knighted in the 1999 New Year's Honours List, appeared at number 154 and was deemed to be 'the most powerful man in British art'. Charles Saatchi did not gain entry to the top 300, even though, in our view, he is at least as powerful in the realm of art as Serota. Perhaps his omission was due to the reduction in his ideological and political powers because of the lesser role he now plays in advertising and the end of the Conservative Party's rule during 1997.

We are not naïve enough to think that those possessing power will not choose to exercise it. Public concern has been expressed many times about the concentration of power in the hands of the media and press baron Rupert Murdoch, but much less concern has surfaced about the power that Saatchi has over contemporary art. Indeed, many in the British art world admire and praise him.

Saatchi's power is threefold: first, economic; second, ideological/political; third, aesthetic/cultural/semiotic. What we

have sought to demonstrate is the way in which the three are interlinked and mutually reinforcing. We have also explained how Saatchi's lifestyle was achieved by the astute exploitation of the creativity and labour of employees in advertising and that of young needy artists, and by the establishment of a value-adding apparatus, which yielded profits when artworks were sold via the art market.

Why those who already enjoy economic and political power, and who influence a major sector of mass culture, should bother with the high culture of fine arts may still require further consideration. We can see the appeal of 'heritage culture' – museums/country houses full of splendid artifacts from past ages – to the more traditionally minded bourgeois, but what of the strange exhibits typical of cutting-edge contemporary art? Perhaps it is because expressions of individual subjectivity and craft skills can still be found in contemporary art, a struggle with forms, materials and codes in response to a changing world; more truthful representations of reality than those characteristic of advertising and mass entertainment. It is not so predigested as mass culture and it makes more demands on the viewer and, despite the existence of a market in art objects and the willingness of more and more artists to follow Warhol's example by becoming business artists, there is still some resistance to mass production and commodification.

Compared to the bureaucratic, compromised, predictable and regimented lives most people lead, the life of the artist seems more idealistic and interesting. It offers greater personal freedom and creative satisfaction – which is why so many young people are drawn to fine art despite the low chances of success. To comprehend, tame and exploit this realm is a challenge only the most thrusting and risk-taking

of *nouveau-riche* businessmen would be likely to take up. Enter Charles Saatchi.

Waldemar Januszczak, one-time art critic of *The Guardian*, was granted an audience with the supercollector in 1985 when the Saatchi Gallery opened. His impression of Saatchi: 'A nice enough chap, a *Guardian* reader no less.' Januszczak continued:

> Symbolically he represents Commerce ... the Monetarist variety which is very interested indeed in what takes place at the top of the tree but has no interest at all in the roots. The return of Commerce to the heart of the contemporary art world, a position it hasn't occupied for fifty years, a position some of us hoped it had ceded for ever, has occurred swiftly and dramatically ... What we have witnessed over the past five years ... is ... the demise of state patronage. Art has been thrust into the hands of business and has changed accordingly.[3]

A few years later another British critic, Peter Fuller, remarked: 'I believe that if art is to flourish in a modern, liberal, capitalist state, it is vital to strengthen those institutions which have an interest in the arts unsullied by the marketplace.'[4] By 'institutions' Fuller meant public organisations such as the Arts Council and the National Trust, but also the British monarchy and the church.

Despite the decline in importance of state patronage, there are still some groups of British artists who advocate state funding. For instance, a 1998 press release from the group BANK (Galerie Poo Poo, London) declared: 'Art should be funded by the state to counteract the effects of rich people on art.'

During the 1980s, publicly-funded institutions were

compelled to rely more and more on the private sector. Encouraged or driven by the Conservative Party's desire to create an 'enterprise culture' in Britain, cash-strapped public arts institutions became more commercially minded. As industry and manufacturing declined, creative or cultural industries – advertising, design, film, fashion, pop music, tourism – were becoming increasingly important to the nation's economy and 'brand' image. Like advertising, Great Britain PLC was a 'people business' and therefore creativity was more and more in demand. A convergence of commerce and culture was accompanied by the danger that critical and dissenting opinions would be sidelined or suppressed, and that fine art and commercial art, museums and shops, would become indistinguishable.

By the end of the 1980s, Davidson maintained, a significant transformation of British society had occurred:

> ... it was just impossible to talk about politics without talking
> about communication, about consuming politics ... it was
> impossible to talk about cultural institutions without asking what
> it was people got out of them ... it was impossible to talk about
> collecting art without taking into account the role of the private
> collector and the market. These were shifts not just in attitude but
> in cultural values that left no one untouched.[5]

The brothers' ambition was to build the biggest and best advertising group of companies in the world. For a time they succeeded. Charles Saatchi was similarly ambitious for his art collection. If he became the biggest collector in the field of contemporary art then he would benefit from the so-called 'law of dominance'. There were other collectors in

Britain but compared to Saatchi their determination was puny and their vision limited.

Writing in 1997, Patricia Bickers noted the 'immaturity of the present market which he dominates' and posed the question: 'Is it the paucity of equal players or, in Thatcherite terms, the limited competition in this country, that allows him to influence the value of the works he collects?'[6] The answer, we suggest, is 'yes'. Saatchi himself has expressed regret that his example has not inspired other wealthy Britons to become major collectors. (Though one can cite the examples of Lord Archer and Janet Wolfson de Botton.) Strangely, he seems to regret his monopolisitic position in the UK – but there are major American, German, Italian and Japanese collectors so there is competition to see who can acquire the most, who can be the first to spot the next tendency in art. Even Saatchi's desire for there to be other collectors can be viewed financially: he needs them to sell off items from his collection. In capitalist economies competition between companies and retailers is generally considered good because it drives prices down, but in art auctions competition between bidders drives prices up.

There was a partial but significant corporate take-over of culture during the 1980s. Herbert I Schiller, writing about the situation in the US, pointed out its threat to democracy: 'The drive to privatise and bring under corporate management as many elements of economic and social activity as possible … has tipped the balance of democratic existence to an uncomfortable precariousness.'[7] The Saatchi Collection was from the outset partly a corporate collection. This led Jon Bird to write, in 1985, shortly after the Saatchi Gallery opened: 'The Saatchi Collection demonstrates the discourse of corporate hegemony and interest masquerading under the

guise of a benevolent and personalised acquisitiveness.'[7]

More and more exhibitions became dependent on business sponsorship and Tory politicians, advertising executives and millionaires became trustees of national museums. Rich men, such as the property tycoon Lord Palumbo, began to meddle in the internal affairs of public museums, much to the distress of some of their staff. It seemed that right-wingers and big business were no longer prepared to tolerate the existence of any realm independent of their values and interests. In the case of Saatchi & Saatchi, corporate involvement in the fine arts was curtailed by the fact that Charles and Doris Saatchi decided to make art collecting a more personal matter.

Charles Saatchi founded his own gallery when he encountered problems with two public galleries in the early 1980s. (Sir Terence Conran, the furniture designer and founder of the Habitat chain, followed a similar path: he began by sponsoring design exhibitions at the Boilerhouse Project in the basement of the Victoria & Albert Museum but then established his own Design Museum at Shad Thames in 1989, opened, appropriately, by Mrs Thatcher.) This paralleled the privatisation process which the Tories were busily implementing – selling off national assets such as British Rail at well below their true value so that a few male managers could become millionaires.[8] If nationalisation should ever become popular again with a Labour government, the Saatchi Collection would be a prime candidate and the gallery entrance charge could then be abolished.

taste and distinction

In his magisterial volume *Distinction: A Social Critique of the Judgement of Taste*, first published in France in 1979, the

French sociologist Pierre Bourdieu argued that taste is never pure, that the different aesthetic choices people make are all distinctions made in relation/opposition to other social groups. The social world, Bourdieu contends, functions simultaneously as a system of power relations and as a symbolic system in which taste distinctions form the basis for social judgement and status. In a materialistic society most people make judgements of others based on the amount, expense and quality of their possessions.

Following on from Bourdieu, John B Thompson wrote:

> Individuals who occupy dominant positions within a field of interaction are those who are positively endowed with, or who have privileged access to, resources or capital of various kinds. In producing or appraising symbolic forms, individuals in dominant positions typically pursue a strategy of distinction, in the sense that they seek to distinguish themselves from individuals or groups who occupy positions subordinate to them. Thus they may attribute high symbolic value to goods [like art works] which are scarce or expensive (or both) and which are therefore largely inaccessible to individuals less well endowed with economic capital.[9]

Supporters of Saatchi will quite rightly argue that by opening a gallery and curating exhibitions he has shared his symbolic capital in the form of contemporary art with the public, that without his purchases and commissions far fewer examples of American and German art would have been seen in this country and fewer British artists would have been able to survive. But it was a mixed blessing because he owns and can sell the contents of his collection, hence Saatchi not only enjoys it as symbolic capital but as actual capital. Buying art may be a way to redeem money, but the

Jenny Holzer, *Money creates Taste* (from the 'Truisms' series), 1977–79. Spectacolor signboard, Times Square, New York, 1982.

astute collector/patron realises that money spent on art today, can be turned back into money – much more money – tomorrow. And, as the American artist Jenny Holzer once stated, via an electronic sign, 'Money creates taste'. Although applicable to supercollectors, Holzer's 'truism' obviously had a much wider range of reference. Its public appearances in the United States were in apt locations: New York (1982), the home of Wall Street, and Las Vegas (1984), the mecca of gambling. Her sign was self-reflexive in the sense that it commented upon its own conditions of existence within capitalism; it also showed that art can still perform critical and educational functions.

The public is at the mercy of Saatchi's selection of what art is deemed worth displaying, and much of it has been meretricious. There is no democratic input in his selection and there is no long-term guarantee of support for the visual arts: the access Saatchi grants today he can withdraw tomorrow. A number of young British artists have benefited from his largesse, but the existence of the Saatchi Collection/Gallery has had a deadening effect as far as radical alternatives in art were concerned. The existence of other methods of art funding and distribution show that history could have been different, that the Thatcherite slogan 'there is no alternative' and Francis Fukuyama's thesis that 'we have reached the end of history because capitalism and liberal democracy have triumphed everywhere' were falsehoods to numb the imagination and will of the opposition.

If the Tories had not been in office for so long and Saatchi had not been able to inflect the direction of British art, no doubt the market in art would have persisted. We suspect that Hirst and several others exhibiting in 'Sensation' would still have succeeded in becoming art stars, and figurative artists such as Lucian Freud would have continued to be successful, but surely there would have been differences too. Improved state funding of art schools and public museums would have prevented much damage taking place. If the Greater London Council had survived under the creative and imaginative leadership of Labour politician 'red' Ken Livingstone, then minority groups would certainly have benefited. Perhaps less new art would have been produced, but it might have been of higher aesthetic quality and of greater social utility. Without Saatchi's influence, more minds might have focused more usefully on these questions: what kind of art should be made, for whom and for what purposes?; what

should be taught in art schools and how many art students should there be?; how can the economic problems of artists be addressed once they graduate?; and how can the gap between the people and radical art be bridged?

Our contention is that Saatchi's main motivation for becoming a patron and collector of new art is the pleasure derived from exercising power and manipulating a realm of visual culture, and that he has chosen to found a collection of art rather than advertising – which in any case he already has access to – because art, though less important than advertising in economic and mass-culture terms, possesses significant social prestige, cultural and economic value. Many contemporary British artists may be lumpen-proletarians (or are behaving as if they were), but fine art and its leading national institutions – like the Tate, the Royal Academy, the Arts Council – have an upper-middle-class and even an aristocratic aura (otherwise, why so many Lords? – Lord Clark, Lord Goodman, Lord Rees-Mogg, Lord Palumbo, Lord Gowrie ...).

Anyone who supports the arts generously gains access to the circle of 'the great and the good' and if Charles Saatchi had troubled to cultivate Tory politicians he too would be a Lord or Sir by now. One of his admirable qualities, we think, is his indifference to such feudal state honours. Advertising, by contrast, is associated with selling and its cultural achievements are very ephemeral (though global). In founding a collection/gallery Saatchi gained a personal fiefdom in which he could make all the decisions. As his first wife Doris once remarked: 'Collecting is a way of ordering and controlling the world and we were both, in our different ways, very concerned with having control.'[10]

postscript: 'sensation' provokes further controversy

After its spell in Germany, the 'Sensation' exhibition was due to open at the Brooklyn Museum of Art, New York in October 1999 (it is also due to travel to Australia). Even before it opened an attack upon its contents was made by Rudy Giuliani, the Mayor of New York. He believed Chris Ofili's painting *The Virgin Mary* with its elephant dung additions was offensive to Catholics, a religion shared by artist and complainant. He called for the exhibition to be cancelled and for financial subsidy provided by the city – $7.3 million and one third of the museum's annual funds – to be cut off. Arnold Lehman, director of the museum, refused to be intimidated and declared that the show would go ahead. He also launched a lawsuit on the grounds that Giuliani's actions violated American rights to freedom of expression. Hilary Clinton, a probable future rival of Giuliani for the post of US senator for New York, defended the museum's right to mount controversial shows even though she herself was unwilling to visit 'Sensation'. Meanwhile, in London the famously reclusive Charles Saatchi allowed himself to be interviewed by Deborah Solomon for *The Guardian*.[11]

As in London, public reaction to 'Sensation' was divided. Groups of animal rights activists and Christians protested outside the museum but others supported the show and criticised the Mayor's attempt to suppress it.

notes

introduction

1 A remark adapted from Terry Eagleton, 'The torn halves', *The Times Literary Supplement*, 10 July 1998, page 6.

2 J A Allen, 'Wheelers, dealers and supercollectors: where are they taking the art market?' *New Art Examiner*, Vol. 13, No. 10, June 1986, pages 22–27. An article first published in *Insight, The Washington Times*, Vol. 2, No. 13, 31 March 1986

3 See: R W Walker, 'The Saatchi factor', *Art News*, Vol. 86, No. 1, January 1987, pages 117–21. To the majority of people – those who are employees or who are unemployed – having millions surplus per annum to spend on something which is not strictly a basic necessity strains the imagination. However, compared to the prices paid in the art market for works by famous dead artists, it is not a huge sum: in 1990 the Japanese tycoon Ryoei Saito paid $82.5 million at Christie's New York for *one* painting: van Gogh's *Portrait of Doctor Gachet*.

4 In 1985, when his gallery was opened, Saatchi did speak on the telephone about his collection and gallery to the American writer Dan Hawthorne but with the proviso that he was not to be quoted directly. He also spoke on the phone to Kenneth Baker from *Art in America*. The British art critic Waldemar Januszczak was granted an audience with Charles around the time of the gallery's opening, see Diary, *London Review of Books*, 21 March

1985, page 21. Later, in 1992, Saatchi talked to Dalya Alberge, 'A very private collector: Charles Saatchi, Britain's leading Modern art collector, talks (but only "a little") to Dalya Alberge', *The Independent*, 3 March 1992, page 19. Then, in 1997, he granted interviews to Catherine Milner, 'Enter, a shy man', *Sunday Telegraph*, 23 March 1997, page 7, and Lisa Jardine, 'Looking after the overlooked', *Daily Telegraph*, 19 November 1997, page 22.

5 P Kleinman, *The Saatchi & Saatchi Story*, London, Weidenfeld & Nicolson, 1987; a paperback edition with a new epilogue was published by Pan Books, London, 1989. I Fallon, *The Brothers: The Rise and Rise of Saatchi & Saatchi*, London, Hutchinson, 1988; a revised and expanded American edition of Fallon's book was published by Contemporary Books, Chicago, in 1989, under the title *The Brothers; The Saatchi & Saatchi Story*. We have used the American edition.

6 H Kureishi, 'Books: Saatchi and Thatcher', *New Statesman & Society*, 2 September 1988, pages 33–34.

7 A Fendley, *Commercial Break: The Inside Story of Saatchi & Saatchi*, London, Hamish Hamilton, 1995. K Goldman, *Conflicting Accounts: The Creation and Crash of the Saatchi & Saatchi Advertising Empire*, New York, Simon & Schuster, 1997.

8 T Brignull, 'Brand of gold', *The Guardian* (G2), 23 October 1995, page 14.

9 M Lewis, 'Lord Saatchi', *Reflections on Success: Famous Achievers Talk Frankly to Martyn Lewis about their Route to the Top*, Harpenden, Herts, Lennard Publishing, 1997, pages 851–64. Maurice Saatchi has also appeared on the popular BBC radio programme *Desert Island Discs* to speak about his life and beliefs.

10 N Serota speaking on the television programme: 'Saatchi special', *The Late Show*, BBC2, 29 March 1990.

11 L Jardine, *Worldly Goods: A New History of the Renaissance*,

London, Macmillan, 1996, page 186.

12 Ibid., page 436.

13 L Jardine, 'Modern Medicis: art patronage in twentieth-century Britain', *Sensation: Young British Artists from the Saatchi Collection*, Brooks Adams *et al*, London, Royal Academy of Arts/Thames & Hudson, 1997, pages 40–48.

14 See Catherine Pepinster, 'Labour don says art needs a rich elite', *The Independent on Sunday*, 1 September 1996, page 8.

15 For analyses of the interaction between fine art and mass culture see John A Walker's *Art in the Age of Mass Media*, London, Pluto Press, revised edition 1994; *Cross-Overs: Art into Pop, Pop into Art*, London & New York, Comedia/Methuen, 1987; *Art and Artists on Screen*, Manchester & New York, Manchester University Press, 1993; *Art and Outrage: Provocation, Controversy and the Visual Arts*, London & Sterling Virginia, Pluto Press, 1999.

16 Of course, some London museums do preserve examples – the Victoria & Albert Museum, for instance, collects posters. Outside of London there is also the History of Advertising Trust (HAT) located in Raveningham, Norwich. HAT was founded in 1976 and is a registered charity and educational trust; it maintains an archive 'to conserve our advertising, marketing and media heritage'.

17 G F Hartlaub, 'Art as advertising', *Design Issues*, Vol. 9, No. 2 (spring 1993), pages 72–76. First published in *Kunstblatt,* June 1928.

18 See the television profile of Kaye: 'Rebel with a cause', *Art House*, Channel 4 (30 November 1997) and Andy Beckett, 'The Kaye Mart', *Guardian Weekend*, 18 July 1998, pages 8–15, and cover.

19 J S Allen, *The Romance of Commerce and Culture: Capitalism, Modernism, and the Chicago-Aspen Crusade for Cultural Reform,* Chicago & London, University of Chicago Press, 1983.

20 This should be of particular benefit to those art and art-history students who are unable or unwilling to face up to the realities of money and power in relation to art and architecture. Art historians teaching in universities who call attention to such facts of life are often accused of 'disliking art' and being 'cynics'.

21 R Hewison, *Culture and Consensus: England, Art and Politics since 1940*, London: Methuen, 1995, pages 220–21. The Jameson quote is taken from *Postmodernism, or, The Cultural Logic of Late Capitalism*, London, Verso, 1991, pages 4–5.

22 M P Davidson, *The Consumerist Manifesto: Advertising in Postmodern Times*, London & New York, Comedia/Routledge, 1992, page 77.

23 W Januszczak, 'Charlie and the chuckle art factory', *Sunday Times Magazine*, 3 January 1999, pages 28–38.

1 / the founding of an advertising empire

1 R Williams, 'Advertising: the magic system', *Problems in Materialism and Culture: Selected Essays*, London, Verso and NLB, 1980, page 184.

2 Remark made during a radio programme, 30 April 1990.

3 P Kleinman, *The Saatchi & Saatchi Story*, London, Weidenfeld & Nicolson, 1987, page 152.

4 It seems that during a dispute with a neighbour about the noise of building work taking place at Charles Saatchi's house in Chelsea anti-semitic notes were put through his door. See K Goldman, *Conflicting Accounts: The Creation and Crash of the Saatchi & Saatchi Advertising Empire*, New York, Simon & Schuster, 1997, pages 153–54.

5 Richard Brooks, 'Saatchis get new client – exit Mammon, enter God', *The Observer*, 20 September 1998, page 6.

6 O James, *Britain on the Couch: Why we're unhappier compared to the 1950s, despite being richer: A Treatment for a Low Serotonin Society*, London, Century, 1997.

7 K Horney, 'The quest for power, prestige and possession', *The Neurotic Personality of Our Time*, London, Routledge & Kegan Paul, 1937, pages 162–87.

8 The mailout was reproduced in Dick Frizzell and others' article, 'Add culture: art, art museums and advertising', *Midwest* (New Zealand), No. 6 (1994), pages 8–13.

9 The painting was one of the prizes on offer to those who had paid £30 for a ticket to a fund-raising event, held in April 1996, benefiting the artist-run Cubitt Street Studios/Gallery, near King's Cross Station, London.

10 M Collings, *Blimey! From Bohemia to Britpop: the London Artworld from Francis Bacon to Damien Hirst*, Cambridge, 21, 1997, page 130.

11 I Fallon, *The Brothers: The Saatchi & Saatchi Story*, Chicago, Contemporary Books, revised edition 1989, page 98.

12 J Galbraith, *The Affluent Society*, Harmondsworth, Penguin Books, 1962.

13 V Packard, *The Hidden Persuaders*, London, Longmans Green, 1957.

14 D Boorstin, *The Image or What Happened to the American Dream*, London, Weidenfeld & Nicolson, 1962, page 209.

15 C Duncan, *Civilizing Rituals: Inside Public Art Museums*, London and New York, Routledge, 1995, page 129.

16 D Lodge, *Nice Work*, London: Secker & Warburg, 1988/Penguin Books, 1989, page 220.

17 D Hill, 'Media: Can they stop us wearing Silk Cut socks?' *The Observer*, 20 July 1997, page 5.

18 J Williamson, '… But I know what I like. The function of "art" in advertising', *Consuming Passions: The Dynamics of Popular*

Culture, London and New York, Marion Boyars, 1986, pages 67–74. First published in *City Limits* in 1984.

19 Dan Glaister, 'Saatchi agency "stole my idea"', *The Guardian*, 2 March 1999, page 3.

20 See the 'advert' Hirst created for the television programme Outing Art: *The* BBC2 *Billboard Project*, directed by Keith Alexander, BBC2, 17 May 1992.

21 F Bonami, 'Damien Hirst: the exploded view of the artist' (interview), *Flash Art*, No. 189 International Edition, summer 1996, pages 112–16.

2 / 'we are all conservatives': the tory party's admen

1 Andrew Gamble, *The Free Economy and the Strong State: The Politics of Thatcherism*, London, Macmillan, 1988, pages 170–71.

2 V L Leymore, *Hidden Myth: Structure & Symbolism in Advertising*, London, Heinemann, 1975, page 156.

3 I Fallon, *The Brothers: The Saatchi & Saatchi Story*, Chicago, Contemporary Books, revised edition 1989, page 139.

4 A Fendley, *Commercial Break: The Inside Story of Saatchi & Saatchi*, London, Hamish Hamilton, 1995, pages 54–55.

5 Catherine Milner, 'Enter, a shy man', *Sunday Telegraph*, 23 March 1997, page 7.

6 Simon Caulkin, 'Bother for the brothers', *The Guardian* (Media), 19 February 1990, page 21.

7 H Young, *One of Us: A Biography of Margaret Thatcher*, London, Pan Books, final edition 1993, page 126.

8 Fallon, *The Brothers*, page 143.

9 Young, *One of Us*, page 127.

10 C Freedman, 'Interview with Damien Hirst', *Minky Manky*,

London, South London Gallery, 1995, catalogue of an exhibition curated by Freedman.

11 M P Davidson, *The Consumerist Manifesto: Advertising in Postmodern Times*, London and New York, Comedia/Routledge, 1992, page 82.

12 Fendley, *Commercial Break*, page 75.

13 Roger Law, quoted in Lewis Chester, *Tooth & Claw: The Inside Story of Spitting Image*, London and Boston MA, *Faber & Faber*, 1986, page 117.

14 W Januszczak, 'A talent to abuse', *The Guardian*, 25 January 1984, page 11.

15 H Haacke, quoted in *State of the Art: Ideas & Images in the 1980s*, Sandy Nairne *et al*, London, Chatto & Windus/Channel 4 Television, 1987, page 177. More on the painting can be found in Brian Wallis (ed.), *Hans Haacke: Unfinished Business*, New York: The New Museum of Contemporary Art/Cambridge MA and London, MIT Press, 1987, pages 260–65.

16 'Business News: the Tate: spart gallery', *Private Eye*, No. 564, 29 July 1983, page 20.

17 Information supplied by Haacke in a letter to the authors dated 21 March 1999.

18 The catalogue documented more works than were displayed at the Tate, see *Hans Haacke: Volume II/Works 1978–1983*, (London and Eindhoven Tate Gallery and Van Abbemuseum, 1984.

19 F Spalding, *The Tate: A History*, London: Tate Gallery Publishing, 1998, page 217.

20 *Art Monthly*, No. 73, February 1984, cover and page 3.

21 J Bird, 'Hans Haacke: "the limits of tolerance"', *Art Monthly*, No. 74, March 1984, pages 15–16.

22 Fallon, *The Brothers*, p. 335.

23 Spalding, *The Tate: A History*, pages 250–51.

24 See Sarah Macdonald, 'Profile: Charles Mills, dusting down the

V & A's image', *Marketing Week*, Vol. 4, 4 November 1988,
page 29.

25 Davidson, *The Consumerist Manifesto*, page 41.

26 Ibid.

27 M Kemp, 'A loss of balance: the trustees and boards of national
museums and galleries', *Burlington Magazine*, Vol. 131, No.
1034, May 1989, page 356.

28 Anthony Seldon with Lewis Baston, *Major: A Political Life*,
London: Weidenfeld & Nicolson, 1997, pages 626, 659.

29 Ibid., page 665.

30 Ibid.

31 Tim Rich, 'Boo!' *Print,* Vol. 50, No. 6, November/December,
1996, page 12. See also Paul Routledge, 'Tories revive "demon
eyes"', *Independent on Sunday*, 1 September 1996, page 1, and
Stephen Armstrong, 'Poster postures', *The Guardian*, 16
September 1996, pages 18–19.

32 Seldon with Baston, *Major: A Political Life*, page 692.

3 / **globalisation, accumulation, conspicuous consumption and
loss of empire**

1 T Levitt, 'The globalisation of markets', *Harvard Business
Review*, No. 3, May–June 1983, pages 92–102.

2 I Fallon, *The Brothers: The Saatchi & Saatchi Story*, Chicago
Contemporary Books, revised edition 1989, page 191.

3 G Norman, 'Style and collecting ...', *Independent Weekend*, 16
November 1991, page 36.

4 'What's new', *Creative Review*, May 1983, page 8.

5 A Fendley, *Commercial Break: The Inside Story of Saatchi &
Saatchi*, London, Hamish Hamilton, 1995, page 79.

6 M P Davidson, *The Consumerist Manifesto: Advertising in*

Postmodern Times, London and New York, Comedia/Routledge, 1992, page 77.

7 H Haacke, *Global Marketing*, London, Victoria Miro, 1987. Also published as 'Text and images', *Art Journal*, Vol. 48, No. 2, Summer 1989, pages 186–89.

8 See also Haacke's earlier letter 'Saatchi/South Africa update' to *Art in America*, Vol. 73, No. 12, December 1985, page 9.

9 Benjamin Buchloh, 'Hans Haacke: memory and instrumental reason', *Art in America*, Vol. 76, No. 2, February 1988, pages 97–108 and 157–59.

10 J A Allen, 'Wheelers, dealers and supercollectors. Where are they taking the art market?' *New Art Examiner*, Vol. 13, No. 10, June 1986, pages 22–27.

11 Ibid.

12 R Hughes, 'On art and money', *New York Review of Books*, 6 December 1984, pages 20–27.

13 K Marx, *Capital: A Critical Analysis of Capitalist production*, Vol 1, Moscow, Progress Publishers, 1954, page 546., page 546.

14 Ibid., page 545.

15 K Goldman, *Conflicting Accounts: The Creation and Crash of the Saatchi & Saatchi Advertising Empire*, New York, Simon & Schuster, 1997, page 131.

16 K Marx, *Capital*, page 552.

17 T Veblen, *The Theory of the Leisure Class: An Economic Study of Institutions,* London, Unwin Books, 1970.

18 Ibid., page 36–37.

19 Ibid., page 37.

20 Ibid., page 64.

21 In the mid 1980s Maurice Saatchi and his second wife, the novelist Josephine Hart, acquired an estate in Sussex with an 1842, mock-Tudor house called Old Hall. The estate consists of 60 acres of parkland plus ten acres of planned enclosures of

flowers, trees and lakes. Maurice became passionately interested in the layout and appearance of the gardens. For an account of this property see Georgina Howell, 'Josephine Hart in Sussex: the author's country life with Maurice Saatchi', *Architectural Digest*, Vol. 52, January 1995, pages 63–71 and 151. This well-illustrated article depicted a way of life associated with the affluent English gentry; it was to prove an embarrassment when Maurice was under attack for being profligate.

22 Veblen, *Theory of the Leisure Class*, page 77.

23 Jean Baudrillard has added a semiotic spin to Veblen's analysis: 'In the economic order it is the mastery of *accumulation*, of the *appropriation* of surplus value, which is essential. In the order of the sign of culture, it the mastery of *expenditure* that is decisive, that is, a mastery of the transubstantiation of economic exchange value into sign exchange value based on a monopoly of the code. Dominant classes have ... assured their domination over sign values ... because this ... represents the ultimate stage of domination,' Jean Baudrillard, 'The art auction: sign exchange and sumptuary value', *For a Critique of the Political Economy of the Sign,* St Louis, MO: Telos Press, 1981, pages 112–22.

24 J Rayner, 'Love or money', *The Guardian*, 30 November 1992, pages 4–5.

25 Louise Baring, 'You've seen his advertising campaigns ...', *Vogue* (UK), Vol. 162, No. 2374, May 1996, pages 144–49.

26 Meg Carter, 'The Saatchi Collection', *Wired*, 2 May 1996.

27 'Lord Saatchi, Interim Report 1997', London, Megalomedia, November 1997. Posted on the Internet: http://193.119.70/profile/profile.html

28 John Harlow, 'Saatchi revives glory days of Hammer', *Sunday Times*, 18 May 1997, page 17.

29 See Emily Bell, 'Saatchi & Saatchi's New Labour of love', *The Observer,* Business Section, 13 April 1997, page 1.

30 Andy Beckett, 'On Golden Square', *The Guardian* (G2), 11
 November 1997, pages 2–3.
31 M&C Saatchi Arts, London, M&C Saatchi, 1998, publicity
 brochure.
32 Letter to the authors dated 16 March 1999.

4 / **the saatchi collection**

1 A Storr, 'Focus: the psychology of collecting', *Connoisseur*, Vol.
 213, No. 856, June 1983, pages 35–38.
2 R Moulin, *The French Art Market: A Sociological View*, New
 Brunswick and London, Rutgers University Press, 1987, an
 abridged translation of a book first published in France in 1967.
 For the chapter on collectors, see pages 79–106. The book was
 reviewed by Yve-Alain Bois in *Art in America*, Vol. 76, No. 7,
 July 1988, pages 35–37.
3 Ibid., page 85.
4 Ibid., page 82.
5 Stuart Dalby quoting Peter Wilson, 'The fine art of survival',
 he Guardian Money, 11 July 1998, page 15.
6 J Baudrillard, 'The art auction: sign exchange and sumptuary
 value', *For a Critique of the Political Economy of the Sign*,
 St Louis, MO, Telos Press, 1981, pages 112–22.
7 J Baudrillard, *The System of Objects*, London and New York,
 Verso, 1996, page 88.
8 Storr, 'Focus', pages 35–38.
9 Moulin, *The French Art Market*, page 83.
10 Storr, 'Focus', pages 35–38.
11 Moulin, *The French Art Market,* page 83.
12 D Alberge, 'A very private collector'.
13 Moulin, *The French Art Market*, page 97.

14 Ibid., page 98.

15 Ibid., page 97.

16 Ibid.

17 Ibid., page 99.

18 Ibid., page 100.

19 Dalby, 'The fine art of survival', page 15.

20 Storr, 'Focus', pages 35–38.

21 I Blum, quoted in, Carter Ratcliff, 'The marriage of art and money', *Art in America*, Vol. 76, No. 7, July 1988, page 80.

22 Hoving, quoted in Louisa Buck and Philip Dodd, *Relative Values or What's Art Worth?* London, BBC Books, 1991, page 63.

23 Moulin, *The French Art Market*, pages 81 and 85.

24 Ibid., page 94.

25 Ibid., page 81.

26 Baudrillard, *The System of Objects*, page 88.

27 Moulin, *The French Art Market*, page 93.

28 Ibid.

29 Ibid., page 95.

30 Quoted in K Goldman, *Conflicting Accounts: The Creation and Crash of the Saatchi & Saatchi Advertising Empire*, New York, Simon & Schuster, 1997, page 225.

31 D Saatchi, 'Artists and heroes', *Artscribe,* No. 37, October 1982, pages 16–19.

32 She told Charles Darrant: 'I'm more like Diana. As Artemis, she lived on the mountain-tops. But she lived alone. I guess that's a description of me.' *Independent on Sunday*, 18 October 1998, pages 22–23. See also the colour cover photo of *Correspondent Magazine*, 17 December 1989, which shows Doris standing beside the statue of Artemis.

33 R Smith, 'Flooding the mind and eye: Jennifer Bartlett's commissions', *Jennifer Bartlett*, by M Goldwater, R Smith and C Tomkins, Minneapolis, Walker Art Center/New York, Abbeville

Press, updated edition 1990 (estimate), page 109.

34 Jonathan Glancey, 'Charles Saatchi buys artworks like Imelda Marcos bought shoes', *Independent Weekend*, 17 February 1996, page 7.

35 Charles Darwent, 'Pieces from a confessional', *Independent on Sunday*, 18 October 1998, pages 22–23.

36 Alberge, 'A very private collector', page 19.

37 Moulin, *The French Art Market*, page 101.

38 P Watson, *From Manet to Manhattan: The Rise of the Modern Art Market*, London, Hutchinson, 1992, page 435.

39 Ibid., pages 434–35.

40 Junius Secundus (Robert Hughes), 'The Sohoiad: or, the masque of art, a satire in heroic couplets drawn from life', *New York Review of Books*, 29 March 1984, pages 17–19.

41 S Chia, 'Letters: Saatchi's "dispersals"', *Art News*, Vol. 84, No. 7, September 1985, page 9.

42 For an account of Landsdowne House see Hugh Pearman, 'Secret spaces', *Design,* No. 496, April 1990, pages 52–54. According to Pearman, the Saatchis leased the whole building and then sub-let the parts they did not need for rents that were the highest in London. Pearman was unimpressed by the minimalist-style interior design of the Saatchi offices and remarked: 'Little effort seems to have gone into this interior at all, beyond the hanging of items from the art collection: every wall is hung with some work or other, usually abstract. If the idea is that the art compensates for the space, the idea has failed. It merely heightens the inadequate setting.'

43 Art for Offices, *Making Art More Accessible*, (London, n.d.), promotional brochure.

44 H Haacke, 'Text and images', *Art Journal*, Vol. 48, No. 2, Summer 1989, pages 186–89.

45 Fallon, *The Brothers*, page 331.

46 Deloitte & Touche (accountants and auditors), Conarco Ltd: Report and Financial Statements 31 March 1997, (Cardiff: Companies House, 1998).

47 A Atha, 'The Saatchi picture show', *Harpers & Queen*, August 1984, pages 66–69.

48 Chris Blackhurst, 'Saatchis face row over gallery loans', *The Observer*, 15 January 1995, page 2.

49 Juliet Hindell, 'Japanese sell off art treasures as bubble bursts', *Daily Telegraph*, 8 July 1998, page 13. Colin Gleadell says he was told the Kiefers were sold for £11 million (letter to the authors, 18 January 1999).

50 Atha, 'The Saatchi picture show', pages 66–69.

51 The artists included Richard Deacon and Lisa Milroy. When asked why he had given works to the Tate, Saatchi replied that he had been asked to do so.

52 F Spalding, *The Tate: A History*, London: Tate Gallery Publishing, 1998, page 221.

53 Schnabel interviewed for the British television programme: 'Saatchi special', *The Late Show*, BBC2, 29 March 1990.

54 Ibid.

55 Castelli quoted by Victor Bockris, *Warhol*, London, Frederick Muller, 1989, page 428.

56 For an example of the reviews, see: John A Walker, 'Julian Schnabel at the Tate', *Aspects*, No. 20, Autumn 1982, unpaginated.

57 P Fuller, 'Exhibitions: Julian Schnabel', *Art Monthly*, No. 73, February 1984), pages 19–20.

58 N Rosen, 'Artopoly: a giant game for dealers, museum curators and artists', *The Guardian*, 19 December 1983, page 10.

5 / **the saatchi gallery**

1 Don Hawthorne, 'Saatchi & Saatchi go public', *Art News*, Vol. 84, No. 5, May 1985, pages 72–81.

2 D Alberge, 'A very private collector'.

3 Godfrey Baker, 'Saatchi is strictly for the fishes, says Ken', *Evening Standard*, 15 February 1999, page 58.

4 D Saatchi, 'Appreciation: Max Gordon, making room for modern art', *The Guardian*, 30 August 1990, page 37.

5 On the gallery see 'Case Studies: The Saatchi contemporary art collection', *Architects' Journal*, Vol. 182, No. 32, 7 August 1985, page 38; 'The Saatchi Collection', *International Journal of Museum Management*, Vol. 4, No. 4 December 1985, pages 395–97; Paula Jackson, 'British Design', *Interiors,* New York, Vol. 146, No. 8, March 1987, pages 142–47, with photos by Richard Bryant.

6 Stuart Morgan, Jon Bird and Adrian Forty, 'The Saatchi museum', *Artscribe*, No. 54, September/October 1985, pages 45–50.

7 Richard Cork, 'Art: Going Public', *Listener,* 28 March 1985.

8 Brian Sewell, 'A case of the emperor's clothes?' *Evening Standard*, 25 March 1985.

9 See, for example, Don Hawthorne, 'Saatchi & Saatchi go public', *Art News*, Vol. 84, No. 5 May 1985), pages 72–81; Kenneth Baker, 'Report from London: the Saatchi museum opens', *Art in America*, Vol. 73, No. 7, July 1985, pages 23–27; Stuart Morgan, Jon Bird and Adrian Forty, 'The Saatchi museum', *Artscribe,* No. 54, September/October 1985, pages 45–50, Jackson, 'British Design'; Alberto Piovano (photographer), 'The Saatchi Collection', *Abitare,* No. 310, September 1992, pages 218–21.

10 Baker, 'Report from London', pages 23–27.

11 Hawthorne, 'Saatchi & Saatchi go public', pages 72–81.

12 W Benjamin, 'The work of art in the age of mechanical

reproduction', *Illuminations,* London, Jonathan Cape, 1970, pages 219–53.

13 See John A Walker, *Art and Outrage: Provocation, Controversy and the Visual Arts*, London and Stirling, Virginia, Pluto Press, 1999, pages 192–97.

14 J Wagg, 'Proposals: Jamie Wagg to Charles Saatchi', *Everything*, No. 17, 1995, pages 12–13.

15 J W Mahoney, 'In pursuit of pessimism: catching up with the Saatchis', *New Art Examiner*, Vol. 14, September 1986, pages 22–25.

16 Ibid.

17 Morgan, Bird and Forty, 'The Saatchi museum', pages 45–50.

18 Sarah Kent, 'New British art: gallery slaves', *Time Out*, 1–8 November 1989, pages 16–17. Kent (b. Rugby 1941), studied painting at the Slade from 1960 to 1965. During the late 1960s she used masking tape and acrylic pigments to create abstract paintings consisting of vertical strips of pigment which generated spatial illusions via contrasts of hue and tone.

19 J Blyth, quoted in, Georgina Adam, 'London: a $77,500 shark', *Art News*, Vol. 94, No. 4, April, 1995, page 43.

20 John A Walker, 'Unholy alliance: Chairman Mao, Andy Warhol, and the Saatchis', *Real Life* magazine (New York), No. 15, Winter 1985/86, pages 15–19.

21 S Ford, 'The myth of the young British artist', *Occupational Hazard: Critical Writing on Recent British Art*, eds D McCorquodale *et al*, London, Black Dog Publishing, 1998, pages 130–41.

22 F Frascina, 'American art?' *Art Monthly*, No. 171, November 1993, pages 19–21. Frascina concluded: 'Ideology inverts the truth of real relations. It operates by means of exclusions, erasure and amnesia lest the "secrets" of these actual relations be revealed in their full dialectical reality. Oppositional examples are only

included when they can be presented so as not to contradict other elements within the effective dominant culture. This is what we get at the Royal Academy and the Saatchi Gallery. Another mega-financed instance of the hermetically sealed bourgeois universe.'

23 For a review of this show see Gilda Williams, 'Young Americans Part I', *Art Monthly*, No. 194, March 1996, pages 24–26.

24 Adrian Searle, 'Monsieur le patron', *The Guardian*, 28 April 1998, pages 10–11.

25 S Kent, 'Richard Wilson', *Shark Infested Waters: The Saatchi Collection of British Art in the 90s*, London, Zwemmer, 1994, page 109.

6 / **art as investment, sales and gifts**

1 Faith, cited by J Addams Allen, in: 'Wheelers, dealers and supercollectors: where are they taking the art market?' *New Art Examiner*, Vol. 13, No. 10, June 1986, pages 22–27.

2 Will Bennett, 'Market stages recovery', *Daily Telegraph*, 3 August 1998, page 14.

3 The tastemakers consist of key collectors, curators and dealers – perhaps only a dozen people. See Geraldine Norman and Edward Lucie-Smith, 'The power of the tastemakers', *Independent Weekend*, 18 August 1990, page 44.

4 *Wall Street*, (1987), directed by Oliver Stone, screenplay by Stanley Weiser, Twentieth Century Fox.

5 For a more extended discussion of these options see John A Walker, 'Artworks as commodity', *Circa*, No. 30, January–February, 1987, pages 26–30, and Mark Harris, 'Trading up or selling out', *Art Monthly*, No. 203, February 1997, pages 1–5.

6 J Alsop, *The Rare Art Traditions: The History of Art Collecting and its Linked Phenomena wherever these have Appeared*,

London, Thames & Hudson, 1982, page 76.

7 H Solomon, quoted in, Carter Ratcliff, 'The marriage of art and money', *Art in America*, Vol. 76, No. 7, July 1988, page 85.

8 Jacobson, paraphrased by Catherine Bennett, 'Pop goes the art market', *The Guardian*, 17 November 1992, pages 2–3.

9 The term 'trend collectors' has been used by the American dealer Bess Cutler. See Richard W Walker, 'The Saatchi factor', *Art News*, Vol. 86, No. 1, January 1987, pages 117–21.

10 P Fuller, 'Editorial: Art and money: post-Saatchi painting', *Modern Painters*, Vol. 2, No. 4, Winter 1989/90, pages 5–7.

11 P Kind, quoted in, Ratcliff, 'The marriage of art and money', page 80.

12 D Alberge, 'A very private collector'.

13 K Baker, 'Report from London: The Saatchi museum opens', *Art in America,* Vol. 73, No. 7, July 1985, pages 23–27.

14 J Adams Allen, 'Wheelers, dealers and supercollectors: where are they taking the market?', *New Art Examiner*, Vol. 13, No. 10, June 1986, pages 22–27.

15 See Geraldine Norman, 'Saatchi selling £6 million of minimalist paintings to buy big', *The Independent*, 1 May 1991, page 1. 'Saatchi "dumps" unwanted art. Saatchi's unwanted art goes cheap', *The Independent*, 15 November 1991, page 3.

16 Alberge, 'A very private collector', page 19.

17 R Bevan, 'Charles Saatchi: the man and the market', *Art Newspaper*, Vol. 8, No. 73, September 1997, pages 20–21.

18 S Scully, quoted in Robert Hughes, 'Art and money: sold!', *Time International*, Vol. 134, No. 22, 27 November 1989, pages 38–43.

19 Ibid.

20 S Chia, 'Letters: Saatchi's "dispersals"', *Art News*, Vol. 84, No. 7, September 1985, page 9.

21 Ian Katz, 'Profile: Charles Saatchi', *The Guardian*, 7 February 1994, pages 8–9.

22 S Chia, statement in, 'Making art, making money: 13 artists comment', *Art in America*, Vol. 78, No. 7, July 1990, pages 138–39.

23 Ibid.

24 M Collings, *Blimey! From Bohemia to Britpop: the London Artworld from Francis Bacon to Damien Hirst*, Cambridge, 21, 1997, page 195.

25 Ibid., pages 193–94.

26 Dick Price, *The New Neurotic Realism*, London, Saatchi Gallery, 1998.

27 Allen, 'Wheelers, dealers and supercollectors', pages 22–27.

28 See the remarks made by dealers in Ratcliff's 'The marriage of art and money', pages 76–85, 145, 147.

29 P Watson, *From Manet to Manhattan: The Rise of the Modern Art Market*, London, Hutchinson, 1992, page 434.

30 G Norman, 'Style and collecting', *Independent Weekend*, 16 November 1991, page 36. For a more detailed profile of Gagosian with colour photos of him and his properties see Dodie Kazanjian, 'Going places', *Vogue* (US), November 1989, pages 412–17, 462. See also Robert Mahoney, 'Interviews: Larry Gagosian', *Flash Art*, No. 151 (March–April 1990), pages 178–79. Francesco Bonami, 'Dealers: Larry Gagosian', *Flash Art*, No. 164 (May–June 1992), page 142.

31 G Norman, 'Star turn "falls to Saatchi's bidding"', *The Independent*, 2 May 1991, page 5.

32 Opinions cited by Jay Rayner, 'Love or money', *The Guardian*, 30 November 1992, pages 4–5.

33 Michael Archer and Marjorie Allthorpe-Guyton interview Janet Green, 'I don't like eggs', *Artscribe*, No. 82, Summer 1990, pages 52–59. In the course of this interview Green, who was then the wife of Michael Green (head of Carlton Communications and a friend of Charles Saatchi), stated that Saatchi 'had a profound

influence over me; his enthusiasm towards collecting was contagious'.

Janet Wolfson de Botton inherited a fortune from her grandfather Sir Isaac Wolfson, founder of the Great Universal Stores chain. After divorcing Michael Green, she married Gilbert de Botton in 1990. (He was also a collector, chairman of Global Asset Management, trustee of the Tate and chairman of the Tate's International Council.) Janet began collecting in 1976 when she bought an abstract painting by John Hoyland. She has close connections with the Tate Gallery: in 1982 she became a member of the Patrons of New Art and five years later a trustee of the Tate Gallery Foundation and, in 1992, a trustee of the Tate. Janet acquired most of her collection during the 1980s, a boom time in the art market. She bought mainly abstract works by British and American artists. She was prepared to buy large-scale pieces even though she had no gallery, like that of her friend Saatchi, in which to display them. This was one of the reasons she decided to present 60 works to the Tate in 1996. They consisted of paintings, drawings, sculptures and photographs by 30 artists who included Carl Andre, Richard Artschwager, Grenville Davey, Gilbert & George, Gary Hume, Richard Long, Lucas Samaras, Julian Schnabel, Sean Scully, Cindy Sherman, Nancy Spero, Richard Wentworth, Andy Warhol and Bill Woodrow. From this list it is clear that Janet responded to many of the same artists that Saatchi did.

See Monique Beudert and Sean Rainbird (eds), *Contemporary Art: The Janet Wolfson de Botton Gift*, London, Tate Gallery Publishing, 1998, and Godfrey Barker, 'Janet de Botton: driven to abstraction', *Art News*, Vol. 97, No. 7, Summer 1998, pages 132–33.

34 R Moulin, *The French Art Market: A Sociological View*, New Brunswick and London, Rutgers University Press, 1987, page 79.

35 P Bickers, 'Sense & sensation', *Art Monthly*, No. 211 November 1997, pages 1–6.

36 B Sewell, 'Brian Sewell's view', *Evening Standard*, 23 October 1998, page 9.

37 See, for example, Dan Glaister, 'Falling stars fear in Saatchi "pruning"', *The Guardian*, 21 October 1998, page 5; Simon Tait and Brian Sewell, 'The artful ways of Charles Saatchi', *Evening Standard*, 23 October, 1998, pages 8–9; Andrew Marr, 'Throwing the baby out with the bathwater?', *The Guardian* (Saturday Review), 24 October 1998, page 3; Andrew Marr, 'Baby for sale', *The Guardian,* 6 December 1998, page 5; Gordon Burn, 'I want it, I want it all, and I want it now', *The Guardian* (G2), 7 December 1998, pages 1–3; Dan Glaister, 'BritArt gets a boost as Saatchi sale raises £1.6m', *The Guardian*, 9 December 1998, page 2; David Lister, 'BritArt's big day out', *The Independent*, Wednesday Review, 9 December 1998, page 1; Andrew Wilson, 'Auction preview', *Art Monthly*, No. 222, December 1998–January 1999, page 57; David Lister, 'Saatchi auction raises £1.6m', *The Independent*, 9 December 1998, page 5; Colin Gleadell, 'Salerooms: Spinning Jenny', *Art Monthly*, No. 223, February 1999, pages 48–49.

38 Christie's Contemporary, London 8 December 1998, London: Christie's, 1998, sale catalogue plus faxed after-sale details.

39 'Art of business: Saatchi is a modern Medici', *The Guardian*, 21 October 1998, page 23.

40 C Gleadell, 'Salerooms: spinning jenny, *Art Monthly*, No. 223, February 1999, pages 48–49.

41 Marr, 'Throwing the baby out with the bathwater?'.

42 P Bickers, Editorial, *Art Monthly*, No. 222, December 1998–January 1999, page 18.

43 Kate Worsley, 'First brushes with the real world', *Times Higher*, 20 November 1998, pages 20–21.

44 P Bonaventura, 'Saatchi's art has a darker side', *The Guardian*, 27
 October 1998, page 21.

45 Rory Carroll, 'Saatchi gives modern works to Arts Council', *The
 Guardian*, 10 February 1999, page 4; David Lister, 'Saatchi
 donates £500,000 BritArt package to nation', *The Independent*,
 10 February 1999, page 9.

7 / the patron and the 'sensation' and 'neurotic realism' exhibitions

1 Roger Tredre, 'British art goes plastic fantastic as Saatchi invests
 in the next sensation', *The Observer*, 12 April 1998, page 18.

2 Gordon Burn, 'I want it, I want it all, and I want it now', *The
 Guardian*, 7 December 1998, pages 1–3.

3 For a thoughtful account of the plight of artists in Britain see
 Naomi Siderfin, 'Occupational hazard', *Occupational Hazard:
 Critical Writing on Recent British Art*, eds D McCorquodale *et al*,
 London, Black Dog Publishing, 1998, pages 26–43. See also Ruth
 Towse, *The Economics of Artists' Labour Markets*, London, Arts
 Council of England, 1995. Towse's research reveals the large
 number of artists on incomes below the national average and the
 significant proportion of artists who go for years without earning
 anything from their art.

4 Jenny Saville, 'Saville's road', *Artists' Newsletter*, March 1996,
 pages 6–7.

5 D Cohen, 'Notebook: letter from London: Charles Saatchi's yBas',
 New Criterion, Vol. 16, December 1970, pages 78–80.

6 Pat Kane, 'A full body of work', *The Observer Review*, 23
 January 1994, page 7.

7 Louise Bishop, 'Model family', *Creative Review*, Vol. 17, No. 4,
 April 1997, pages 36–38. Shaun Phillips, 'Big Ron, little Ron',
 The Face, June 1997, pages 106–12.

8 A Lewis, 'The logic of organised sensations', *The Art Book*, Vol. 5, No. 2 March 1998, pages 5–6.

9 K Hauser, 'Sensation: young British Artists from the Saatchi Collection', *New Left Review*, No. 227, January/February 1998, pages 154–60.

10 Lewis, 'The logic of organised sensations', pages 5–6.

11 For a semiotic analysis of this painting see: John A Walker, 'Marcus Harvey's "sick, disgusting" painting of Myra Hindley', *tate,* the art magazine, No. 14, Spring 1998, pages 56–57.

12 Several newspaper articles gave the reasons for the resignations, for example Vanessa Thorpe, 'Hindley picture is a sensation too far for artist Ayres …', *Independent on Sunday*, 21 September 1997, page 5; M Sandle, 'The Arts: The RA is rotten at the top …', *Daily Telegraph*, 23 September 1997.

13 Brooks Adams and others, *Sensation: Young British Artists from the Saatchi Collection*, London, Royal Academy of Art/Thames & Hudson, 1997.

14 Lewis, 'The logic of organised sensations', pages 5–6.

15 S Ford & A Davies, 'Art capital', *Art Monthly*, No. 213, February 1998, pages 1–3.

16 Lewis, 'The logic of organised sensations', pages 5–6.

17 Ibid.

18 Bryan Robertson, 'Something is rotten in the state of art', *Modern Painters*, Vol. 10, No. 4, Winter 1997, pages 15–16.

19 L Jardine, 'Looking after the overlooked', *Daily Telegraph*, 19 November 1997, page 22.

20 See for example, the articles and letters from readers in *Modern Painters*, Vol. 10, No. 4, Winter 1997.

21 Cohen, 'Notebook: letter from London', pages 78–80.

22 *Without Walls*, Channel 4 Television, 22 November 1994.

23 See Anthea Gerrie, 'BritArt makes London world culture capital', *The Observer*, 20 July 1997, page 16. Journalists also claimed

that London was swinging again as in the 1960s. See 'London swings again!' *Vanity Fair*, No. 439, March 1997.

24 George Walden has observed: 'Patriotism is another force at work on ministers. One reason they speak as they do of British contemporary art is that it is highly rated on the international market, and all ministers today have a great respect for markets.' 'Politics: art, where is your sting?' *Modern Painters*, Vol. 10, No. 4, Winter 1997, pages 70–72.

25 Nicola Kuhn, 'You can puff all you like Damien, but the wind's gone out of BritArt', *The Guardian*, 16 March 1999, pages 10–11.

26 D Lister, 'Sorry Damien, however hard you try, you've become passé', *The Independent*, 30 May 1998, page 3.

27 J Jones, 'The "ism" that isn't', *The Guardian*, 5 January 1999, pages 10–11.

28 C Brown, 'Painting epiphany: happy days are where, again?' *Flash Art*, No. 200, International Edition, May/June 1998, pages 76–79. See also Andrew Lambirth, 'Real oil painting is real cool', *The Independent*, 28 April 1998, page 16.

29 M Maloney (curator), P Ellis (introduction), *Die Young Stay Pretty*, London, Institute of Contemporary Arts, 1998.

30 Op. cit.

31 A Searle, 'Dumb and dumber', *The Guardian*, 1 December 1998, page 10.

32 T Lubbock, 'The trouble with Saatchi'. *The Independent*, Tuesday Review, 19 January 1999, page 11.

33 Nicci Gerrard, 'Is this the future of British Art?', *Life: The Observer Magazine*, 10 January 1999, pages 12–15 and front cover.

34 T Jackson, 'British art goes back to basics', *Big Issue*, 9–14 June 1998, pages 16–18.

35 J Jones, 'Not much to shout about', *Observer Review*, 17 January

1999, page 8.

36 Kuhn, 'You can puff all you like Damien'.

37 J J Charlesworth, 'Must try harder', *Caffeine* Artspaper, No. 6, 1999, pages 18–19.

38 M Collings, 'Diary: being entertained', *Modern Painters*, Vol. 11, No. 4 Winter 1998, pages 86–88.

39 L Jardine, 'Arts: coffee trader? Come off it, Sewell, Charles Saatchi is the British art world's greatest living asset', *New Statesman*, Vol. 126, No. 4316, 10 January 1997, pages 38–39.

8 / absences and alternatives

1 J W Mahoney, 'In pursuit of pessimism: catching up with the Saatchis', *New Art Examiner*, Vol. 14, September 1986, pages 22–25.

2 P Blake, 'My 30 years in Advertising', *Campaign* 30th Anniversary, 18 September 1998, page 15.

3 For more on DIAS, Latham and APG, see John A Walker, *John Latham – The Incidental Person – His Art and Ideas*, London: Middlesex University Press, 1995.

4 APG still persists under the name O + I (Organisation and Imagination). Its coordinator is Barbara Steveni, Latham's wife.

5 See Liz McQuiston, *Graphic Agitation: Social and Political Graphics since the 1960s*, London, Phaidon Press, 1993, pages 28–29, 183. For another discussion of graphic subversion see Rick Poynor, 'Design is advertising, Part 2: nomadic resistance', *Eye*, Vol. 8, No. 30, Winter 1998, pages 36–43.

6 For more on alternatives to the gallery system and the relation between art and mass media see John A Walker, *Art in the Age of Mass Media*, London, Pluto Press, second edition 1994, and *Cross-Overs: Art into Pop/Pop into Art*, London and New York,

Comedia/Methuen, 1987.

7 L Golub, quoted in *State of the Art: Ideas and Images in the 1980s*, by Sandy Nairne and others (London: Chatto & Windus/Channel 4 Television, 1987), page 172.

8 Mark Wallinger and Paul Bonaventura, 'Turf accounting', *Art Monthly*, No. 175, April 1994, pages 3–7.

9 Sarah Kent, George Melly and Cosmo Landesman, *Private View at the Saatchi Collection*, Channel 4 Television, 5 May 1993.

10 Mahoney, In pursuit of pessimism', pages 22–25. Regarding the relation between radical art and the bourgeois class, Roland Barthes has observed: 'True, there are revolts against bourgeois ideology. This is what one generally calls the avant-garde. But these revolts are socially limited, they remain open to salvage. First because they come from a small section of the bourgeoisie itself, from a minority group of artists and intellectuals, without a public other than the class which they contest, and who remain dependent on its money in order to express themselves. Then, these revolts always get their inspiration from a very strongly made distinction between the ethically and the politically bourgeois: what the avant-garde contests is the bourgeois in art or morals ... but as for political contestation there is none.' *Mythologies*, London, Jonathan Cape, 1972, page 139.

11 See the catalogue, *A New Spirit in Painting*, with an essay by Christos M Joachimides, London, Royal Academy of Arts/Weidenfeld & Nicolson, 1981.

12 S Ford, 'The myth of the young British artist', *Occupational Hazard: Critical Writing on Recent British Art*, eds D McCorquodale and others, London, Black Dog Publishing, 1998, 130–41.

13 Ibid.

14 C Milner, 'Enter, a shy man', *Sunday Telegraph* (Art Review), 23 March 1997, page 7.

15 See Stuart Jeffries, 'British art is high on its own vulgarity. And it's all Margaret Thatcher's fault', *The Guardian* (Arts), 19 April 1997, page 6.

16 An anonymous 'conceptualist' quoted by Ian Macmillan in 'Cheque mate', *Time Out* supplement to the 'Sensation' exhibition, London, Time Out, 1997, pages 6–7.

9 / **power and culture**

1 J Baudrillard, *For a Critique of the Political Economy of the Sign*, St Louis, MO, Telos Press, 1981, page 170.

2 'The Power 300', *The Observer*, 1 November 1998, 16-page supplement.

3 W Januszczak, Diary, *London Review of Books*, 21 March 1985, page 21.

4 P Fuller, 'Editorial: art and money: post-Saatchi painting', *Modern Painters*, Vol. 2, No. 4, Winter 1989/90, pages 5–7.

5 M P Davidson, *The Consumerist Manifesto: Advertising in Postmodern Times*, London and New York, Comeda/Routledge, page 78.

6 P Bickers, 'Sense and sensation', *Art Monthly*, No. 211, November 1997, pages 1–6.

7 H I Schiller, *Culture Inc.: The Corporate Takeover of Public Expression*, New York and Oxford, Oxford University Press, 1989, page 3. For a well-researched and informative article about corporate patronage in Britain see Chin-tao Wu, 'Embracing the enterprise culture: art institutions since the 1980s', *New Left Review*, No. 230, July–August 1998, pages 28–57.

8 See Ewen MacAskill, 'MPs damn easy profits on rail sell off', *The Guardian*, 10 August 1998, page 2.

9 J B Thompson, *Ideology and Modern Culture: Critical Social*

Theory in the Era of Mass Communication, Cambridge, Polity Press, 1990, page 158.

10 'The Saturday profile: Charles Saatchi, the artful dealer', *Daily Telegraph*, 20 September 1997, page 16.

11 See various reports in *The Guardian*, 24, 28, 30 September 1999.

index

CS = Charles Saatchi
S&S = Saatchi & Saatchi
Bold page numbers refer to illustrations

picture credits

Front cover: Peter Clarke,
© Guardian Syndication
page 2: © Michael-Ann
Mullen/Format, portrait of the
authors, (1999)
page 13, © K McMillan
page 26, © Solo Syndication,
London
page 31, art director: Bill
Atherton; copywriter: Jeremy
Sinclair; photographer: Alan
Brooking. Reproduced
courtesy of Saatchi & Saatchi
page 33, Collection Simon
Josebury. Photo: © C Lowe
and R Thomson
page 41, reproduced courtesy of
Gallaher and Saatchi &
Saatchi. Photo: © John A
Walker
page 44, Tate Gallery Collection.
Photo: Tate Publishing.
© Succession Picasso/DACS,
1999
page 45, reproduced courtesy of
Gallaher & M&C Saatchi
page 49, © New Statesman, 1998
page 53, art director: Martyn
Walsh; copywriter: Andrew
Rutherhood. Reproduced

courtesy of the Conservative
Party and Saatchi & Saatchi
page 56, © M Birt/Katz Pictures
page 57, reproduced courtesy of
Saatchi & Saatchi. Photo: ©
Melanie Friend
page 59, © Carlton Television
Ltd
page 61, Michigan: Gilbert and
Lila Silverman Collection.
Photo: Zindman/Fremont,
reproduced courtesy of Hans
Haacke/VG Bild-kunst. ©
DACS, 1999
page 69, creatives: Martin
Casson and Nick Drummond.
Reproduced courtesy of the
Conservative party and M&C
Saatchi
page 75, creatives: Rita Dempsey
and Phil Mason; film director
Richard Loncraine of James
Garrett & Partners.
Reproduced courtesy of
British Airways and Saatchi &
Saatchi
page 77, collection: Eli Broad
Family Foundation, Santa
Monica. Photo: Fred Scruton.
© Hans Haacke/VG Bild-

Kunst. © DACS, 1999

page 88, London: private collection

page 105, reproduced courtesy of the Robert Mapplethorpe Foundation, New York

page 108, © Michael-Ann Mullen/Format

page 109, reproduced courtesy of Beauchamp Estates

page 110, reproduced courtesy of Prudence Cuming Associates. © Jennifer Bartlett

page 119, © N Bailey/Rex Features, London

page 125, photo: © S Adler/ the Guardian and Observer Syndication. *Accatone* © Julian Schnabel

page 131, photo: A Bartos, courtesy of The Saatchi Gallery, London. Warhol's paintings © The Estate and Foundation of Andy Warhol

page 134, *Firetruck* now belongs to the Eli Broad Family Foundation, Santa Monica. Photo: Stephen White, reproduced courtesy of The Saatchi Gallery, London. *Firetruck* © C Ray

page 137, © Michael-Ann Mullen/Format

page 139, photo of gallery interior supplied to Wagg by the Saatchi Gallery. Photo of Mrs Thatcher courtesy of the Thatcher Foundation and other photos of Tory

politicians the Press Association. Reproduced courtesy of J Wagg

page 153, photo: ©Anthony Oliver, reproduced courtesy of The Saatchi Gallery, London. *20:50* © R Wilson

page 168, © I D Tana

page 174, London: Nick Silver Collection. Photo: courtesy of The Contemporary Arts Museum, Houston. Sculpture © D and J Chapman

page 183, photo: © *The Independent* Picture Syndication/G Griffiths. *Plan* © J Saville

page 188, photo: © John Reardon

page 195, © R Young/Rex Features, London

page 205, S White, © The Saatchi Gallery, London

page 213, photo: Stephen White, reproduced courtesy of The Sonnabend Gallery, New York and White Cube, London and the Saatchi Gallery, London. Painting © A Bickerton

page 219, digital photographic montage/print. Reproduced courtesy of SAS. Painting: Berlin: Deutches Historiches Museum

page 223, painting: Chicago, Ulrich Meyer and Harriet Horwitz Collection. Photo: Diana Church, reproduced courtesy of Leon Golub and Jon Bird